Exploring
Colored Pencil

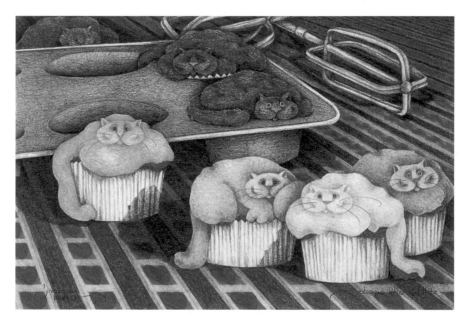

Jamie S. Perry, *Still Life With Cupcats,* 1994.
Colored pencil, 8" x 12" (20 x 30 cm).

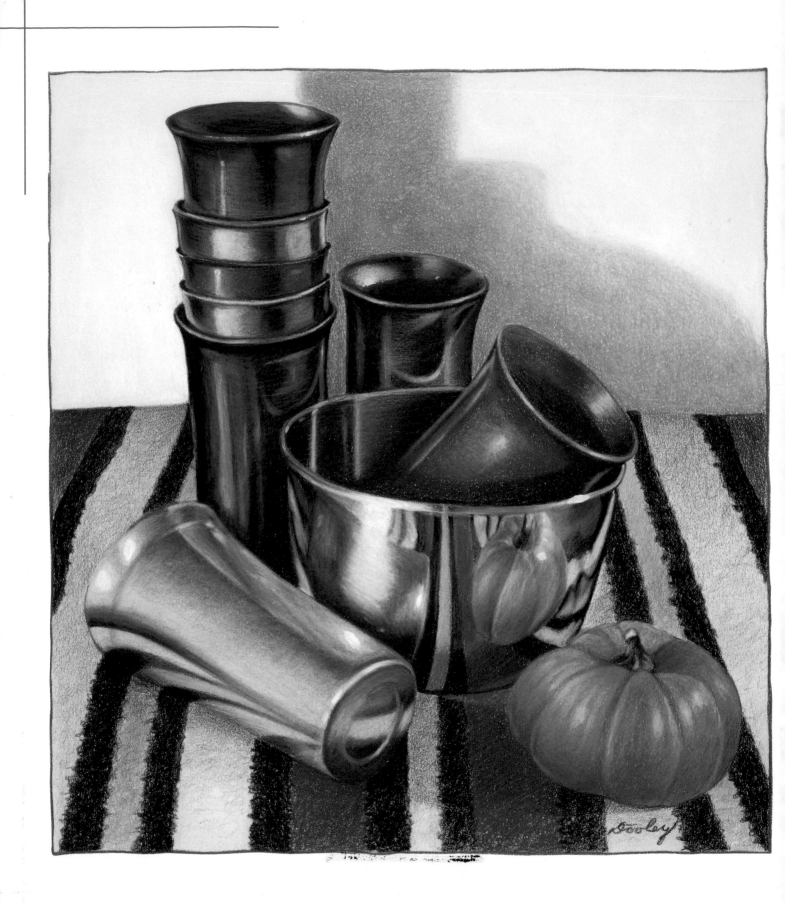

Exploring Colored Pencil

SANDRA MCFALL ANGELO

Davis Publications, Inc.

Publisher: Wyatt Wade
Editorial Director: Helen Ronan
Developmental Editor: Nancy Wood Bedau
Production Editors: Nancy Burnett, Carol Harley
Manufacturing Coordinator: Jenna Sturgis
Copyeditor: Susanna Brougham
Design: Janis Owens
Editorial Assistance: Colleen Strang, Robin Banas

Library of Congress Catalog Card Number: 99-63008
ISBN: 0-87192-315-7

Back Cover:
Julie Wolfson, *Horse Study,* 1996. (See page 95)
Thomas Thayer, *Unity,* 1994. (See page 50.)

Title Page: **David Dooley,** *Everwear,* 1992.
Colored pencil on illustration board, 16" x 14" (40 x 36 cm).

10 9 8 7 6 5 4 3 2 1
Printed in Hong Kong

Acknowledgments

First, this book is dedicated to my Creator who gifted me with creativity, purpose, and the ability to be a catalyst who develops untapped creative potential in others. Second, I owe my career to Mr. Dillon. I've never taken a specialized writing course, yet I earn my living as a writer because I had a fastidious English teacher in the tenth grade at Wheaton Academy. Wherever you are, Mr. D., thanks. Third, I'd like to thank Nancy, my editor, whose coaching, encouragement, and editorial skills have imparted high standards of excellence to this book.

Fourth, thanks to those folks in the wings whose friendship and encouragement make my work possible: my fax friend, Ken, whose irreverent, impertinent missives keep me from taking myself too seriously; my good friends David and Debbie who have always shared my vision and tirelessly supported my efforts; Orville, who fills in where my dad left off; Tiko, who's been there for me from day one, stepping on my cape when I try to become superwoman; Deborah, who has astonishing talent and a heart to match; and Julie Wolfson, who gave generously of her time and talent to make this a better book. Next, there is a person who has always believed in me, even when my dreams were just wishes spoken into thin air. Thanks, Jo. You watched goals turn into reality, and part of the reason I succeeded is your confidence in me. And finally, this book is a tribute to my parents, Virginia and Ernest McFall, whose amazing lives taught me by example that if you have faith, there's nothing you can't do. They taught me to believe, even when there was no glimmer of hope. I've discovered that faith is truly the evidence of things not seen and the antecedent to success.

I hope that this book will instill faith in you, my readers—a belief that you can indeed develop foundational skills that will empower you to express your creative self. And when you succeed, so will I.

A special thanks to all the contributing artists, whose names are listed under each drawing.

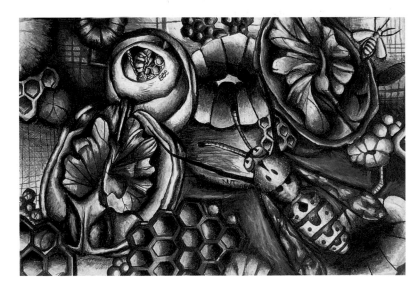

A limited palette of complementary colors can achieve striking results. See chapter three for layering techniques.

Student work: Susan Vaclavik (age 18). *Walnuts and Bees,* 1998. Colored pencil, 10" x 15" (25 x 38 cm).

Contents

Preface

Introduction

How to Use This Book/xiv

Beginner/xiv • Intermediate/xiv • Advanced/xiv

A Note to Teachers/xv

Beyond This Book/xv

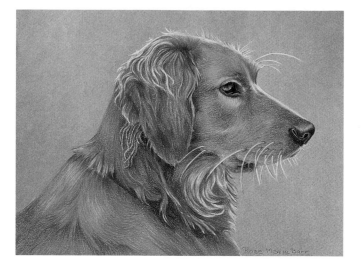

To practice rendering long fur, this artist drew a vignette of her son's dog, Lucy. (See chapter eight for how to draw animals.)

Student work: Rose Marie Barr (age 65), *Lucy,* 1998. Colored pencil, 8½" x 11" (22 x 28 cm).

PART ONE
Methods and Materials

1 Introducing a New Medium

A History of Use/4

The Manufacturing Story/8

Let The Fun Begin!/11

2 Materials

Colored Pencils/13

Pencil Density/14 • Caring for Your Colored Pencils/14 • Archival Properties/15

Watercolor Pencils/16

Colorless Blender/16 • Brushes/17 • Caring for Your Brushes/17

Technical Pens/18

Drawing Surfaces/19

Textured Papers/20 • Colored Papers/20 • Archival-Quality Paper/21

Experimenting with Alternative Surfaces/22

Windberg Panels/22 • Multi-Media Panels/22

Accessories/23

Sharpeners/23 • Erasers/23 • Dust Brushes/25 • Tape/25 • Masking Products/25 • Opaque White/26 • Transfer Paper/26 • Fixative/26

3 Layering Techniques

What Is Grisaille?/29

Grisaille Techniques/30

DEMONSTRATION:
GRISAILLE—UNDERDRAWING WITH GRAY/31

Monochromatic Layering/32

Building Color/33

Transparent Layering/34

DEMONSTRATION:
USING COLOR OPPOSITES FOR SHADING/35

Burnishing (Opaque Layering)/36

Burnishing Tips\30

DEMONSTRATION: BURNISHING LAYERS OF COLOR/37

BEGINNER EXERCISES/39

INTERMEDIATE EXERCISES/40

ADVANCED EXERCISES/41

4 Watercolor-Pencil Techniques

Advantages of Using Watercolor Pencils/43
A Mixed-Media Approach/44

Adding Pen and Ink/44 • Using Water-Soluble Graphite/46

**DEMONSTRATION:
SIX TECHNIQUES FOR WATERCOLOR PENCILS/45**

BEGINNER EXERCISES/47

INTERMEDIATE EXERCISES/48

ADVANCED EXERCISES/49

Rich colors can be achieved with colored pencil by using opaque painterly burnishing techniques, discussed in chapter three.

Richard Tooley, *Indoor/Outdoor,* 1995. Colored pencil, 18" x 12" (46 x 30 cm).

5 Working on a Colored Ground

Testing Your Colors/53

Setting a Mood/53

Selecting a Colored Ground/54
Creating a Collage of Colored Grounds/56

Underpainting with a Colorless Blender/56 •
Underpainting with Watercolor/59

**DEMONSTRATION:
USING A COLORLESS BLENDER/57**

Monochromatic Drawings on Colored Papers/60

Method One/60 • Method Two/60

BEGINNER EXERCISES/62

INTERMEDIATE EXERCISES/63

ADVANCED EXERCISES/64

This Australian artist uses colored pencils to create illustrations that are Surrealistic in nature. See chapter seven for more on the creative process.

Emma Barber, *Personal Deception,* 1993. Colored pencil, 42" x 30" (106 x 76 cm).

PART TWO
The Drawing Process

6 Design Techniques

Composition/67

Six Techniques

One: Use a Blowup/68

Two: Consider the Concept of Thirds/68

Three: Take a Bird's-Eye View/68

Four: Take a Worm's-Eye View/69

Five: Use Converging Lines/69

Six: Push the Subject Back/69

Working Out a Composition/70

Atmospheric Perspective: Creating Depth/71

Six Techniques

One: Focused or Fuzzy/71

Two: Larger or Smaller/71

Three: Higher or Lower/72

Four: Bright or Dull/72

Five: Converging Lines/73

Six: Overlapping Objects/73

BEGINNER EXERCISES/73

INTERMEDIATE EXERCISES/74

ADVANCED EXERCISES/75

7 The Creative Process

For the Beginner/78

Master the Basics/78 • Find a Good Teacher/78 • Try a Variety of Styles and Media/78 • Emulate the Masters/79

Guidelines for Creating Original Art

Expose Yourself to Creative Art/80 • Practice Creative Synergy/81 • Build a Reference File/83

The Creative Process/84

BEGINNER EXERCISES/86

INTERMEDIATE EXERCISES/87

ADVANCED EXERCISES/88

This artist takes a graphic approach to colored pencil with floral imagery laid over geometric graphic designs. Her work is drawn on black paper and outlined with gold markers and gold colored pencils.

Deborah Stromsdorder, *Azure Sea,* 1993. Colored pencil, gold markers, on black Arches paper, 25" x 25" (63.5 x 63.5 cm).

PART THREE
Subject Matter

8 Drawing Animals

Observe/91

Movement, Behavior, and Anatomy/91 • Habitat/93

Practice/93

Creating Textures/93 • Working with References/95 • Depicting Shadows/95 • *Body Shadows*/95 • *Cast Shadows*/95 • *Helpful Hints*/96

BEGINNER EXERCISES/97

INTERMEDIATE EXERCISES/98

ADVANCED EXERCISES/99

9 The Great Outdoors

En Plein Air Sketching/102

Explore Your Style Preferences/103

DEMONSTRATION: NATURE UP CLOSE/104

Choosing a Nature Sketchbook/105

DEMONSTRATION: THE BIG PICTURE/106

BEGINNER EXERCISES/107

INTERMEDIATE EXERCISES/108

ADVANCED EXERCISES/109

10 Still Lifes

Selecting a Subject/112

DEMONSTRATION: STILL LIFE VALUE STUDIES/113

Setting Up a Still Life/114
Common Errors/114

BEGINNER EXERCISES/115

INTERMEDIATE EXERCISES/116

ADVANCED EXERCISES/117

11 The Human Face

Why Are Faces So Difficult to Draw?/119

Helpful Techniques/120
Using a Grid/120 • Using a Window/121 • Starting with a
Black-and-White Drawing/122

Drawing Parts of the Face/122
Drawing the Eyes/122 • Drawing the Nose/123 • Drawing the
Mouth/124 • Drawing Skin/124 • Drawing Hair/126 • Drawing
the Ears/126 • Drawing the Teeth/126

Colored-Pencil Portraits/128
Tips for Success/128 • Correcting Your Work/129 • Adding
Faces to Your Photo File/129 • *Eliminate Harsh Shadows/130* •
Correct Photo Flaws/130 • *Modify Colors/130*

BEGINNER EXERCISES/131

INTERMEDIATE EXERCISES/132

ADVANCED EXERCISES/133

Appendix

Portfolios/135
Recording and Promoting Your Work/135

Conservation/136
The Five Enemies of Paper and Pencils/136
1. Poor Quality Paper and Other Grounds/136 • 2. Ultraviolet
Light/136 • 3. Bugs/136 • 4. Humidity/136 • 5 Heat/136
Fugitive Colors/137 • Matting and Framing/137

Glossary/139
Resources/140
Index/143

Colored pencil can be easily combined with graphite pencil and
other media. See chapter two for information on materials.

Student work: Mack Hockstad (age 15), *Perceiving the Future*,
1997. Colored pencil and graphite.

Preface

Sandra's advice to artists is "draw what you love." Animals show up frequently in her artwork, and her drawing classes at the San Diego Wild Animal Park attract animal lovers from all over the nation. See page 30 for earlier steps in this drawing.

Sandra Angelo, *Whiskers on Kisses,* 1998. Colored pencil on pastel paper, 5" x 4" (13 x 10 cm).

I discovered colored pencils myself, when I was awarded a summer fellowship from Rhode Island School of Design. Not wanting to lug canvases, paints, turpentine, and brushes on the airplane when I left for school, I impulsively threw a set of colored pencils and a tablet into my suitcase and took off. That summer I discovered the vast potential of the medium, and I was hooked. I had always loved to draw, but I longed to add color to my work. With this new medium, I had the advantages of both painting and drawing. And since I've always preferred to make lifelike, realistic drawings, colored pencils offered additional benefits. When I'd use a brush to render detail, I felt like a hippo threading a needle. But with the pinpoint precision offered by colored pencils, I could now put the goose bumps on a drawing of a plucked chicken.

When I returned to California from Rhode Island, I began to seek out and interview the nation's foremost colored-pencil artists. As I created magazine articles, books, videos, and TV shows and organized symposiums on the topic, I became connected with a wide web of colored-pencil devotees, from beginners to masters. I discovered their enthusiasm and passion for drawing, as well as their artistic accomplishments, which have long been over looked by the traditional art world. Although most art schools view drawing as just a study or preparation for painting, the masters I interviewed were going far beyond the sketch and offering up marvelous, stunning works of art.

Now as I travel the nation to present workshops for resorts, universities, manufacturers, and retailers, I encounter people who repeatedly tell me that one thing hooks them on the medium: my slide show. Upon viewing the phenomenal range of styles and the incredible versatility of the pencil, novices and professional alike discover how easy it is to combine colored pencils with other media or even to toss aside their paintbrushes and become diehard drawing artists.

This book will reveal the reason for this excitement. Take a stroll with me through the art work presented on these pages, and learn techniques and simple secrets that can change your drawings forever. Whether you are an amateur or a professional, you'll be astounded at what you can do with the common colored pencil!

—Sandra McFall Angelo

Introduction

Artist Barbara Newton is a master at creating simple yet intriguing still-life arrangements. See chapter 10 for more on this subject matter.

Barbara Newton, *Plums,* 1994. Colored pencil on vellum Bristol board, 11½" x 12" (29 x 31 cm).

When people see the wide range of styles and effects that can be achieved with the colored pencil, their reaction is always the same: "I can't believe that's colored pencil!" Simulating the look of oils, acrylics, watercolor, airbrush, and more, the pencil is probably today's most versatile art tool.

Colored pencil provides many other advantages. You can stop and start your work without fussing with expensive equipment, toxic solvents, or elaborate surfaces. If the phone rings while you're drawing, when you come back to your work, nothing will have dried out. And this medium is perfect for travel. With just a few pencils and a pad of paper, you can make a foray into the jungle, sit in your backyard, or lounge by a gurgling stream and record all the beauty with just a few simple strokes.

Here's some good news for the beginner. Learning to draw is as easy as learning to write. If you can write your name, you already have all the fine motor skills necessary to succeed with colored pencils. You've used pencils since you were in grade school, so you know how to hold them. After a brief study of the basic techniques and mastery of a few drawing skills, success will be well within your reach.

The beginning chapters thoroughly discuss the tools and equipment you will need to get the best results. Chapter one includes a brief history of colored-pencil art, followed by a discussion of materials in chapter two. Chapter three through five address specific techniques to help you master this medium. Step-by-step demonstrations will guide you in developing skill and confidence. A list of activities and assignments at the end of each chapter will help you explore these techniques yourself.

Chapters six and seven explore creativity, the basic principles of composing your own original art, and sources of inspiration to get you started on the path to personal expression. A thorough discussion of atmospheric perspective and design will provide you with key secrets for creating dynamic drawings. Finally, in Chapters eight through eleven, you'll study special methods for drawing a wide range of textures related to specific subjects: dewdrops, flowers, satin, fur, foliage, water, grass, skin tones, hair, eyes, metal, glass, and much, much more.

Special attention is given to drawing from nature and achieving a likeness when drawing faces. You'll be amazed at how easy it is to learn these techniques! To stir your enthusiasm and whet your appetite, this book contains an inspiring showcase of colored-pencil work done by both students and professionals. So grab your pencils, turn the page, and let's get started.

Beverly Marcum, *The Bus* (detail), 1987.
Colored pencil and ink quill, 10" x 8' (25 x 244 cm).

How to Use This Book

This book is designed to address the needs of a variety of readers, from the beginning student to the advanced artist. In each section, exercises have been provided for three levels: beginners, intermediate students, and advanced artists.

Beginner

If you are just getting started as an artist, you may benefit from the step-by-step demonstrations of techniques for working with colored pencils. At the end of each chapter, you'll find assignments that will help you explore the techniques yourself. You may want to practice by doing studies of the vignettes in chapters eight through fourteen, since they illustrate methods for creating various textures. Once you have mastered the exercises at the beginner level, you can move on to complete the intermediate assignments.

Intermediate

If you already understand colored-pencil techniques, you will enjoy the creative assignments for intermediate students. Choose your own level of difficulty. It is generally best to start with assignments that seem easy and gradually increase the level of challenge. Simple assignments breed success and success breeds self-confidence and motivation to continue practicing. Practice will lead to further success.

Advanced

If you are a skilled artist, you might enjoy tackling some of the advanced assignments at the end of each chapter. Or you might have fun making up your own exercises. Study the methods described in chapters three through six, and then use your imagination and your own reference library to experiment with these techniques.

A Note to Teachers

I jokingly tell my beginners that I have never met two art teachers who agree on anything. There's an element of truth in this statement—artists who become teachers can be somewhat opinionated and favor a particular approach to art. This courage of conviction enables them to be trailblazers and innovative thinkers.

Although the methods presented in this book are tried and true, as teachers we know that many paths can lead students to mastery of a medium and self-confident creativity. Here are a few tips that have worked for me that you may want to try.

Because I specialize in teaching beginners with varying levels of self-confidence, I have discovered that step-by-step lessons are important. When novices are presented with too many options, they may become confused and unsure of themselves. They don't yet have enough knowledge to make their own choices. By telling them exactly what steps to take at first, the teacher grants them a bit of security in unfamiliar territory. Untrained students lack skills, not talent. Starting with easy exercises promotes early success.

My approach to training the creative mind is traditional. I believe that beginners should develop fundamental skills before they are asked to be creative. Once beginners have a grasp of drawing skills and an understanding of color theory, composition, and perspective, they will be equipped to explore creative self-expression. Nothing is more frustrating to a beginner than having a great idea and no skills.

I treat beginners with gentleness, giving them much encouragement and guidance. Once they move on to the intermediate level, I find them eager to accept more vigorous critiques. For feedback, I give eighty percent praise to beginners and twenty percent suggestions. When a student has mastered basic skills, I give fifty percent praise and fifty percent suggestions. I never move beyond the fifty percent mark because I believe that everyone need to know what they are doing right, as well as how to improve.

I like to encourage advanced students to experiment and to test the limits of the media. When I give a creative assignment, I often invite students to say to themselves, "She didn't say we couldn't . . ." This teases them into finding off-the-wall, creative approaches to a specific assignment. As long as it meets the basic criteria of the lesson, I accept any artwork, be it outlandish or laughable. After all, creativity is often generated by laziness, defiance, or unconventional thinking.

Beyond This Book

Some beginning students might find it helpful to watch colored-pencil demonstrations on video. Close-ups of the instructor's hand show the direction and pressure of her strokes, how particular textures can be created, and so on. Videos by the author of this book are listed in the Appendix, under Resources (page 139).

This artist, a former aerospace engineer, used flat colored shapes to depict this F/A 18, a jet designed by the company he worked for. He incorporated the flags of all the countries that fly this airplane: Switzerland, Australia, the United States, Canada, Spain, Kuwait, Finland, and Thailand.

Student work: Robert Myers (age 67), *F/A 18*, 1997. Colored pencil, 12½" x 15" (32 x 38 cm).

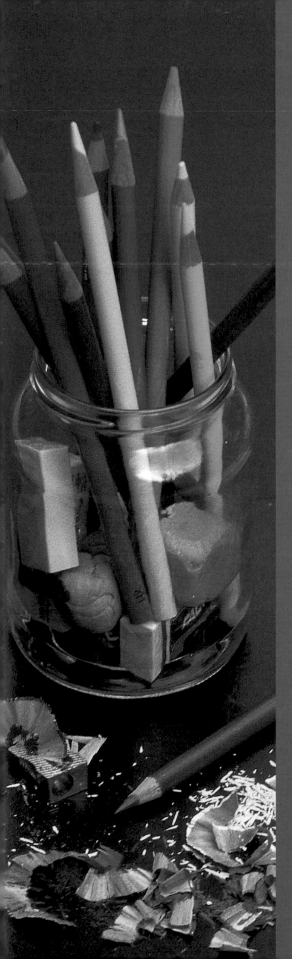

1

Methods and Materials

Introducing a New Medium

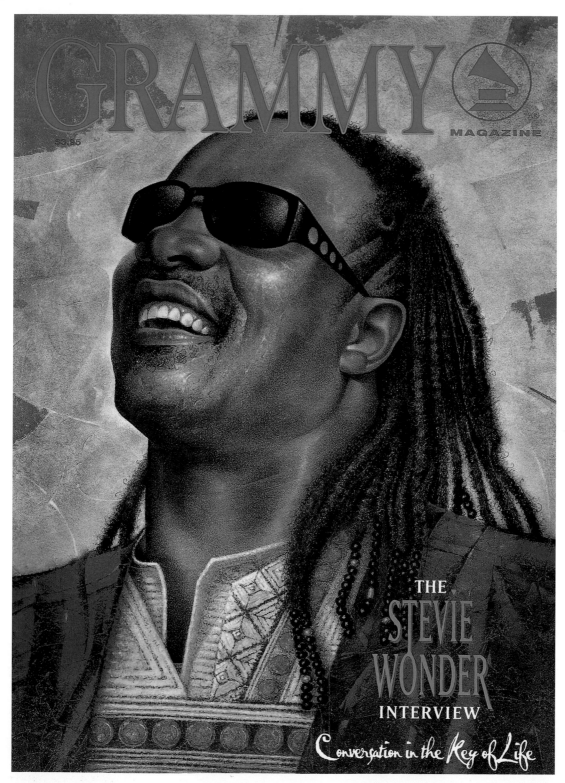

Colored pencils have been in use for less than a century. Compared to painting with oils or sculpting from marble, the medium is still in its infancy. Yet during this brief time, colored pencils have been used for everything from simple childhood scribblings to covert military operations. During World War II, the Allies manufactured a pencil that contained both a hidden map of Germany and a compass! These unusual colored pencils assisted bomber pilots who were shot down in enemy territory. More traditional users include designers, architects, and illustrators. And, in the last few decades, more and more fine artists have begun to explore this versatile medium to create a wide range of art.

1–1
Award-winning artist Steve Miller combined colored pencil with graphite, oil pastels, and a bit of metallic paint in a portrait of musician Stevie Wonder. The work was featured on the cover of *Grammy Magazine* in the summer of 1996.

Steve Miller, *Stevie,* 1996.
Colored pencil and mixed media, 11" x 8½" (28 x 22 cm).

1–2
In the hands of a precise artist, colored pencil can be used to achieve stunning realism. Artist Deborah and her husband, Bruce, spotted and photographed this owl on one of their many photo shoots.

Student work: Deborah Settergren (age 45), *Here's Looking At You, Kid,* 1998. Colored pencil on colored paper, 11" x 8" (28 x 20 cm).

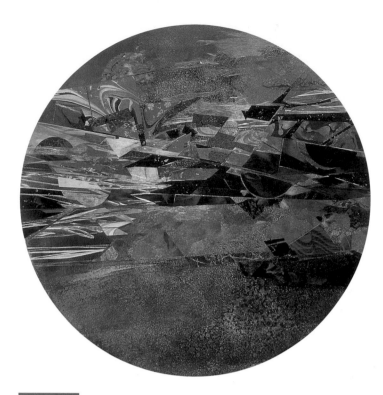

1–3
Although colored pencil is more commonly used to portray realism, some artists use the medium in more abstract works. This artist feels that light to dark applications of colored pencil allow her to create illusions of space in her monoprints and collages, and to use "drawing techniques that I have used for many years with graphite."

Mada Leach, *Skydance #7,* 1998.
Colored pencil and mixed media, 17" circle (43 cm).

A History of Use

Although colored pencils are a relatively new artistic medium, the use of graphite dates back to the early 1500s, when a deposit was found in Borrowdale, England. The material, also called "black lead," is a crystallized form of carbon. Although graphite was first used primarily as a lubricant, medicine, and in armament manufacturing, Dutch artists popularized it as an artist's material in the 1600s.

The standard graphite pencil we know today can be traced back to 1832. At that time, the first factory to manufacture pencils was established in Keswick, England. By the mid-1800s, German immigrants were making graphite pencils here in the United States.

The origin of the colored pencil is less clear. By the early 1900s, at least one form of this artist's tool was available in Europe. A young Marcel Duchamp included blue pencil in a mixed media work called *Flirt.* The drawing, signed 1907, was completed near Paris. In a series of figure drawings dated between 1913 to 1915, the Austrian artist Gustav Klimt used both blue and red colored pencils. The drawings, housed today among the museums of Vienna, are composed in black with color used mainly to highlight lips and eyes.

In the United States, the architect Frank Lloyd Wright commonly added blue and red colored pencil to his sketches of the early 1900s. By the 1920s, at which time green and brown were also available, Wright employed colored pencils in place of ink and watercolor to create polished architectural drawings. At about this time, American artists such as Stuart Davis and Grant Wood also began to use colored pencils to create studies for their paintings.

In the 1930s, two companies, Eberhard Faber and Berol, began producing commercial wax-based colored pencils in the United States. Caran d'Ache, in Switzerland, also began production. And in 1938, Daniel Berolzheim, the founder of Berol pencils, announced a new line of colored pencils. These pencils were more lightfast than earlier types and were available in 36 colors.

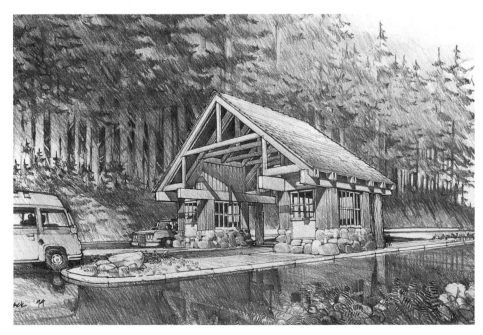

1–4

Primarily known as a painter and printmaker, artist Ellen Lanyon experimented with colored pencil before the medium was commonly used. Her choice of unusual objects and light, almost transparent, application of colored pencil gives her work a surreal quality.

Ellen Lanyon, *Equinox,* 1995.
Colored pencil on black paper, 19¾" x 25½" (50 x 65 cm). Courtesy of the artist.

1–5

Architects have been using colored pencil for years. Drawn to its pinpoint precision, they find the pencil well-suited for the detail necessary in architectural rendering.

Jens Lerback, *Mt. Rainier Entry Station,* 1996.
Colored pencil, graphite, 18" x 24" (46 x 61 cm). Courtesy of the artist and FFA Architects/planners.

As colored pencils improved, more fine artists turned to them. In the 1960s a number of well-known artists, including Cy Twombly and Lucas Samaras, created finished works of art in colored pencil. The medium gained further status during these years when a museum purchased a colored-pencil drawing by the British artist David Hockney. Colored pencil had finally arrived!

Today, museums around the world collect the colored-pencil works of countless twentieth-century fine artists, including Jennifer Bartlett, Claes Oldenburg, Wayne Thiebaud, and Roy Lichtenstein. Some photographers, such as Judith Golden, use colored pencils to draw over their prints. Even in the age of computers, this simple medium remains useful for myriad purposes. Artists and illustrators use colored pencils to create advertisements, magazine and book covers, children's books, and greeting cards. Cartoonists, animators, and fashion designers also may have occasion to use them in their respective professions. And, of course, colored pencils remain a favorite with children around the world.

1–6
A versatile artist known for her massive sculptures, Pat Renick likes to explore all kinds of media. This abstract work mimics the look of torn paper.
Patricia A. Renick, *Untitled,* 1988. Colored pencil, 15" x 11" (38 x 28 cm). Courtesy of the artist.

1–7
A well-known conceptual artist and sculptor, Claes Oldenburg finds colored pencil a useful medium for sketching out his ideas.
Claes Oldenburg, *Proposal for a Bridge Over the Rhine at Dusseldorf in the Shape of a Colossal Saw,* 1971. Colored pencil and pencil, 11" x 14½" (28 x 37 cm). Collection of Claes Oldenburg and Coosje van Bruggen, New York.

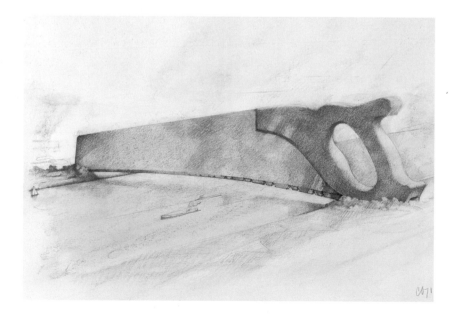

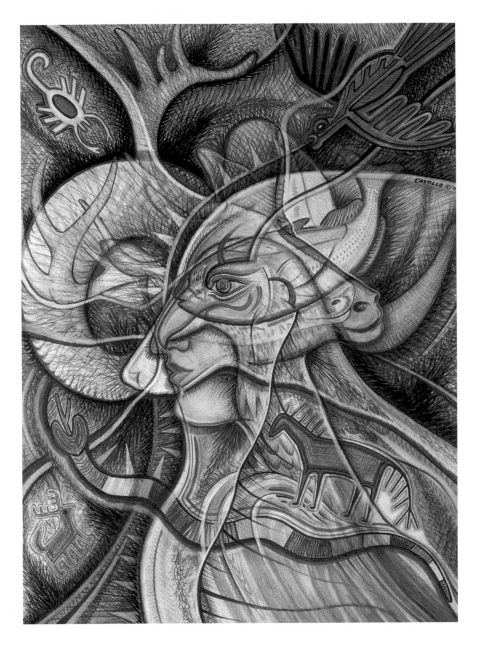

1–8
Mario Castillo's skillful layering of images and colors created this fascinating multilevel drawing. Coining the term "perceptualism" to describe his work, he draws inspiration from his study of naguals (or shamans) in Mexican folklore.

Mario Castillo, *Nagual Woman Traveling Thru Huichol Dreamtime,* 1996. Colored pencil and mixed media, 30" x 22" (76 x 56 cm).

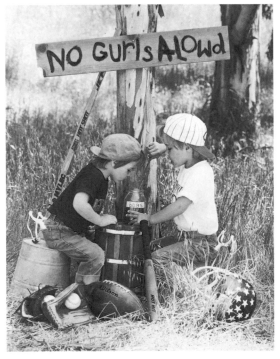

1–9
Before color prints were available, black and white photographs were sometimes hand-tinted with colored inks and dyes. This artist has updated the technique by using colored pencil to tint photos for her line of greeting cards.

Nora Hernandez, *No Gurls Allowed,* 1995. Colored pencil, photograph, 14" x 11" (36 x 28 cm).

1–10
With the first graphite pencil factory established in 1832, Rexel Cumberland pencils began a tradition that would lead to the introduction of the wax-based and water-soluble pencil known today as Derwent.

The Manufacturing Story

The making and selling of colored pencils is a huge enterprise. An estimated six billion of them are made each year in forty different countries. Berol and Faber remain important producers, but companies such as Staedtler, Derwent, and Bruynzeel have joined them. The pencils are now available in many forms, from the traditional smudgeproof and waterproof varieties to those that are water-soluble. Today's colored pencils may be thick or thin, hard or soft, and they come in more than 100 colors. Companies continue to improve the lightfastness of the pigments and even make many that are of archival quality.

To understand how a colored pencil works, it's helpful to take a glimpse into the manufacturing process. Although one company actually created an enormous specimen that was seven feet long and weighed fifteen pounds, most standard colored pencils are about seven inches long.

The colored material at the pencil's center is made from clay, pigment, and water. This mixture is combined with a gum to bind the ingredients together and soaked in wax to make it smooth. Once mixed, solid cylinders called billets are constructed from the material. The billets are cut into strips and dusted to keep them from sticking together. Ovens dry the billets to remove the water, harden the mixture, and prevent warping. Professional-quality pencils contain large amounts of pigment while other brands are composed of mostly binders and wax with very little color. This is why it is so difficult to achieve color saturation with a poor quality pencil.

The raw materials used in the manufacturing process are gathered from all over the world: clay from Great Britain and Germany, gum from Iraq and Iran, and wax from Brazil. And, since the early 1960s, California has provided the timber for the wooden casings. Most quality colored pencils are made with California cedar, because the wood has a straight grain and is soft enough to be sharpened without splintering. The cedar is also specially treated so that it won't warp. A single California cedar tree, which is related to the redwood, may yield enough wood to encase up to 150,000 pencils.

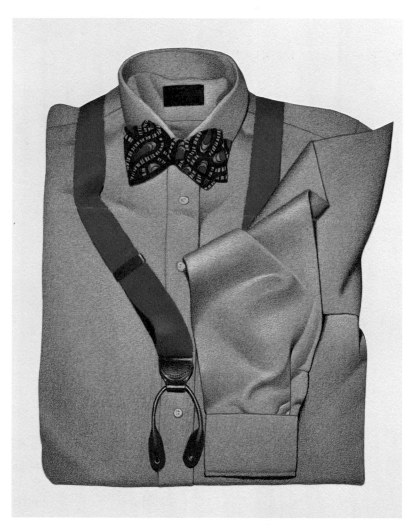

1–11
Illustrators have found colored pencil well suited to a variety of uses, from fashion design to book illustration.

Bill Nelson, *Shirt and Tie with Braces,* 1996.
Colored pencil, 9" × 8" (23 × 20 cm).

1–12
Colored pencil is a favorite among high school students, who find inspiration in all kinds of subject matter. The rich, opaque color of the strawberry's exterior contrasts nicely with a more transparent layering of color for the interior.

Student work: Elizabeth Benotti (age 15), *Strawberries,* 1997.
Colored pencil, 12" × 18" (30.5 × 45.7 cm).

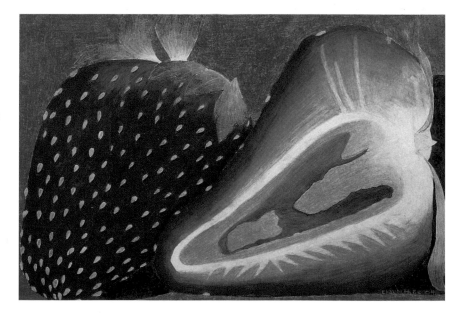

1–13
Artist Mary Engelbreit uses colored pencils and markers to create charming images, usually accompanied by hand-lettering. Her work is then licensed to over fifty companies that make different gift products, such as greeting cards, gift bags, and calendars.

Mary Engelbreit, *Princess of Quite a Lot,* 1993. Colored pencil, markers, 7" x 5" (18 x 13 cm). © ME ink. Reprinted with permission of Mary Engelbreit Studios.

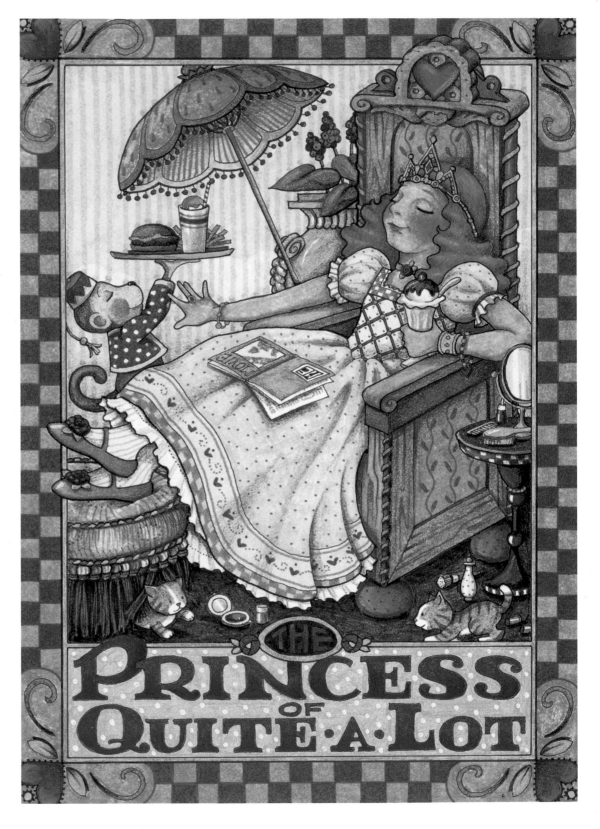

Let the Fun Begin!

Until recently, colored-pencil works received relatively little notice in comparison to other works on paper, such as pen-and-ink drawings or watercolors. But they are steadily gaining greater attention. Just a few years ago, art books barely mentioned colored pencil; today many publications are devoted solely to an exploration of the medium. The 1990s even saw the foundation of a number of organizations which promote the development of colored pencil as a fine art medium through juried competitions and the publication of best works.

No longer simply a sketching tool, colored pencil is an art medium that can be layered, mixed, used as a wash, and combined with a whole host of other media, such as pen and ink, pastels, and watercolor paint. It is versatile, easy-to-control, inexpensive, portable, and non-toxic. An ever-increasing group of both art students and professionals believe it to be a tool that combines the possibilities of both drawing and painting. The following chapters will help you to discover the joys of colored pencil for yourself.

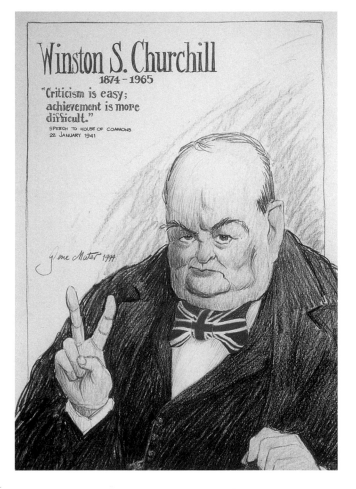

1–14

Cartoon artists, who rely on a skillful use of line to create their images, often use colored pencil, sometimes in conjunction with pen and ink. This work was commissioned by a fan of Winston Churchill.

Gene Mater, *Winston Churchill,* 1994.
Colored pencil, 16" x 12" (41 x 30 cm).

2 Materials

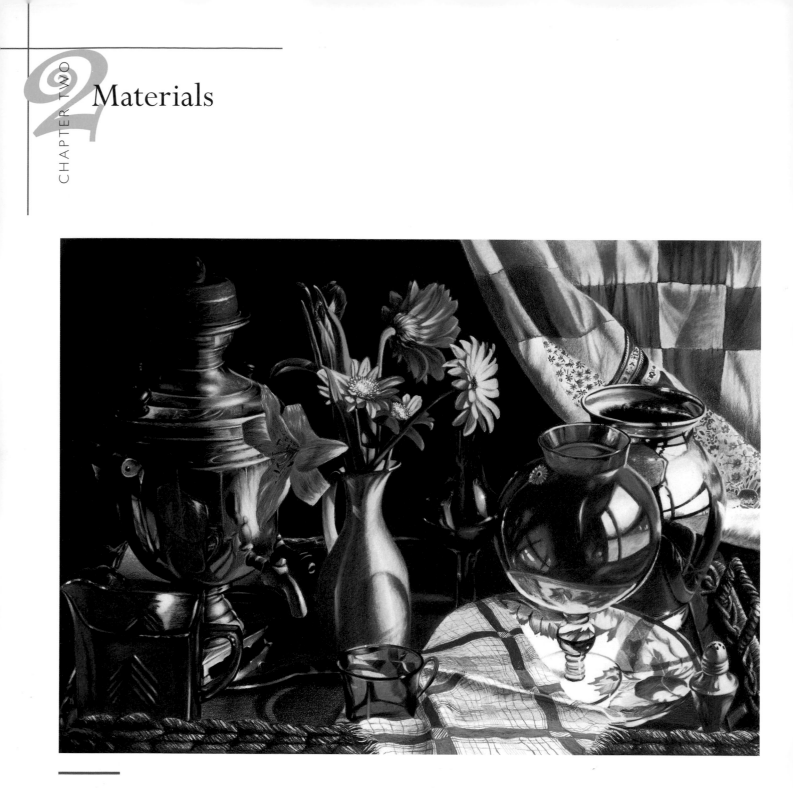

2–1
Using antiques that lie around his country farm, artist David Dooley sets up still lifes that capture reflections of the midday sun. As you can see from this drawing, powerful effects can be achieved with just a common pencil. This work can hold its own in comparison to an oil or acrylic painting.

David Dooley, *Coffee on Wicker,* 1993.
Colored pencil, 24" x 30" (61 x 76 cm).

The sumptuous, rich tones of colored pencil are surpassed only by its astounding versatility and simplicity as a medium. Compared to working with its complicated cousins—oils, acrylics, and watercolors—creating art with colored pencils can be relatively simple and inexpensive. To get started, you need only a few pencils, some good-quality paper, a sharpener, and a dust brush. Once you get excited about the potential of the medium, you may add an expanded range of exotic colors, a few accessories, and a sampling of pencils with a range of hard and soft densities.

As you become familiar with pencil techniques, you can expand your repertoire, mixing colored pencils with a wide variety of media including watercolor, graphite, pen and ink, oil pastels, acrylics, and so on. You can also apply colored pencil to different surfaces, such as canvas, Multi-Media Panels, specially coated Windberg Masonite Panels, illustration and mat board, fabric, wood, and even sculptural materials. The possibilities for experimentation are endless.

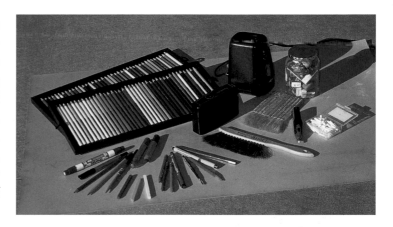

2–2
Counterclockwise: colored pencils, colorless marker, ink pen, watercolor pencils, colored sticks, watercolor crayons, technical pens, drafting brush, goat hair brush, battery-operated eraser, eraser refills, jar of kneaded and plastic erasers, electric sharpener, and battery-operated sharpener.

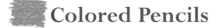

Colored Pencils

Because they can achieve a wide variety of styles and techniques, professional-grade pencils are recommended for students using this book. The pigments in professional-grade pencils will deposit rich, luxurious tones with very little pressure. Even if you bear down hard on an inferior pencil, it will simply crush the paper without delivering much color because it contains little pigment.

When you purchase colored pencils, note that price indicates quality. If you are on a tight budget, it is better to buy a small professional set rather than a big amateur set of pencils. And there's good news for people with limited funds. Colored pencils, even the professional grades, are extremely low in cost compared with watercolors, oils, and acrylics. Yet they can achieve the same effects as the more expensive media.

Like standard lead pencils (called graphite for the gray-black substance in the lead), colored pencils are available in various densities (hard and soft leads). To better understand density, refer to the graphite density chart. As the numbers get higher on the right side of the scale, the lead becomes softer. As the numbers increase on the left side of the scale, the lead becomes harder.

Graphite Density Chart

Hard	Medium		Soft

6H	5H	4H	3H	2H	F	H	HB	B	2B	3B	4B	5B	6B

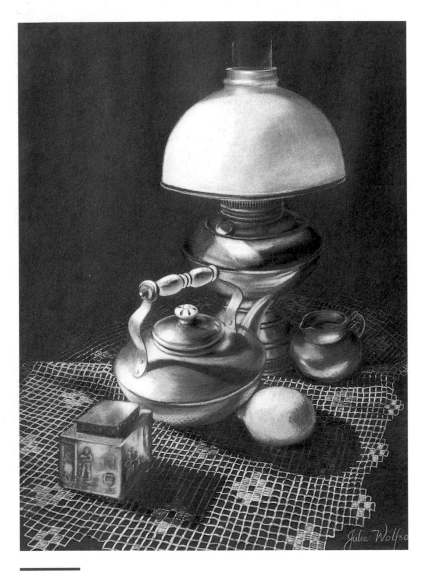

2–3
Bathed in evening sun, these objects made a perfect still life for Julie Wolfson. To achieve a delicate, soft mood, she used a hard lead for transparent layering and to create the intricate lace work on the table.

Student work: Julie Wolfson (age 69), *Still Life*, 1995.
Colored pencil, 11" x 8" (28 x 20 cm).

Although most colored pencils don't specify a density, you can get a general idea of their relative hardness or softness by trying them out. Hard lead pencils will retain a sharp point even under considerable pressure. Soft lead pencils will crumble when sharpened to a fine point. The harder leads are perfect for achieving transparent layering and methodical blending. The sharp lead will deposit pigment into the small grooves of the paper and, if kept very sharp, will provide a very smooth, even color application that can simulate the effect of an airbrush. Hard leads are also wonderful for applying very fine detail.

Soft leads deposit a deep saturation of pigment and are great for the smooth blending required in techniques such as burnishing (See chapter three).

Some brands of colored pencil have struck a nice balance between hard and soft leads. These medium leads are versatile, offering rich, full-bodied colors while retaining the hardness necessary to create fine details.

Pencil Density

Although some artists will stick to one brand, most colored-pencil enthusiasts find themselves using a variety of pencils for diverse applications. For example, to cover a large area swiftly, it makes sense to use a woodless colored pencil. These solid, woodless leads can fill in massive spaces quickly, almost like a crayon. To color the same area with a pencil, you would have to sharpen it over and over again.

When you want brilliant, glossy hues like those in fig.2–1, use a soft lead pencil. Soft leads build thick, solid layers quickly. When you want to achieve fine detail, like the lace seen in fig.2–3, you can switch to a hard lead pencil, which will retain a sharp point longer.

Caring for Your Colored Pencils

Regardless of how you store your pencils, make sure the container cannot be overturned easily. If a pencil drops

on the floor, the lead will break inside the wood casing and then chip off in your sharpener. Pencils are more fragile than they seem.

When you are working on a drawing, it's convenient to store the colors you've selected in a plastic bin like the one shown in fig.2–4. When you return to your drawing later, you don't have to figure out which pencils you were using.

Temperature can affect both colored pencils and colored-pencil drawings. Remember that colored pencils are in part made of wax. If you leave them in your hot car or in the sun, sometimes the pigment will separate from the wax, leaving little deposits of white wax on the pencil leads. This, however, is not a serious problem and will not interfere with your drawing. Simply sharpen the pencil to remove the deposit.

Archival Properties

Keep in mind that pencils, like all other art pigments, include fugitive colors—ones that tend to fade or change over time. Archival-quality materials (ones that endure well) are important to all artists. Many colored-pencil manufacturers publish a lightfastness guide, which lists pencils with fugitive colors and rates each pigment based on its permanence. Lightfastness brochures can generally be obtained by writing to the product manager in the marketing department of a given company. Such information will help you choose pencils that will extend the life of your artwork.

2–4
This spinning carousel can hold about two hundred pencils. You might organize your supplies by storing dry colored pencils in the outside tier, watercolor pencils in the middle, and brushes and graphite pencils in the center. The rectangular plastic bin is a handy container for storing pencils that have been selected for a particular project. When pencils get too short, store them in a separate container, such as a plastic lipstick box.

 # Watercolor Pencils

Why would an artist choose watercolor pencils over watercolor? For one thing, you can't draw with a watercolor cake or tube. If you are creating a realistic drawing and want to control the precise placement of pigment, you can simply draw lines with a watercolor pencil and then wet the drawing. Also, techniques that involve drawing (explained in chapter four) can work only with a pencil. Last but not least, there is a cost advantage. When you compare the cost of professional-quality watercolor pencils to watercolor tubes or cakes, you will save a lot of money by buying the pencils. (A set of twelve pencils costs from ten to fifteen dollars. A set of twelve professional watercolor tubes ranges from sixty to one hundred dollars.)

Like dry wax pencils, watercolor pencils are available in both amateur and professional grades. Avoid using amateur-grade pencils because, again, they lack adequate pigment. Because it is so easy to mix colors with watercolor pencils, you really don't need to buy a large set in the beginning.

For creating large works or making broad strokes, you might consider switching to wax-based watercolor crayons. This tool varies from standard colored pencils only by the width of its lead. Watercolor crayons are fatter than colored pencils. Some crayons are large chunks of colored-pencil pigment wrapped in thin paper, and some are encased in a wooden sheath. For artists who like to draw loose, spontaneous sketches, these crayons can add a wonderful impressionistic effect. Because they are so fat, they lend themselves to bold sweeping strokes rather than fine detail. All watercolor-pencil techniques work well with watercolor crayons.

You can also use a water-soluble graphite pencil to enhance your work with watercolor pencils. It can be used to create quick black-and-white value studies that stand alone or serve as a value underpainting for a colored-pencil drawing.

Colorless Blender

To create a smooth background or underpainting similar to the look of watercolor, a colorless blender can be used. Although there are two products on the market called a colorless blender, this book refers to the colorless blender that is essentially a marker that contains no dye. (The other product is a colorless wax pencil that is used for burnishing.) When applied to dry colored pencils, this colorless marker causes the wax pencil to liquefy and seep into the pores of the paper.

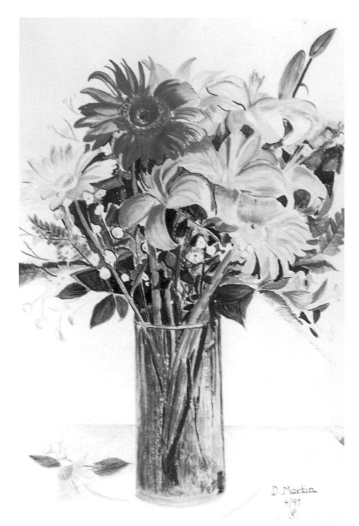

2–5

When this artist received a bouquet from her son for Mother's Day, she preserved her gift by painting it with watercolor pencils. She then took the painting to the copy shop, made a 4" x 6" color laser print, folded it into a greeting card, and sent it to her son as a thank-you card.

Student work: Doris A. Martin (age 77), *Bouquet of Love,* 1997. Colored pencil, 14" x 11" (36 x 28 cm).

Brushes

Most colored-pencil artists use watercolor pencils primarily to underpaint or tint a whole paper, to lay in washes, or to create special effects. Because most drawing is done with a dry pencil, colored-pencil artists typically do not invest a lot of money in watercolor brushes. Still, there are several rules to observe when selecting a brush to use with watercolor pencils. First, the brush needs to have soft fibers. As a general rule, drawing artists are more comfortable with brushes that are mounted in the round because they can achieve more detail. However, soft flat brushes are great for covering a large area quickly, such as a background or a depiction of the sky.

Although you won't need to buy first-quality sable brushes, avoid very cheap brushes because the minute you place them in water, they will start shedding. Some inexpensive alternatives to sable are first-quality sable-synthetic blends. If you plan to spend a lot of time using brushwork to enhance your work with watercolor pencils, you may want to invest in a sable brush because it will hold a very fine point.

Caring for Your Brushes

Always wash the pigment out of a brush, first with water, and then with a well-diluted mixture of liquid soap and water. Rinse it thoroughly, and return the brush to its original condition by shaping it to a point. Never let a brush stand in water for long periods of time. If you leave it askew, it will develop a "cowlick" and may never return to its original shape. On the road, store brushes flat in a container aerated with holes, so the brushes can breathe. In the studio, store them on end in a carousel. If you store a wet brush in an airtight container, it can develop mildew. If you have invested in sable brushes, remember that bugs like to eat these fibers. Keep dry brushes in mothproof containers, or store cedar chips in your brush drawer.

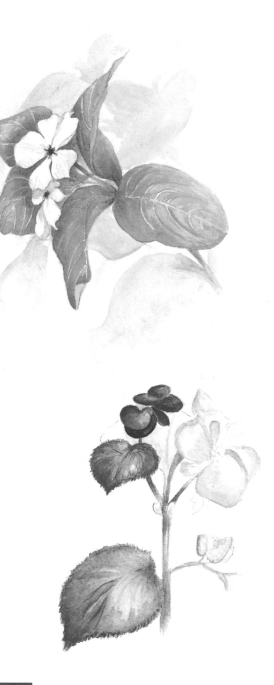

2–6
Watercolor pencils can be used to achieve a delicate balance between soft focus and precise detail.

Carolyn Fairl, *Vinca and Begonias,* 1996.
Watercolor pencil, graphite, 10" x 7" (25 x 18 cm).

Technical Pens

The permanent technical ink pen is an indispensable aid to making watercolor-pencil sketches. To maintain an even flow of ink, always store technical pens horizontally. Ink sketches made with permanent pens can accept a wash with watercolor pigment without developing blurred lines. Or you can create a watercolor section and then define the edges with a permanent pen. This type of sketch is commonly used for greeting cards, children's books, and many other forms of illustration.

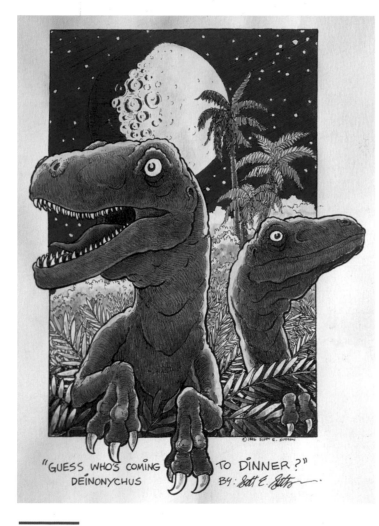

"GUESS WHO'S COMING TO DINNER?"
DEINONYCHUS BY: Scott E. Sutton

2–7
An illustrator of children's books, Scott Sutton creates his whimsical, imaginative drawings with a combination of watercolors, ink and colored pencils.

Scott Sutton, *"Guess Who's Coming to Dinner?" Deinonychus,* 1996. Pen, ink, watercolor and colored pencil on Kidfinish Bristol board, 17" x 11" (43 x 28 cm).

Consider the following factors when buying a technical pen. They are available in refillable and disposable styles, and the refillable pens are quite pricey (fifteen to thirty dollars) and require careful cleaning after each use. The disposable pens can be bought at a fraction of the cost (three to six dollars) and do not clog. However, when they are empty, they must be thrown away.

Also think about the archival properties of the ink. If you plan to preserve your artwork, check the packaging to make sure the ink won't fade. Many pigments used to create art supplies are in fact permanent. Dyes (the material used to tint fabric), on the other hand, fade mercilessly. Until recently, all inks were made from colored dyes that faded when exposed to light for long periods of time. But now manufacturers have discovered a way to suspend finely ground art pigments in a water-based liquid that can pass smoothly through fine-tip pens without clogging. These pigments have elevated pen and ink to an archival-quality medium that will not fade. In addition, these inks are waterproof and stand up to an application of water-based medium.

When buying technical pens, look at the nib size. Although each company has its own numbering system, generally the higher the number, the larger the nib size; so a .03 nib would be larger than a .05 nib. When combining pen and ink with watercolor pencils, it's nice to have a variety of nib sizes to work with.

Finally, the inks in technical pens are available in various colors. Check with each manufacturer to be sure its colored inks are of archival quality. (See chapter four for ways to combine pens with pencils in your work.)

If you can't afford a three-dollar technical pen, the old-fashioned quill and nib dipped in India ink will suffice. These pens are a bit more difficult to control, as the ink flow is not easily regulated. To avoid mishaps, practice your ink strokes on a scrap paper before applying the quill to a watercolor sketch.

Because ink lines are hard to erase, many artists prefer to create a contour line drawing on the paper before beginning to ink the drawing. Because graphite pencils are slick and may resist the ink, a non-photo blue, hard-lead colored pencil is often used. This color is not visible to the camera, so if you reproduce your ink drawing there is no need to erase the line drawing.

Drawing Surfaces

Pencils have been used on everything from bedroom walls to papier-mâché because their waxy pigment will stick to many surfaces. Nevertheless, most professional artists' surface of choice is paper—but not just any paper. Because pencils are made out of wax, they don't adhere to a slick ground. You've probably discovered this yourself while trying to use a pencil to write on the back of a greeting card. It is difficult to get pencil lead to adhere to a completely smooth surface. It just doesn't stick.

Colored-pencil papers must have minute "wells," which chip off pigment and trap a bit of it as the pencil glides over the surface. These small cavities in the paper are essential for work in colored pencil. This slight roughness of surface is referred to as the paper's tooth, bite, grain, or texture. Although some artists may choose a highly textured paper in order to achieve a

2–9
Using a colorless marker, Gianera underpainted every area except the stucco wall. Here she wanted the rough surface of the Multi-Media Panel to show through her pencil strokes, so she laid the pencil on its side and lightly shaded the shadow areas, creating the natural look of stucco.

Jan Gianera, *Spring Shadows,* 1993.
Colored pencil, 14" x 9" (36 x 23 cm).

2–8
You don't have to cover an entire drawing with color. A striking effect can be achieved by adding color to just one element.

Student work: Deborah Settergren (age 43), *Shades,* 1996.
Colored pencil and graphite on tan paper, 9" x 6" (23 x 15 cm).

special effect, most colored-pencil enthusiasts prefer a paper with a medium grain or a very slight tooth. Paper companies use a variety of terms to describe this type of surface: vellum, regular, or kid.

When deciding which paper is best for your project, buy samples of a wide variety of papers and test them. You will quickly determine your favorites. Find the drawing surfaces that suit you best, but always be open to experimenting. You may discover a new style of drawing simply by trying an unusual surface.

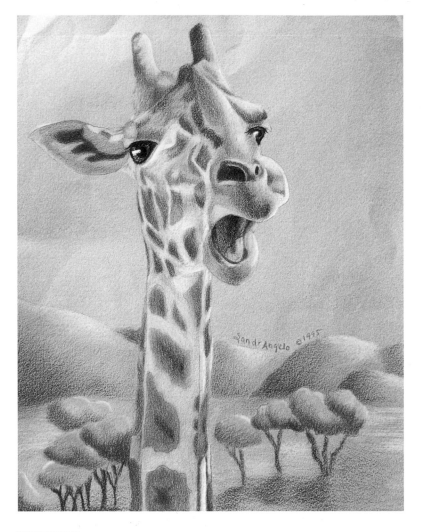

Textured Papers

When selecting a paper for drawing, you must decide how strong a role you want the surface of the paper to take in the finished artwork. Textured papers will definitely influence the final result. In fig.2–9, the artist used a highly textured surface to create the look of stucco. If she had used a smooth paper, she would have had to draw all those bumps on the wall. Instead, her paper did the work for her.

At the art supply store, you can find highly textured papers in the watercolor paper section, among the pastel papers and the mat board. Always test the paper to see if the pencil will adhere to it. If your drawing needs to be permanent, make sure the paper has suitable archival properties.

Colored Papers

There are three basic advantages to working on a colored ground. First, using a colored paper will often cut your drawing time by fifty percent or more, because most of the color you need is already there. Second, when a background is colored, it often conveys a finished look, whereas a white background begs to be filled. Colored grounds can save time for busy artists.

Colored grounds can lend a sense of color harmony and vital unity to your drawing. In fig.2–10, the tan surface provides color unity in the undertones of both the giraffe and the landscape. Because the paper was already tan, very little pencil had to be added to those sections of the drawing.

And finally, powerful drama or subtle mood can be achieved by drawing on a colored paper. For example, in fig.2–11 the striking effect is enhanced by the contrast between the light pigments and the black background. Also, it shows how a black background can appear full with little else added.

2–10
On a photo caravan at the San Diego Wild Animal Park, the author snapped a humorous photograph of this giraffe. In the class that followed, she showed her students how to modify the photo by using a toned paper to lend color harmony to the piece.
Sandra Angelo, *Serengeti Serenade,* 1995.
Colored pencil, 10" x 8" (25 x 20 cm).

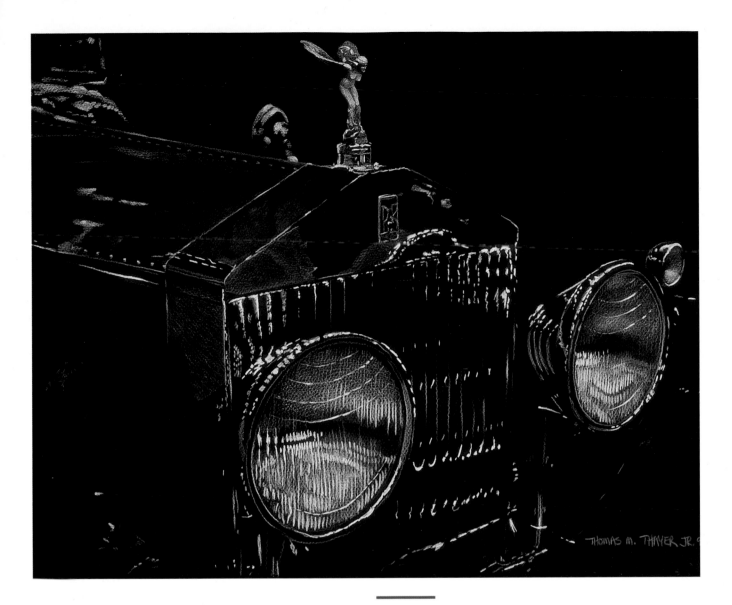

Archival-Quality Paper

If you want your drawings to last for a long time, take care to select an archival-quality surface. Unfortunately, the art-paper industry has not developed standardized labeling practices. Here are some general guidelines to follow when purchasing paper.

If a paper is labeled one hundred percent rag or cotton, it has been made entirely from natural fibers. Such papers are generally of archival quality and will outlast cheaper ones. Papers described as acid free, neutral pH, and archival are probably of good quality as well, but it makes sense to write to the manufacturer for specific

2–11
Strong contrast between the colored ground and the subject makes these colors seem very vivid. Because not all colors are striking on black, it's a good idea to first test the pencils on the back of the paper to see if they will saturate the color or amplify its intensity.

Thomas Thayer, *The Rolls,* 1992.
Colored pencil, 16" x 20" (41 x 51 cm).

information, since terms can be used in different ways. For example, some one hundred percent cotton watercolor papers have been sized with acid-based chemicals, which destroy their natural archival properties.

To find out how to best preserve your drawings, see the Appendix.

Experimenting with Alternative Surfaces

Because paper is seemingly less permanent than canvas, works on paper are sometimes valued less by collectors, and this is reflected in the price they sell for in the marketplace. It's not uncommon for a work on paper to fetch fifty percent less than art on canvas. To address this problem, many colored-pencil artists have explored more permanent drawing surfaces.

Windberg Panels

Nationally acclaimed realist artist, Dalhart Windberg recently developed a product that provides an excellent permanent ground for colored-pencil art. His colored masonite panels, which are lightly coated with a layer of marble dust, offer an archival-quality surface with just the right amount of bite to it. Many colored-pencil drawings (which look like paintings), could easily hold their own in price when drawn on one of these panels, since collectors tend to view this durable surface with more respect.

Multi-Media Panels

Available in both black and white, the Multi-Media Panel was recently developed by an industrial firm that used to make plastic molds. Constructed from synthetic fibers, this archival-quality panel has considerable tooth, lending itself to a wide variety of media, including colored pencils. Its surface can be manipulated to produce different textures—a big advantage for the artist who wants both smooth and rough surfaces in a single piece. The panel can be sanded in some areas to create a smooth ground. A word of caution: The panel should be sanded gently, since bending or crushing the board will cause it to chip and break, just like plastic.

2–12

This artist experiments with colored pencils on Mylar. Because it is possible to draw on both the back and the front of the Mylar, color layering is easier to achieve.

Robert Guthrie, *Pacific Beach House,* 1995. Colored pencil, 6¼" x 9¾" (16 x 25 cm).

Accessories

Sharpeners

To achieve a smooth, uninterrupted layer of color, it is important to keep a very sharp point on your pencils. Even on a paper with slight texture, a dull pencil will cover only the uppermost surface and will leave small white specks of paper showing through. This can be a desirable effect if used correctly, but most of the time the specks are distracting. A pinpoint-sharp lead will deposit little bits into the wells of the paper, eliminating the white dots and creating a solid look. The instrument of choice for most colored-pencil enthusiasts is the electric or battery-powered sharpener. You can extend the life of a sharpener by frequently using it to sharpen a graphite pencil. Because graphite is a lubricant, it will keep colored-pencil wax from building up on the blades.

Take care when selecting a battery-powered sharpener. They're not all created equal. Open the casing, and examine the sharpening mechanism. Be sure that your sharpener has metal blades like the one pictured in fig.2–13. The less expensive models are simply a hand-held sharpener mounted on a motor. These sharpeners are very ineffective and will chew pencils to bits.

When your pencil gets short, you can use a pencil extender to prolong its life.

Erasers

It's difficult to erase work done in colored pencil. First of all, the pigment will have stained the paper's surface, leaving a color residue behind. This may be covered with subsequent layers of color, but because colored pencil is transparent, the pigment residue may influence the next layer of color. Second, when you erase your mistakes, you will find that the friction from a plastic eraser will melt the pencil wax and create a slurry with a ridge next to the area that was not erased. In addition, the pressure from any eraser can crush the bite of the paper.

2–13
Be sure to choose a battery-powered sharpener with metal blades instead of a wimpy handheld sharpener mounted to a motor. All good sharpeners have blades like the ones pictured here. For pencils with a larger diameter, use a vertical-mounted electric sharpener, which won't creep across the table as you push in your pencil. For watercolor crayons, you can use a large handheld sharpener like those sold at cosmetic counters. A sandpaper block is handy for refining a pencil point between sharpenings.

The best solution for erasing colored pencils is the small handheld battery-operated eraser, which will gently glide over the surface of the paper without crushing the bite. It will remove all layers of wax and leave a fresh surface for future pencil application.

There are several different grades of battery-operated erasers on the market. The low-priced erasers will last for a few months, and the high-priced models will last up to a decade or two. Plug-in electric erasers work well too, but they are very expensive and cumbersome, and since they require an electric outlet, they're not as portable. If you can't afford a battery-powered eraser, try to avoid erasing altogether by practicing your techniques on a piece of scrap paper or on the outside edges of your drawing. Artists commonly work out composition problems and value studies before starting the performance piece.

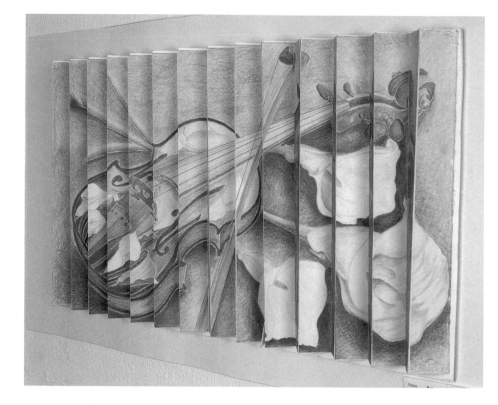

2–14
These two drawings are part of the same artwork, seen from opposite sides of paper that has been folded like an accordion. The drawings were made first, then carefully cut into vertical strips and glued to the folded sections.

Student work: Rebecca Scudiere (age 15), *Just Fiddlin' Around,* 1997.
Colored pencil and oaktag,
22" x 22½" (30.5 x 57 cm).

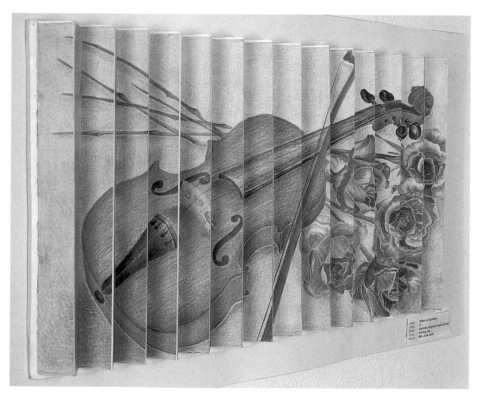

Dust Brushes

Pencils tend to leave a residue of crumbs on the paper's surface. If these are not brushed away frequently, they can become embedded in the paper and difficult to eradicate. A handy tool for brushing these crumbs away is the drafting brush used by engineers and architects. If you are traveling, a small goat-hair brush will fit comfortably in your pencil box. Be sure that you use only soft brushes with natural fibers. The stiff texture of synthetic fibers can mar your paper or drawing.

Tape

Some artists like to tape their drawing paper to the table to provide a crisp, clean border and to prevent crumbs from slipping under the paper. If you use tape, choose an archival-quality tape that can be easily removed when you are finished. Masking tape and cellophane tape will not only tear the paper, but also will leave a residue of glue that over time will stain the paper brown and break down its archival properties.

Masking Products

To enhance certain drawings, you may want to flick paint on part of your paper or wash color onto a large area. To protect a portion of your drawing you can use clear or colored masking fluid. Colored masking fluid is often preferred because it is easy to see when it comes time to remove it. However, because it sometimes stains, it is best to test it first on a scrap piece of paper. This fluid coagulates very quickly, and if it dries on your brush, you'll have to discard it. Keep a dish of warm, soapy water at hand to rinse your brush in immediately. When you are finished applying washes and they have dried completely, you can remove the masking fluid with a rubber cement pickup or by rubbing with a very clean finger.

Frisket paper is another product that can be used for masking. This transparent product is available in rolls

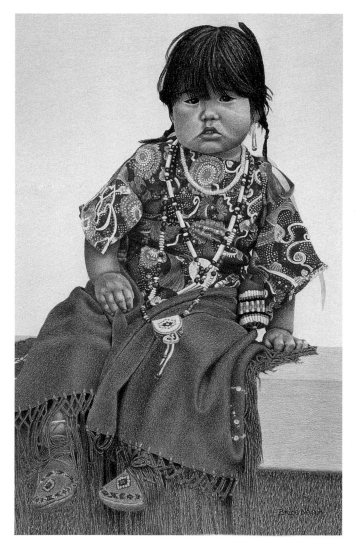

2–15
Intricate detail, like the fabric and beadwork in this young girl's clothing, represent a tremendous investment of time and effort. Take care to learn about the archival properties of the materials you use in order to preserve the quality of the finished piece.
Bruce Nelson, *Indian Girl #4,* 1988.
Colored pencil, 24" x 15½" (61 x 39 cm).

and sheets. Simply lay the frisket over your drawing and trace the outline of the area you would like to mask. Use an X-acto knife or scissors to cut out the shape. This frisket paper will adhere to the paper to protect it while you paint, and its low-tack surface makes it easy to remove when you are done. Remember that the edges of the masked area will have sharply defined lines. Factor those hard edges into your drawing.

Opaque White

Because colored pencil is transparent, it is virtually impossible to apply pure white over a color. To add white highlights to a drawing, such as the white in a cat's whiskers or the highlight in an eye, you can use an opaque white commonly used by graphic designers. This product, which appears to be a hard, dry, water-soluble paint, is sold in small jars and applied with a wet brush.

Transfer Paper

Because erasing can damage your drawing surface, you may want to work out a detailed composition first on a sheet of sketch paper, then transfer it to your performance paper. Transfer paper is a thin sheet of paper that has been coated with color on one side. To transfer a line drawing, place the transfer paper color-side down on the performance paper. Clip or tape the preliminary sketch on top, and use delicate pressure as you trace the lines of your sketch. Don't press too hard or you will make indentations in the paper. However, if your pressure is too light, the lines won't transfer. Check periodically to make sure your lines are transferring.

CAUTION

Fixative is a toxic material and must be used with great care. When you are ready to spray your drawing, always take it outside, place four weights on the corners of the drawing, and spray several light coats of fixative over the piece with sweeping horizontal strokes. Keep the can about twelve to eighteen inches from the drawing, and wear a protective mask over your nose and mouth to keep from breathing the fumes. Allow about five to ten minutes between coats for the fixative to dry. It is better to spray several light coats than one heavy coat. Heavy application of fixative may cause it to drip.

Fixative

There are two reasons for using fixative to seal a colored-pencil drawing: to prevent smearing of the colors, and to prevent wax bloom. Wax bloom is caused by heat or friction, which separates the wax from the pigment and causes a white milky film to form over the drawing. When you are layering gently, this bloom generally will not occur. But if you exert heavy pressure or expose your drawing to heat, the bloom is likely to form. Bloom can be removed with a soft tissue (rub gently so as not to smear the drawing), but it will keep returning until you seal the drawing with several light coats of fixative.

A workable fixative leaves a nice tack on the drawing so that the paper will accept more layers of colored pencil if you wish to make adjustments later. Don't be confused by the term workable. After the drawing has been sprayed, nothing underneath the fixative can be changed. In this case, workable means you can work on top of the fixative.

Because fixative can alter the color of pigment, it is advisable to test it before using it on a drawing. Build a color scale, making a small rectangular swatch with each pencil you will be using in your drawing. Cover one half of each color with a piece of paper, and spray the color scale with fixative. When you lift the paper, you can see which swatches changed color when treated with the fixative.

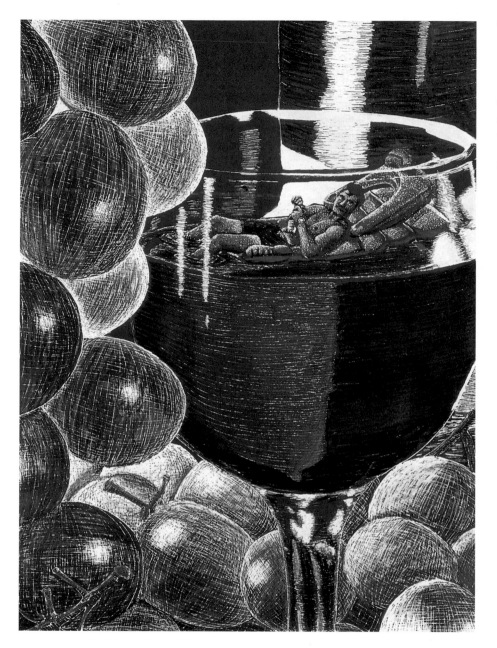

2–16
For this high school assignment, a drawing was scratched into a clay-based paper. This created a reversed or negative effect, with shaded areas as white instead of black. Colored pencil was then added to the white areas to create depth.

Student work: Mike Penrod (age 18), *Tim Floating in a Glass of Wine*, 1998. Scratchboard and colored pencil, 11" x 8½" (28 x 22 cm).

Finally, experiment with your materials, and see how far you can push them. Always ask yourself, "I wonder what would happen if . . ." You may invent the next hot new method for working with this friendly new artist's tool—the fabulous, versatile colored pencil.

3Layering Techniques

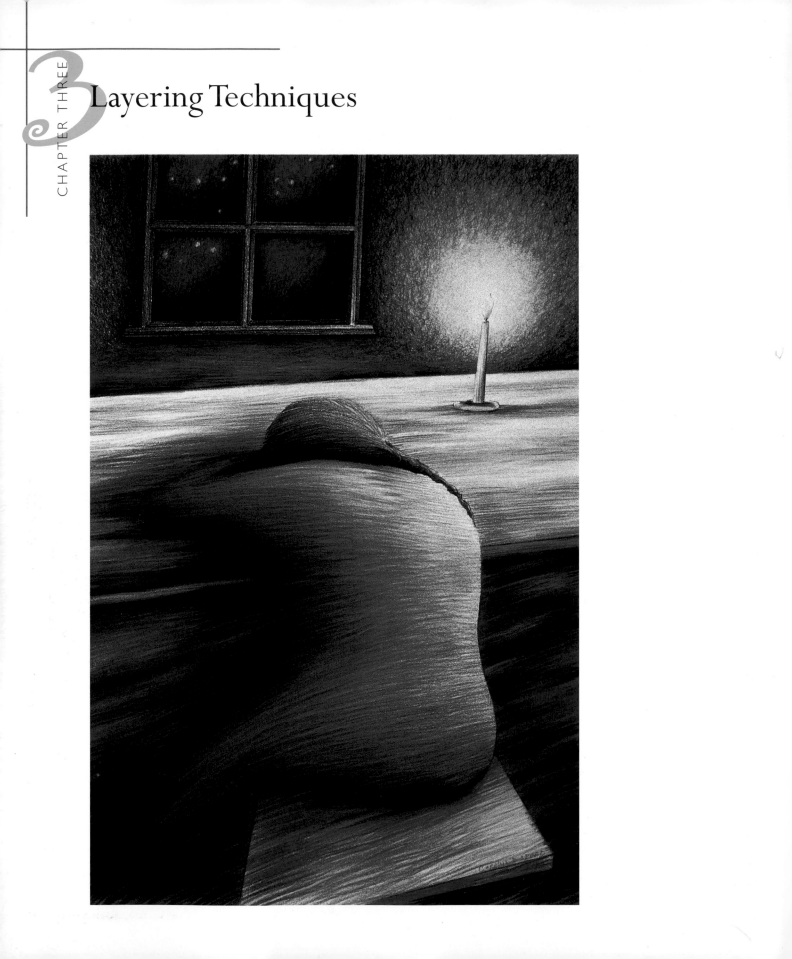

 Because they are dry, colored-pencil hues will not mix like wet paints. Instead, a variety of colors can be developed by layering. Layering, the most fundamental of all colored-pencil techniques, provides the foundation for understanding all colored-pencil applications. Because colored pencil is transparent in nature, every color applied in a drawing will be influenced by any pigment underneath it as well as the color of the surface upon which it is layered. Unlike an opaque medium, colored pencil automatically produces a variety of colors on the paper's surface as the layers build up, and the resulting blend of dots produces a pointillistic effect.

What Is Grisaille?

In past centuries, color pigment was very expensive and hard to come by. To conserve their pricey pigments, artists developed the grisaille (greez EYE) method. They would complete an entire painting in black and white first, establishing a full range of dark and light values. They subsequently applied transparent washes of pigment over the black-and-white studies to create a variety of values of each pigment.

Most professional colored-pencil artists use a form of grisaille, developing an elaborate value study before adding color. This underdrawing imparts volume and depth to their work. The medium used for this preliminary value study varies from artist to artist. Some lay down a complete graphite drawing, which is sprayed with a workable fixative. Layers of colored pencil are then applied over the graphite. Others photocopy the value drawing onto colored paper and color the copy with colored pencils. Some artists build value studies with a range of gray colored pencils (fig.3–2), and still others simply use a variety of colors to create their own grays. Finally, artists who enjoy working with watercolor pencils often complete the preliminary value study with a water-soluble graphite pencil (fig.3–3).

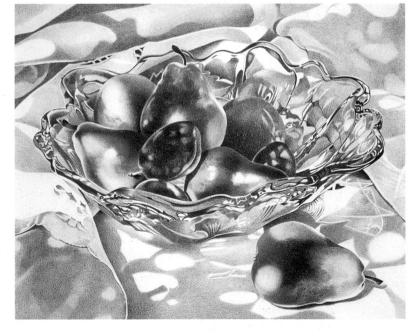

3–1
Some artists freely incorporate layers of colored pencil lines into their style of drawing. Others carefully blend the layers together until the individual pencil strokes are not visible.
Carolyn Reed, *Waiting Up for Him,* 1997.
Colored pencil, 24" x 20" (61 x 51 cm).

3–2
The artist began this drawing with a value study using gray colored pencils. She then built color by layering local hues over the grisaille drawing.
Barbara Newton, *Summer Harvest,* 1995.
Colored pencil, 15" x 18" (38 x 46 cm).

Although the choice of medium can vary, creating an underdrawing of light and dark values is a prerequisite for effective colored-pencil rendering. Without this value study, drawings lack depth.

Grisaille Techniques

Because most artists are comfortable with black-and-white pencil drawings, the grisaille graphite technique makes a perfect starting place for beginners. Adding color to a black-and-white drawing is not nearly as difficult as learning the intricacies of color theory.

To begin a grisaille graphite drawing, create a contour line drawing that will serve as a map for your shading. Then, complete a black-and-white pencil study. This value study should differ from traditional drawing in that all values should be about two shades lighter than normal. Avoid really dark values because strong graphite tones can make subsequent layers of color appear quite muddy. After you carefully check the drawing for accuracy, spray it with a light coat of workable fixative. You can now add color by laying a sharp colored pencil on its side and lightly dusting (layering) each area with color.

3–3
In this drawing, a water-soluble graphite underpainting was covered by watercolor washes, and then sprinkled with salt to create a starlike effect. When the paint was dry, details were added with dry colored pencils.
Tiko Youngdale, *First One In,* 1992.
Colored pencil, 12" x 16" (30 x 41 cm).

SANDRA SAYS

This graphite study served as a value study for my colored-pencil drawing. I photocopied my graphite drawing onto a sheet of toned paper and overlaid the value study with colored pencils.

Sandra Angelo, *Whiskers on Kisses,* 1998.
Colored pencil, 5" x 4¼" (13 x 11 cm).

Grisaille: Underdrawing with Gray

This demonstration shows how an artist can use the grisaille technique to build volume into her work.

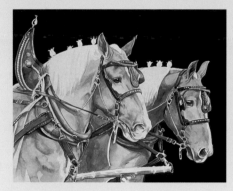 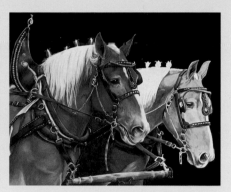

Step One: The artist began with a value underdrawing created with gray colored pencils.

Step Two: Colors were then layered over the underdrawing.

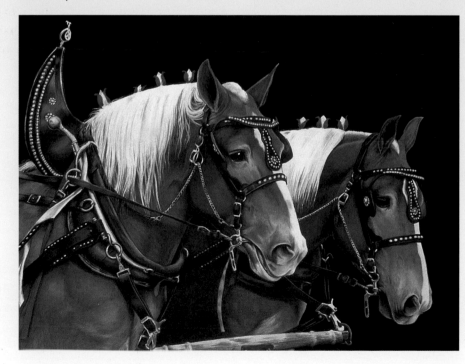

Step Three: Because of the strong values provided by the underdrawing, the finished work has a rich, full-bodied look, similar to that of a painting.

Bethany Caskey, *The Good Team,* 1992. Colored pencil, 14" x 17" (36 x 43 cm).

3–4
Layering dark blue and green colored pencil over a graphite value drawing lends a subdued feeling to this work.

Allan Servoss, *Figure in Landscape,* 1994.
Colored pencil, 14" x 20" (36 x 51 cm).

Using graphite for the grisaille technique generally works best for subjects involving muted, subtle tones. Antiques, nature, animals, old photographs, and anything with dull colors works well. Brightly colored subjects generally require an underdrawing made with a series of grays derived from complementary colors or gray pencils instead of graphite.

Monochromatic Layering

An understanding of color theory is a foundational skill for working in all media. If you haven't mastered the basics of color mixing, colored-pencil drawing can be quite intimidating at first. This book assumes that you have spent some time learning color theory and how to mix colors in other media.

3–5

Anyone who has tried to buy white paint to match a wall color knows that there can be hundreds of "white" color swatches to choose from. This drawing shows the dramatic results of using a variety of hues to formulate variations of white.

Barbara Newton, *White on White,* 1995.
Colored pencil, 11½" x 12" (29 x 30 cm).

However, even if you haven't mastered color theory, you'll still be able to succeed at monochromatic layering (*mono* means "one" and *chroma* means "color"). The simplest monochromatic layering involves just one colored pencil and a contrasting colored paper. By varying the pressure of your pencil, you can create a range of values.

The second way to work with monochromatic values is to use closely related colored pencils to create the appearance of one hue. This can even be done to create objects that are essentially white. In fig.3–5, the artist created a drawing with a monochromatic look, but used a variety of hues to build the white areas.

Building Color

One of the most fundamental concepts to grasp in color mixing is the difference between value and intensity. *Value* is the lightness or darkness of a color. *Intensity* is the brightness or dullness of a color. Students often confuse values and intensities. Instead of brightening a color with an intense hue, they might lighten it with white, turning it pastel instead of bright. Instead of darkening or dulling a color with the complement, they often reach for black, making the color muddy. Practice the following guidelines to strengthen your understanding of color mixing.

☾ To lighten a color add white. For example: to create lavender, add white to violet.

☾ To brighten a hue, use the color in its maximum intensity. For example: when you want to lighten the *value* of an orange pumpkin, you would use a white pencil. However, to brighten the *intensity* of an orange pumpkin, you would apply more yellow. Yellow and red make orange, and yellow is the brighter of those two colors; thus yellow is used to brighten orange.

☾ If you want to darken or dull a color, add the complementary color of the exact same value. For example: if you wish to darken or dull the color orange, use the complementary color blue, the color located across from the orange on the color wheel. It is important, however, to know which blue pencil to pick up. If the orange you wish to modify is dark in value, you would select a dark version of blue. As the hue gets lighter, you would choose a much lighter complement.

Most colored-pencil hues have been essentially pre-mixed. In addition to pure red, yellow, blue, and so forth, you are provided with a range of colors that have already been altered in value and intensity. For instance, a dark orange color is the result of orange that has been mixed with a complementary blue.

Get familiar with the colors in your box of colored pencils by making a color wheel similar to the one shown in fig.3–6. Arrange the colors by value, in descending order from light to dark. Because no brand of colored pencils contains a complete set of exact com-

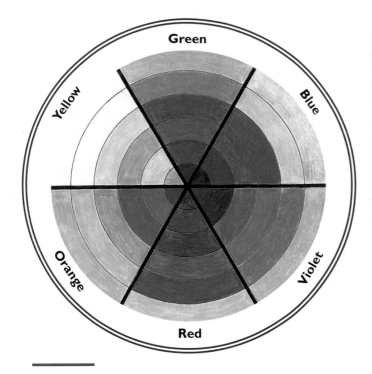

3–6

To better identify color opposites, use your colored pencils to generate a color wheel. Lay down each hue in a sequence that moves from light to dark. You may also want to write the name or number of each colored pencil on its color band, to help you quickly locate the pencil you want.

3–7

In response to a ninth-grade assignment, this student repeated her line drawing of a tennis shoe into all six sections of a hexagonal color wheel. For each primary or secondary color slice, she was allowed to use the local color (for instance, red) plus black, white, and tertiary colors on either side. Layering was used to create a sense of depth.

Student work: Starlynn Lott (age 15), *Brand New Sneaker,* 1998. Colored pencil, 10" x 10" (25 x 25 cm).

plements, your color wheel will not be precise. However, the wheel can be useful when you want to alter a color, by charting which pencil would serve as the approximate opposite. For example: to darken the pink in the outermost band, use the mint green in the outermost band across from it on the wheel.

 Transparent Layering

Because colored pencil is transparent, a rich spectrum of hues as varied as those found in nature can be created simply by layering one color over another. For example, if you look at your hand, you will see that your skin tone is made up of numerous colors. To try to match this color with just one pencil would be difficult, if not impossible. However, layering color on the paper results in a pointillistic combination of pigments that together produce subtle nuances of color. The look created by

this blending cannot be achieved with opaque media like paint.

Layered colors are much richer than those of a single pigment. Rather than use a plain purple, for instance, it is better to blend a purple that combines all the colors used to mix purple paint. For a light, bright purple, use strong reds and lighter blues. For a darker color, use more blue. To make the hue less intense, use the complement, yellow, to dull the color.

Transparent layering creates an optically solid look while still allowing the paper and each layer of color some prominence in the final drawing. The sharpness of the pencil will affect the artist's success with this technique. A dull point prevents pigment from penetrating the tiny wells in the paper, leaving white flecks that can detract from the subject. (I call this objectionable texture "dandruff.") If, however, layers of color are applied with a very sharp pencil, minute particles of pigment will fill the wells of the paper, resulting in complete coverage of the area.

Using Color Opposites for Shading

This pumpkin was created using the orange and blue hues from the color wheel.

Step One: The darkest areas were first colored with the appropriate blue. Medium areas were built up using dark oranges (oranges pre-mixed with blue), chosen from the darker values on the color wheel.

Step Two: With the underdrawing complete, the local color (the natural color of the object, in this case orange) was layered over the medium and dark areas.

Step Three: The highlights were layered with bright yellow and yellow orange, then layered over with bright orange. To retain a highlight's brilliance and develop contrast in a drawing, do not use dull colors in a bright area.

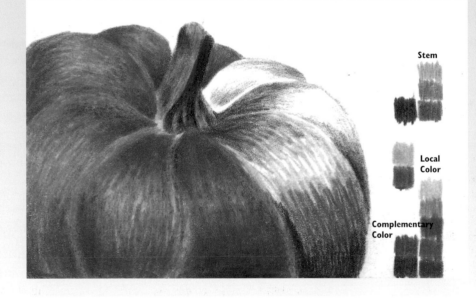

Stem

Local Color

Complementary Color

Masters of the transparent layering technique share a common fetish—a pinpoint-sharp pencil. Ann Massey, an artist who draws exclusively with the black colored pencil, begins a work session by sharpening ninety-five black pencils. When her pencil becomes the slightest bit dull, she reaches for a sharper pencil so that infinitesimal bits of wax will be evenly deposited in the pores of the paper. This results in beautifully clear layers, as you can see in fig.3–8.

Artists who gravitate to this technique typically prefer brands of pencil with a harder lead, because it retains a sharp point longer. Transparent layering can also be achieved with soft leads, but much more sharpening is required, meaning that the pencil will shorten rapidly. Bill Nelson, a professional illustrator who uses soft leads, reports that he goes through a pencil every half hour and four or five sharpeners per year. Because he keeps his pencil so sharp, his work looks as if it was airbrushed over the paper. (See fig.3–9.)

3–8
An American artist who resides in Paris, France, Ann Massey has captured the lively spirit of Frenchman Henri Berenger. Using black colored pencils exclusively, she achieves exquisitely fine details with pinpoint-sharp pencils.

Ann James Massey, *Henri Berenger,* 1995. Colored pencil, 9½" x 7¾" (24 x 20 cm).

3–9
A well-sharpened pencil has left a layer of pigment as soft and even as color sprayed by an airbrush.

Bill Nelson, *Ollie,* 1994. Colored pencil, 10" x 8" (25 x 20 cm).

Burnishing (Opaque Layering)

Burnishing simply means rubbing hard to create a lustrous surface. When you burnish a drawing, you apply the final layer of color with such heavy pressure that all colors underneath meld together and create an opaque wax barrier. Your goal is to completely cover the surface of the paper. Yet even burnished colored pencil remains transparent—the color of the paper and the previous layers of colored pencil will influence the final drawing.

All effective burnished drawings begin with an underdrawing made according to the transparent layering technique. The underdrawing contains sumptuous hues that, when burnished, will create an opulent new color.

Burnished drawings are built in four stages. First, the artist creates a line drawing, then develops a value drawing with transparent layers to establish light, medium, and dark tones. Next, local colors (the hues in the subject being rendered) are layered over the value study, until the drawing looks like a completed transparent layered drawing. To burnish the drawing, the artist first applies medium pressure, working color by color in the same sequence used in the transparent drawing. The pressure of the pencil is gradually increased with each pass. Most artists find that they must make several passes with each pencil before the colors are blended completely. (See the Demonstration on Burnishing.)

Burnishing Tips

When burnishing, it is crucial not to exert heavy pressure until all the layers of color have been applied. Pressing hard flattens the paper's tooth, and it becomes difficult to apply additional pencil layers. If you attempt to burnish after the bite has been crushed, chunks of pigment will lift off the paper, leaving bare spots in the drawing.

Never spill light colors into dark areas, and never

Burnishing Layers of Color

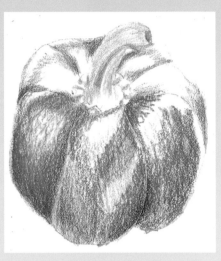

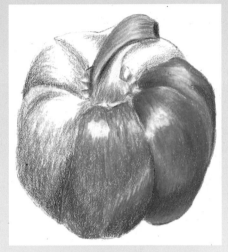

Step One: A contour line drawing was done, using very gentle pressure with an F graphite pencil. (The lines here were made darker than necessary so the drawing would reproduce well in this book. Your drawing should be much lighter.)

Step Two: All the colors were layered gently with very sharp pencils, using the transparent layering technique.

Step Three: The same colors were applied again in the same sequence, using heavier pressure. Each highlight was burnished with white to provide a protective barrier which preserves the whites.

Step Four: The pepper was then burnished several times, with a gradual increase of pressure until the paper's texture was completely obliterated. Adjacent colors were carefully overlapped and blended to create smooth transitions from dark to light.

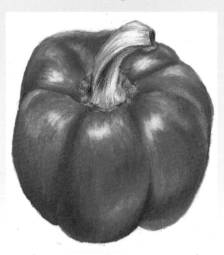

place dark colors in a light area. Let medium tones overlap both the light and the dark tones, serving as a bridge between the lights and darks.

It is imperative to brush the paper constantly while you burnish. The heavy pressure will leave pencil crumbs on it. If these crumbs become embedded in the paper, they will be virtually impossible to remove. These fragments can also cause problems if they get under the paper. As you draw over them, they will leave an impression in the surface.

The burnishing method, when properly employed, can simulate the powerful look of photorealism seen in acrylics or even oils (See fig.3–10). Although many artists prefer a particular technique, any of the layering techniques described so far can be combined effectively.

3–10
Contrast between the shiny ornaments and the dark, granular paper enhances the drama in this burnished drawing. Tiny self-portraits in the reflection of each Christmas ball add another level of interest.

Deborah Zeller, *Christmas Ornaments,* 1995.
Colored pencil, 21½" x 27" (55 x 69 cm).

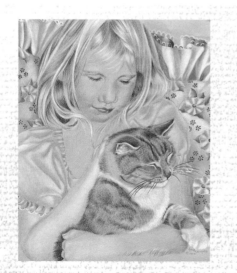

SANDRA SAYS

This drawing combines two techniques: burnishing and transparent layering. I used transparent layering to create the cat, the hair, and the skin tones because that method allowed the tan paper to become a part of the drawing. However, I didn't want the colored ground to influence the bright chintz fabrics, so I burnished the couch and the dress.

Tip: Use caution when combining techniques in one drawing. Burnished portions of a drawing can sometimes overpower areas that have been layered gently.

Sandra Angelo, *Trading Purrs for Pats,* 1994.
Colored pencil, 16" x 12" (41 x 30 cm).

1. Create a monochromatic drawing using one colored pencil or one color plus black and/or white.

• Select an object that has strong contrasts between light and dark tones, such as a face in shadow.

• Complete a contour line drawing on a contrasting colored paper, establishing a map for your shading.

• Using one colored pencil, shade the object. Create a wide variety of values simply by changing the pressure on your pencil.

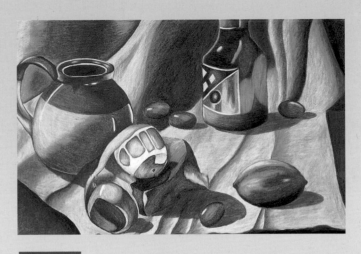

3–11

For this assignment, high school students used one color plus black and white to create shades and tints.

Student work: Sharon Huang (age 18), *Still Life,* 1998.
Colored pencil, 8½" x 11" (22 x 28 cm).

2. Complete a grisaille drawing with graphite and colored pencils.

• Select a favorite object from your closet, such as a baseball glove, hat, boot, sneaker, stuffed animal, or doll. For your first effort, select an object with fairly neutral or subtle colors.

• Do a contour line drawing with an F graphite pencil to establish a map for your shading.

• Shade the object with a graphite pencil, using only light and medium values. When you are convinced that the graphite drawing is finished, spray it with a workable fixative. Be sure to wait until it is complete because nothing you have drawn in graphite can be changed after the fixative is applied. Caution: Fixative is toxic, so do the spraying outdoors, and wear a mask over your nose and mouth.

• Build up the volume by shading the drawing with colored pencils. You can color the whole drawing or selectively color only portions of it to emphasize interesting shapes.

3–12

Using a graphite pencil for her value study, this artist colorized her black and white drawing with soft, subtle tones. To achieve a subdued palette, she used gentle transparent strokes instead of heavy burnishing.

Kathi Geoffrin Parker, *Patches and Radar,* 1991.
Colored pencil, 18" x 23" (46 x 58 cm).

1. Practice transparent layering over a gray value study.

• Study the images in the demonstration box on page 37.

• Select a favorite object from your closet, such as marbles, a ballet slipper, a hockey stick and ball, or a model car.

• Make a value study of this object, using at least three gray pencils: light gray, medium gray, and dark gray. Changing the pressure as you use each pencil will produce a wide range of gray values. To accurately render the object's volume, it is best to employ a minimum of six to eight values in your drawing. If the object is characterized by warm hues, use warm grays for your underdrawing; use cool grays if the colors are cool.

• Using very sharp colored pencils, layer color over your value study until the hues are sumptuous and the drawing has volume. Remember to use very gentle pressure. The transparent layering technique allows the paper's texture to show through in the final drawing.

Tip: Maintain a very sharp point on your pencil as you draw. When the pencil becomes the slightest bit dull, sharpen it. Keep layering with a sharp pencil point until you get rid of all the "dandruff." Choose colored pencils with hard leads to keep a sharp point more efficiently.

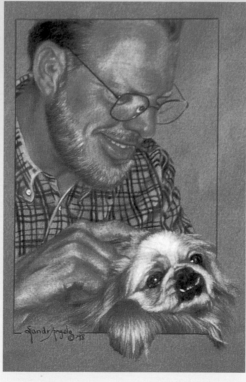

2. Using the same guidelines as for the first exercise, this time select a photo reference for your drawing. Complete this exercise first on plain white paper to study layering colors without the influence of colored paper underneath. (For information about working on a colored ground, see chapter five.)

3–13
This value drawing was completed on white paper, which is easier to erase, then photocopied onto the colored paper.

3–14
Sandra Angelo, *Best Friends,* 1998. Colored pencil on colored paper, 5" x 4" (13 x 10 cm).

Research the grisaille technique in a library or on the Internet. Find several artists who masterfully used this method in watercolor, oils, and pastels. Discuss with a fellow student the ways in which these principles can be applied to colored-pencil drawing.

1. Burnish a value study created with complementary colors.

• Create a still life from objects found in your home. Deliberately select objects characterized by complementary colors. In fig.3–15, the artist chose objects with reds and pinks to complement a range of greens. Make sure your arrangement is well lit by placing it near a window or under strong lamplight.

• On a preliminary sheet of paper, work out your palette by arranging two sets of complementary colors by values, working from light to dark. For example, if using reds, start with a patch of pink color, then deep pink, mauve, mulberry, and Tuscan red. Lay down the exact complements of those colors, from light to dark: mint green, darker pastel green, and so forth until you reach dark green.

• Create an underdrawing by sketching the values in your still life with one color, then layering its exact complement on top. The complements will form a gray value drawing that provides great undertones for grisaille.

2. Create a value underdrawing without using graphite or gray pencils.

• Choose a simple still-life object, and stylize your drawing to give it an attitude, for example, a tired boot, a macho saddle, a cocky hat, an elegant vegetable, an angry fruit, a raucous shirt, a prim purse.

• Instead of using gray pencil or graphite, using your own mixture of complementary colors to create a shaded underdrawing.

• Layer the local hues of the object over your value study until you achieve a three-dimensional look.

• Experiment with burnishing all or a portion of your drawing to create an opaque look.

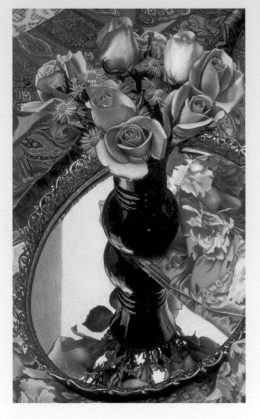

3–15
Photographic realism can be achieved by burnishing a grisaille underdrawing composed of layers of various grays.

Barbara Edidin, *Silent Partners,* 1995. Colored pencil, 21" x 12.5" (53 x 32 cm).

3–16
In this playful graphic design, a gradual value change in the colors of the label gives it a bit of depth while setting off the white rim around the interior images.

Student work: Mattias Hallbom (age 18), *Ketchup Explosion,* 1996. Colored pencil.

Watercolor-Pencil Techniques

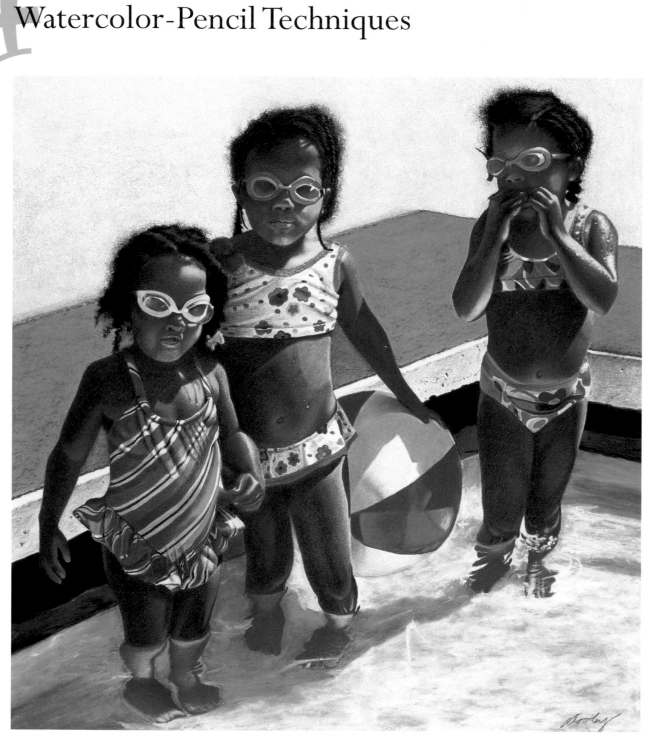

4–1

David Dooley underpainted each figure with light watercolor-pencil washes, then burnished wax-based pencils on top to add the fine details. He laid a frisket over the figures to protect them and completed the background with oil pastels.

David Dooley, *New Goggles*, 1994. Watercolor pencil, 25" x 24" (63.5 x 61 cm).

The water-soluble colored pencil is a very versatile and portable tool that makes sketching on location a breeze. And this pencil has the added benefit of being both a drawing and painting instrument.

Of course, the camera is a great tool for capturing an exhaustive record of a particular subject, especially moving animals. Still, after your photo shoot, it's a good idea to pause and sketch the animal's antics with watercolor pencils. These in-depth studies will familiarize you with the animal's behavior, the colors and textures of feathers or fur, and unique gestures. You'll find that the act of drawing will have substantially increased your recall when you are back in the studio.

There seems to be a magical connection between the hand and the mind. For instance, if you made a list of things to do and then lost the list, the exercise of writing it down probably would have impressed the items in your mind. You are likely to recall many details without even referring to your list. The same is true when you paint or sketch a subject. You are more likely to remember minute facts about the subject, the ambience of the location, and other details if you take the time to paint and draw what you see while you're there.

Advantages of Using Watercolor Pencils

Somewhat intimidating for beginners, watercolors tend to run and bleed all over the paper. If you are a novice watercolorist, you might feel totally out of control, especially if you want to produce realistic pieces. By contrast, watercolor pencils are easier to manage because they are a drawing instrument as well as a painting tool. Whereas you can't draw with a watercolor cake or tube, the watercolor pencil is fabulous for sketching. Unlike unwieldy watercolors, water-soluble

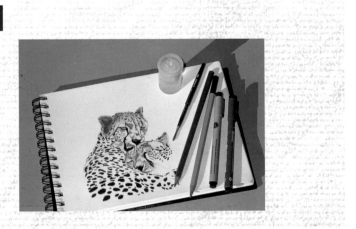

Sandra Angelo, *Tender Moments,* 1997.
Colored pencil, 7" x 10" (17 x 25 cm).

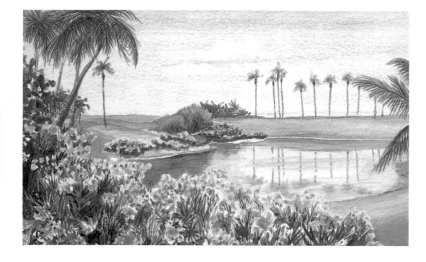

4–2
Julie Wolfson underpainted this scene with water-soluble colored pencils and applied the details with a combination of permanent colored pens and wax-based colored pencils.

Student work: Julie Wolfson (age 72), *Desert Hot Springs*, 1998.
Colored pencils and pens, 9" x 12" (23 x 30 cm).

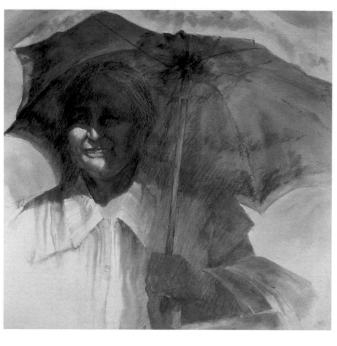

4–3
Watercolor pencils can combine the transparent look of watercolor with the hatching lines typically associated with sketching.
Patry Denton, *Oh Sunny Day*, 1990.
Colored pencil, 16" x 16" (41 x 41 cm).

pencils can make you feel secure because you can place pigment exactly where you want it. And these colors stay put unless you purposely use brush and water to create other effects.

Watercolor pencils are also much less expensive than other forms of watercolor. They're nontoxic, portable, and extremely versatile, and they can achieve the transparent look of watercolor, opaque realistic rendering, or loose sketches, depending on how they are applied. In fig.4–3 the artist used watercolor pencils to combine the transparent look of watercolor with the hatching lines normally associated with sketching.

Although this tool is versatile, watercolor-pencil painting does have limitations. Because the instrument is very small, you may find it difficult to cover large areas quickly. Here's a handy rule for choosing between watercolor paints and watercolor pencils: If the area to be covered is much larger than 5" x 7", wash it with watercolor paints. If the drawing requires small, intricate details, pick up a watercolor pencil.

Before you start to work seriously with watercolor

pencils, fill a page full of doodles, trying each of the six methods listed in the next section of this chapter. Familiarize yourself with what this tool will do for you.

A Mixed-Media Approach

Adding Pen and Ink

Watercolor pencils can be combined with other media to create a loose, free style suitable for greeting cards, children's books, and many forms of illustration. You don't need to limit yourself to black ink, either. Using permanent colored ink pens, you can create a lively line drawing that can be washed with coordinating paint.

Six Techniques for Watercolor Pencils

One: Draw a swatch of color on a piece of scrap watercolor paper. Load your wet brush from this patch of pigment, and then apply it to your artwork. This technique is one of the best ways to build vivid, splashy colors because the brush will pick up a lot of color. The end result will look like a watercolor painting, as you can see in fig. 4–3.

Two: Lay down a wash of clear water, and draw into the wet area. This method will retain the linear look of a drawing, but inside the damp section, the lines will be softened by the water and slightly blurred.

Three: Put a drop of water on your palette. Place the pencil lead directly in the small bead of water so that the tip of the pencil becomes wet. Draw with a wet lead. This will give you maximum brilliance and full color saturation. Take care not to immerse the whole pencil in water—it will weaken the lead and cause the pigment to dissolve inside the wooden sheath.

1

2

3

4

5

6

Four: Draw with a dry watercolor pencil. After you've placed the pigment where you want it, daub your pencil marks with a wet brush. You can achieve either intense pigment saturation or light colors, depending on how much pencil color you've applied to the paper. Keep in mind that when water is added, the colors sometimes change in intensity. You can avoid unpleasant surprises by testing your colors on a separate sheet of paper.

Five: Draw a swatch of color on a piece of scrap watercolor paper. Load a very wet brush from this swatch. Now flick your loaded brush against the watercolor pencil, splashing your paper with flecks of color. This technique is great for depicting sand, gravel, sleet, freckles, and so on. Multicolor splashes are terrific for simulating the mottled colors in subjects such as leaves, beaches, and bushes. Note that when you spatter on wet paper, the spots will blur. On dry paper, such color specks will stand out distinctly.

You can control the spatters by masking adjacent areas with either liquid masking fluid or frisket paper (see chapter two). Or, just cut a piece of tracing paper in the shape of the area you want to protect, and lay the paper over it. Some spatters may slip under the paper, but if absolute precision is not important, this method of masking is fairly adequate.

Six: Apply a wet brush to the tip of the pencil to load color onto the brush. The painterly strokes achieved with this method will look much like those of a watercolor painting.

4–4
A single layer of pigment was sufficient for this simple cartoon.

Joe Bull, *Felix and Fido,* 1996. Colored pencil, 4" x 5" (10 x 13 cm).

4–5
Watercolor-pencil washes, followed by detailed colored-pencil sketching, were used to create these orchids. The background was then washed with black ink.

Tiko Youngdale, *Orange Orchids,* 1992.
Colored pencil, 12" x 9" (30 x 23 cm).

Ink can also be used to fill in backgrounds, as you can see in fig.4–5. The artist used watercolor pencils to paint the orchids, placed the details with dry wax-based colored pencils, and then filled in the background with a black ink wash. To fill in the large areas, she used a brush and then brought the ink to the edges of the flowers with a fine ink pen. You can see that the combination of ink and watercolor pencil offers the best of two worlds. Fine-tip pigmented pens can provide superfine detail, and watercolor-pencil washes can fill in the blanks and wash the drawing with color. An infinite variety of styles can be created with these two harmonious media.

Using Water-Soluble Graphite

Just like the watercolor pencil, water-soluble graphite can be used to achieve any of the techniques mentioned in this section. The only difference is the color. Water-soluble graphite creates strictly black-and-white artworks. However, this tool is available in a variety of densities just like a standard drawing pencil. The density you select will affect the value saturation. A 2B offers light washes, whereas an 8B will provide deep, dark tones. Some high-quality brands have only one density, imparting a full range of values with just one pencil. When using this pencil, you can achieve dark values by simply loading plenty of pigment onto your brush. A lighter value can be produced by using more water.

For those on a limited budget, water-soluble graphite is a great tool. You can use this pencil and a brush to create soft black-and-white sketches. Or you can wash your value drawing with a few watercolor pencils, and voilà—you have a beautiful color painting.

Research watercolor techniques at the library. Describe the similarities between watercolors and watercolor pencils. What are the limitations of these two media? What are effective ways of combining them?

1. Fill a practice page with experiments in techniques for watercolor pencils and water-soluble graphite pencils. Don't try to make pretty pictures—just create painted swatches or vignettes of small objects. See what the pencils will do for you.

Step One: Using an F graphite pencil, complete a contour line drawing on a watercolor block.

Step Two: Draw patches of watercolor pencil on a scrap piece of watercolor paper, and use the patches to load your brush. Shade each area of the drawing with a light wash of the appropriate color.

2. Practice creating an underpainting with watercolor pencils. This simple exercise will help you understand one approach to watercolor-pencil painting. Choose a simple object to draw. Focus on the object itself, and don't worry about the background for now.

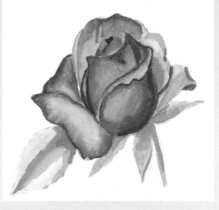

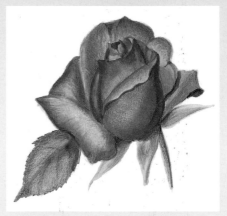

Step Three: Load your brush with more pigment. Wash a second layer over each shaded section to create a darker value in the shadows.

Step Four: When the underpainting is completely dry, use sharp, dry wax-based colored pencils to fill in details and highlights.

Illustration by Julie Wolfson.

1. Do a black-and-white value study in water-soluble graphite pencil, like the one shown on this page.

• Analyze a color photo in terms of its values: light, medium, and dark. If you are having trouble determining the values, take the color picture to a photocopy shop. Make a good-quality black-and-white copy of the photo, and study the values.

• Begin with a line drawing that will serve as a map for the placement of values. Using an F graphite pencil, press very lightly so the lines won't be evident in the final drawing.

• Load a wet brush with water-soluble graphite. Lay in light washes depicting the light, medium, and dark values.

4–6
The lines seen here are extremely heavy so that they will show up clearly in this book. Your line drawing should be much lighter than this one.

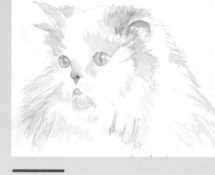

4–7
Studies such as this lay a foundation for working with values in more ambitious drawings later. Visualize how color and details might be added to this drawing.

2. Review the instructions in this chapter for working with watercolor pencils. Create a greeting card using watercolor pencils or watercolor pencils combined with ink. Fig. 4–8 was underpainted with watercolor-pencil washes. Details were then added with dry wax-based colored pencils.

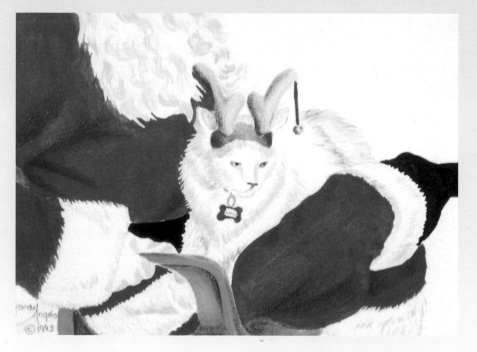

4–8
The author underpainted each section of this drawing with washes of water-soluble colored pencil. Underpainting can cut the drawing time by more than 50%.

Sandra Angelo, *Santa, Claws, and I Wish You a Merry Christmas,* 1993.
Colored pencil, 5" x 7" (13 x 18 cm).

David Dooley often uses watercolors to create an under-painting and a collage of colored grounds. This step-by-step illustration was produced on Crescent 300 Hot Press Watercolor Illustration Board because it doesn't buckle. This surface also accepts watercolor pencils very well.

If you want a challenge, try to make a drawing based on this vignette in this demonstration. Or set up your own still life or use a photo as a subject for your artwork.

Step One: Establish a light contour line drawing to delineate the placement of shapes and shadows. When you are satisfied that your drawing is accurate, lift any excess graphite with a kneaded eraser to lighten the lines. Beginning with the lightest colors, apply washes in each area that needs a colored ground. Let these areas dry.

Step Two: Start your colored-pencil application by laying in the darkest colors first, establishing a value drawing. (Use the transparent layering technique to build up the undercoat for burnishing.) Follow this with a sequence of colors, working from dark to light. Remember: Never spill light colors into dark areas, and never

place dark colors in a light area. Let medium tones overlap both the light and the dark tones, serving as a bridge between the lights and darks.

Step Three: Using the same color sequence, begin to burnish each area of the drawing.

Step Four: Draw the finishing details with a very hard lead pencil, taking care to sharply define the focal point and all objects in the foreground. If you desire, you may spray your drawing with several light coats of fixative to prevent wax bloom from developing in the burnished areas.

David Dooley, *Five in a Row,* 1991.
Colored pencil, 20" x 28" (51 x 71 cm).

Working on a Colored Ground

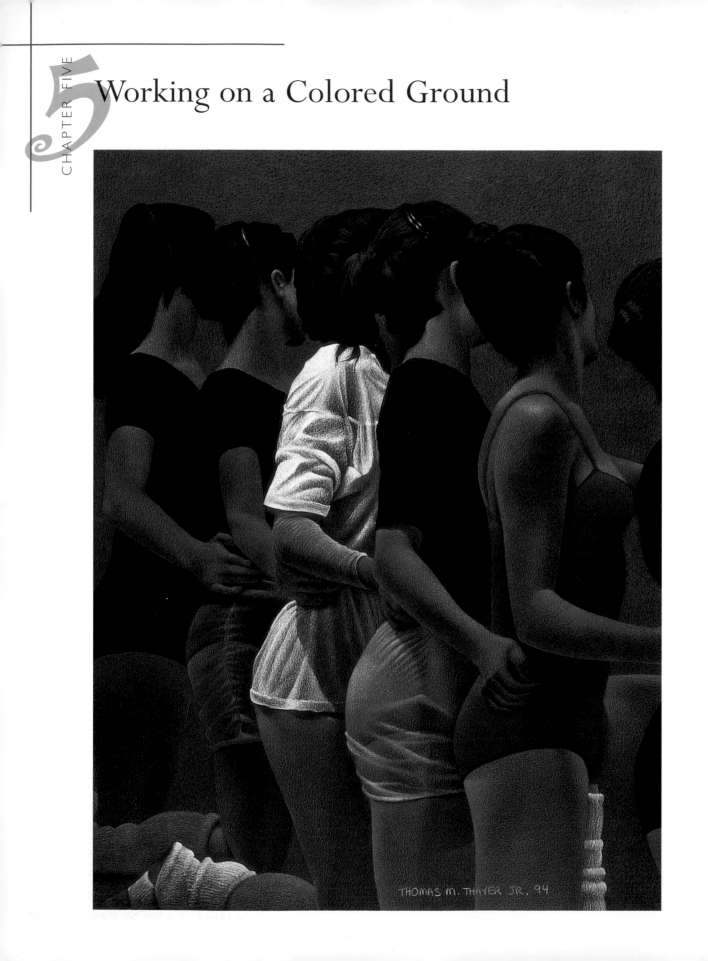

Have you ever felt harried, unable to slip into your creative world because of the pressures of time and endless obligations? In a fast-paced lifestyle, how can we grab enough time to do creative work? I've found a way! Drawing on a colored ground. A scene that would have taken five hours to complete can now be finished in half the time!

White backgrounds seem to beg to be filled in, but colored backgrounds already seem complete. In addition, colored papers lend unity to the entire piece, binding each element together with tonal harmony.

When you wish to draw on a colored surface, you have several options:

• You can choose a colored paper.
• You can color white paper with washes, using watercolors, watercolor pencils, or an airbrush.
• You can use a colorless blender to create a collage of colored grounds.

Let's look at some guidelines for using colored grounds.

This cat was completed on a plane ride from San Diego to Chicago. When I have only a snippet of time, I can actually finish a whole drawing very quickly by using a colored ground. A tremendous amount of time was saved by simply choosing a paper that contained the dominant hue found in the subject.

Sandra Angelo, *Murphy,* 1995. Colored pencil, 8½" x 11" (22 x 28 cm).

5–1
"I want my drawing to be the dramatic one that grabs everyone's attention when they walk into a gallery," says artist Thomas Thayer. He achieves this sense of drama by using strong, bright colors on a dark background.
Thomas Thayer, *Unity,* 1994. Colored pencil, 20" x 16" (51 x 41 cm).

5–2

Because colored pencil is transparent, the paper influences each hue. If you wish to use yellow on a black paper, try making an underdrawing with white pencil before you lay the yellow down. The lemon on the top was drawn on black with pure yellow, whereas the other lemon was undercoated with white first. See how much more brilliant the yellow is in the second drawing?

Illustration by Julie Wolfson.

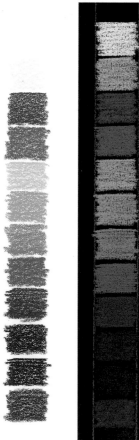

5–3

These color charts show how dramatically the same set of colors change when applied to various colored papers.

Testing Your Colors

Because colored pencil is transparent, the color of the paper will influence each hue. Always test your colors before beginning a drawing. Hues that appear to be compatible may turn ugly when applied to a colored surface. For example, yellow, which seems to be a perfect companion for black, will turn into a sickly lime green when applied to black paper. (See fig.5–2.)

If you want to prevent a dark paper from overpowering your pencil marks, you can place a layer of white pencil underneath it. This barrier of white will intensify the color itself and retain more of its brilliance. Remember, however, that any hue applied over white will take on a pastel tinge. To determine how colors will be affected by a white sublayer, simply test them on a scrap piece of the same colored paper. (See fig.5–3.)

Setting a Mood

The mood of a drawing (fig.5–4) is determined by the pressure used on the pencils and the value contrast between a paper's color and that of the subject. Both white and black can look intense on a medium-tone paper. Yet when white is placed on black paper, it can turn very gray. Although a black paper can make colors appear sallow, this effect can be used to your advantage.

Applying colored pencil with a very light pressure allows the color of the paper to pervade the pencil colors, toning them down to create subtle hues. A heavier application can achieve a strong sense of drama, like the white-on-black treatment in fig. 5–1.

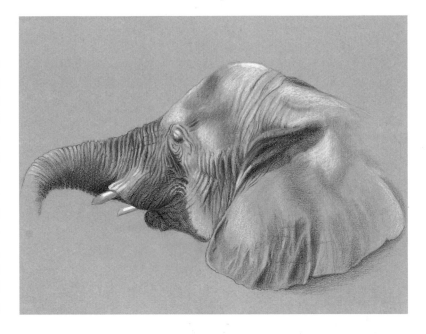

5–4
By choosing a toned paper that contains the dominant color in your subject, you can cut your drawing time and bring color harmony to your work.

Student work: Julie Wolfson (age 70), *Elephant Study,* 1996. Colored pencil, 8" x 13" (20 x 33 cm).

SANDRA SAYS

To save time, some artists make a chart of all their colors on each of their favorite papers, so they don't have to test their pencils before every drawing. I often test pencils on the back of my paper while I am drawing. If I find a color that works well, I record the pencil's name and number and the subject I applied it to. When I return to my work later, I'll know which pencils to use.

Selecting a Colored Ground

Always choose your subject before you select a colored ground. Base your paper choice on the dominant hue in your subject. For example, when the artist drew the heron surrounded by water (fig.5–5), she used a blue paper. This saved considerable time because much of the color she needed was already there.

Trying to force a subject to fit an inappropriate paper can meet with disastrous results. One of my students tried to draw a peach-toned infant on lime green paper. The result was a sickly looking baby.

Various colored cotton papers and tinted pastel papers are suitable for use as colored grounds. Some brands of colored paper have a vellum finish on both sides. This slightly rough surface is ideal because,

although it definitely has enough tooth to grip the wax pencil, its texture is not overly bumpy. A heavily textured surface, such as that of pastel paper, will cause pock marks in your drawing, which can be very distracting. Unless you want to use the rough surface of a pastel paper to create a special effect, simply turn the paper over and use the smoother back side.

5–5
Colored paper can provide a tonal unity in an image where a particular color, in this case the blue of the water, is to be dominant.
Evelyn Fournier, *Great Blue Heron,* 1986. Colored pencil, 16" x 25" (41 x 63 cm).

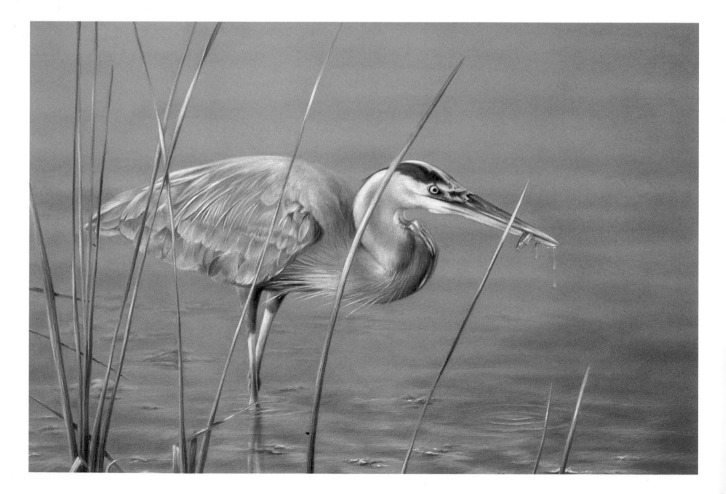

A textured surface should benefit the drawing rather than distract the viewer from the main subject. Here's a good test for evaluating the use of texture in a given drawing. Ask yourself, "When I look at this drawing, do I notice the texture of the paper?" The answer should be no. Texture should amplify and enhance the drawing in an understated way, and should not draw attention away from the subject. (See fig.5–6.)

Usually artists select a colored paper because they want it to be seen. The paper's color will permeate your drawing if you use a very gentle touch. You can achieve this look with the transparent layering technique. Place smooth, even layers of color on your paper with a very sharp pencil. (A dull pencil will create an unattractive texture.)

Before you invest a lot of time in a drawing, be sure you are using a high-quality paper or other ground. I've seen many students put hours of labor into a complex project, only to be disappointed when the paper soon fades or disintegrates. If you use a piece of construction paper or colored papers made for children, your pencil

marks will skid, and worse yet, in a few days the paper will begin to fade and disintegrate. Don't even practice on bad paper. You will get high-quality results only if you use high-quality products. At first, it's best to buy just one sheet of a given paper and to test it before beginning a time-consuming drawing.

If you wish to work on surfaces that will last indefinitely, consider products such as Windberg Masonite Pastel Panels, Multi-Media Panels, and one hundred percent rag colored mat boards. These surfaces are great for work that will be handled quite a bit or carried around. The extra thickness keeps the board or panel from getting damaged.

When selecting a surface for making your own colored grounds with watercolor pencils or watercolor, always choose one that accepts water without disintegrating. Multi-Media Panels, Windberg Panels, watercolor paper, and watercolor illustration board are all good choices. These have been properly sized and treated for water application.

Creating a Collage of Colored Grounds

5–7
You can use colored pencils and a colorless blender to create colored grounds only where you want them. Parts of this drawing have an undercoating of black, whereas the top and bottom of the vase were underpainted with a mulberry hue.

Sandra Angelo, *Shadow's Nap,* 1993. Colored pencil, 11" x 8½" (28 x 22 cm).

Although working on colored papers is a fabulous way to save time and effort, you may sometimes find that instead of one solid background color, you need different colored grounds for different areas of your drawing. You can create a collage of colored grounds by using a colorless blender, watercolors, airbrush, or even watercolor pencils, putting every color exactly where you need it.

For example, if you want a strong black background in one area, but black paper would not be suitable for the rest of your drawing, you can simply apply black pencil to one section. Then use a colorless blender to get rid of the white flecks and leave the rest of the drawing white. (See fig.5–7.)

Underpainting with a Colorless Blender

One of the most inexpensive and wondrous tools invented for the colored-pencil artist is the colorless blender (see chapter two, page 16). Unlike watercolors, this blender will work well on any drawing surface to create background color. Although some illustrators may complete a rough sketch using just the blender over one colored pencil, most artists simply use it to underpaint their drawing surface. All blended areas are then covered with plush layers of colored pencil.

In each section that requires underpainting, select the area's lightest hue for the ground. This light color will show through subsequent layers and contribute the highlights to the area. (Because colored pencil is transparent, using a dark underpainting would prevent you from obtaining light colors in that section.)

To avoid muddy colors, apply the blender to only one color. Although the word *blender* implies that the tool should be used to be meld multiple layers of color, this is a misnomer. (A better name would be colorless marker.) If you blend numerous hues with this tool, they will look murky. The blender simply tints the paper with the

Using a Colorless Blender

Richard Thompson set up this still life next to his window and worked in his studio at the same time each day so that the lighting would be consistent. Because natural light changes rapidly, it took him several weeks to complete the drawing. If you want to ensure consistent lighting for a still life, you can draw in a dark room with a spotlight on your arrangement of objects. Or you can take a slide or photo of it.

For this drawing Thompson underpainted each section with a marker. Whereas the dyes in markers are fugitive (meaning that they will fade), pigments in most professional-grade colored pencils are not. You can achieve the same effect by simply underdrawing each section of the paper with the appropriate colored pencil. Then blend each section with the colorless blender. Together these blended areas will serve as a collage of colored grounds for your drawing.

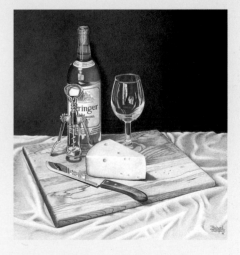

Step One: Begin by applying a single layer of one colored pencil to each section. Use the colorless blender to stain each area. If you stop right after you've applied the blender, your drawing will look like it was done with a marker. Although this look is fine for abbreviated illustrations by fashion designers or art directors, it is not suitable for fine art renderings.

Step Two: To achieve the rich look associated with professional colored-pencil drawing, multiple layers of colored pencil have been built over each blended area.

Final Drawing: Numerous layers of colored pencil have been layered over the underpainting to produce luminous colors.

Richard Thompson, *Still Life with Cutting Board,* 1991. Colored pencil, 16" x 16" (40.6 x 40.6 cm).

5–8
This dramatic "worm's-eye view" (discussed in chapter six) of the sycamore tree was under-painted with watercolors to create a collage of colored grounds.

5–9
The artist then applied colored pencils over the washes.

Julie Marguerite Allen, *Arizona Fantasia,* 1990. Colored pencil, 30" x 22" (76 x 56 cm).

first and lightest color. If you want to mix hues, use colored pencils over the colored paper that you've created with the blender.

Be sure to clean the blender between every color application. To do this, use a scrap piece of paper and keep running the blender over the surface until you don't see any color on your paper. The tip of the blender will most likely appear stained, but if no color is appearing on the paper, it is clean and ready to be used in the next section. Each time you finish blending, replace the cap immediately (to make sure it's tight, listen for a snap) or the blender will dry out.

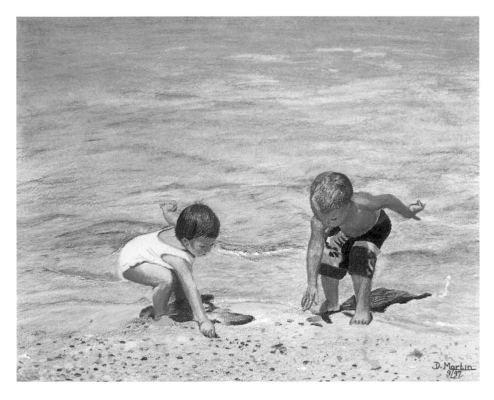

5–10
This artist underpainted her paper with watercolor pencils to create a colored ground. Leaving most of the underpainting untouched, she simply added a few details in the foreground with colored pencils.

Student work: Doris Martin (age 77), *At The Dunes,* 1997. Colored pencil, 8½" x 11" (22 x 28 cm).

Underpainting with Watercolor

When you wish to create an underpainting with watercolors or watercolor pencils, you'll need to apply many of the rules for underpainting with a colorless blender. For example, it is usually best to restrict the underpainting to the lightest tone in a given area. Apply a single color wash to each area, and finish the drawing with dry pencils. (See figs. 5–8 and 5–9.)

However, unlike those made with the colorless blender, watercolor washes may look quite attractive on their own without multiple layers of colored pencil. You might limit your drawing to just a few key details, allowing the watercolor-pencil drawing to look like a watercolor painting. (See fig. 5–10.)

When you use watercolors or watercolor pencils,

enjoy the advantages that a brush can bring to your drawing. Whereas work created with a blender and a pencil tends to be tight and controlled, brushes can create loose and spontaneous renderings. It is fun to play around with these methods to see which direction you would like to take. Often a strong case can be made for tightening up a drawing, yet the same drawing can be delightful in a loose style. It is simply a matter of personal preference.

If you decide to apply dry pencils over watercolor washes, wait until the wash is completely dry. If you don't wait, the pencils will skid, and pigment will have trouble adhering to the surface of the paper. I always use dry wax-based pencils to draw on washes. Although watercolor pencils produce vivid hues when water is added, their effects are fairly lackluster when used dry.

Monochromatic Drawings on Colored Papers

If you want to create a drawing with very subtle drama, try using only one colored pencil or a series of colored pencils to create hues of the same family (See fig.5–11). These muted drawings can be very effective.

A monochromatic drawing can be created with a limited palette of colored pencils or by simply using graphite with one or two colored pencils. Combining graphite with colored pencil seems less daunting to beginners. After all, everyone has been using the pencil since grade school for everything from arithmetic to phone messages.

It is also less threatening to use a photograph as a reference, since the subject will hold still and the lighting remains static. If you need to modify your photo reference, consider doing a black-and-white study on white paper first. Work out the composition problems, the textures, what to leave in, and what to leave out. Then transfer this drawing to colored paper. There are two ways to do this.

Method One

You can complete a graphite drawing on a colored paper. After you are satisfied that the drawing is accurate, spray it with a light coat of workable fixative to seal the graphite and keep it from smudging. Now you can use white or a few light-colored pencils to add the brightest highlights. Because your drawing already has a full range of values, you won't have to apply much color.

Method Two

You can take your graphite rendering to the copy shop and photocopy it onto colored paper. It is best to make your photocopy about two shades lighter than the original drawing so that when you add color, your drawing won't look muddy.

This method has one drawback. If you are not careful, you can accidentally lift the photocopy ink off your paper as you work. To avoid this problem, you can spray the toner with a workable fixative, or you can start applying color in the bottom right-hand corner and work toward the top left. (Reverse these instructions if you are left-handed.) This way, your hand will be touching only the areas that have been covered with colored pencil. You may need only a few pencils to complete a monochromatic drawing over the photocopy.

5–11

Although the predominant hue in this monochromatic drawing is a grayish green, the artist broke the pattern slightly with selective patches of golden brown.

Thomas Thayer, *Winter Warming,* 1991. Colored pencil, 30" x 20" (76 x 51 cm).

Thomas M. Thayer Jr. 91

To learn how to make an underpainting with a colorless blender, try copying the step-by-step drawings on this page. If this seems too easy, choose your own simple still-life object, and use the colorless blender to create your underpainting.

Step One: Complete a contour line drawing of the foxglove, using an F graphite pencil. Be sure to use very light pressure so your lines will not show in the final drawing.

Step Two: Fill in the contours with appropriate colors, using a dry colored pencil.

Step Three: Using the tip of the blender, go over each section until the colored pencil is blended and the pigment has saturated the paper. Be sure to clean the blender when changing colors

Step Four: Layer colored pencil over the underpainting until the drawing looks rich.

Look at the monochromatic drawing in fig.5–12. Notice how the paper's color is used as a value in the drawing. Compare this to fig.2–9. Even though both artists drew a car, the end results are extremely different. What makes Thomas Thayer's drawing more dramatic?

1. Using only a white colored pencil, create a drawing on a dark or medium-tone colored paper. Choose a subject that contains a variety of light and medium values. To achieve light values, press harder. To create dark values, decrease pencil pressure and allow the paper to show through.

2. Use up to five different colors to create a single hue. For example, what colors would you use to create a range of values in a drawing of white eggs?

Consider using a subdued palette and breaking the monochromatic mood with one colorful element. For example, in fig.5–13, the artist created most of the drawing with monochromatic tones and then altered the mood by adding a child in a brightly colored outfit.

5–12
This monochromatic drawing was accomplished with just three hues.

Student work: Kathryn Vierra (age 48), *Volvo Sport,* 1995. Colored pencil, 9" x 8" (23 x 20 cm).

5–13
The monochromatic treatment of this drawing is broken by the child dressed in red. This contrast, intensified by a strong light source, adds drama to the work.

Ken Raney, *Dino Walk,* 1991. Colored pencil, 10½" x 8" (27 x 20 cm).

1. Create a drawing on a colored ground in which the negative space depicts the subject. To compose a negative space drawing, choose a subject that has an interesting silhouette. Leave the silhouette devoid of pencil and simply define the subject by drawing what's around it. (fig.5–14)

2. Study the work of Matisse. Notice how he often used flat color to depict each shape. He also loved to use pattern, and the heavy outlines around his objects resemble those of a coloring book or the lead lines in stained glass. Create a flat pattern drawing, using the colored pencil, the colorless blender, and a technical pen with permanent black ink.

• For your subject, choose a brightly colored photograph, preferably a composition with three or more distinct shapes.

• When sketching the subject, make the shapes flat and arrange them on the paper to your liking. This exercise is not about realistic representation, so have some fun with it.

• Use a palette that appeals to you. You can base this palette on formal color theories or simply select hues based on your personal whims. If you are curious about what palette appeals to you, look in your closet. You generally dress in your favorite colors.

• Fill each shape loosely with a colored pencil, and then blend all or some areas with the colorless blender.

• Use colored pencils to apply thick layers of flat color to each shape, until you have thoroughly covered the entire paper.

• Try outlining some or all of the shapes with permanent black ink.

5–14
The negative space in the silhouette of the tree interacts with the negative space of dark blue sky showing through the clouds.

Student work: Deborah Settergren (age 43), *Palms,* 1996.
Colored pencil on black paper,
8" x 11" (20 x 28 cm).

5–15
The look of textured paper is generated by a patchwork grid of detailed lines behind the main figures.

Student work: Kyndell Everley (age 17), *Shogun,* 1998.
Colored pencil, 10" x 15" (25 x 38 cm).

2

The Drawing Process

Design Techniques

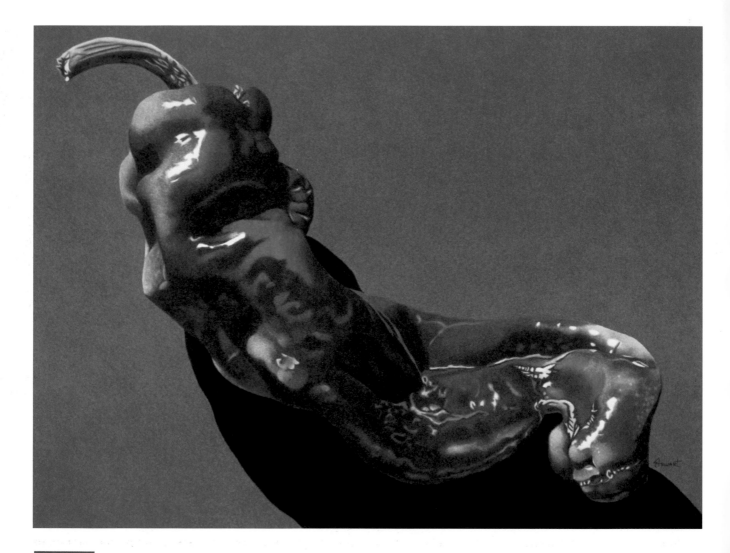

6–1
An effective compositional tactic is to blow up a subject to fill the entire page. A heavy black shadow helps anchor the image in the picture frame.

Shelley M. Stewart, *Red Hot Mama in Repose,* 1995.
Colored pencil, 13" x 18" (33 x 46 cm).

Loud splashy drawings. Soft, subtle moods. Arresting drama. Bold statements. These are just a few of the effects that can be achieved by applying a range of design techniques to your drawings. Creative composition can make or break a drawing.

Whether you are building a photo reference file or sketching on location, it is helpful to use a viewfinder such as a camera or an empty slide mount to determine the best composition of the elements in your drawing. If you hold a viewfinder in front of you, look through it, and move it around, you'll be able to see the subject from differing points of view. If you are shooting static subjects such as landscapes, you can try several different points of view.

Composition

Six basic techniques are generally used to create interesting compositions. These apply to all two-dimensional art, including paintings, drawings, and photography. You will find that many great compositions incorporate several of these techniques. As a beginning artist, it is a good idea to use these techniques when composing your drawings. Once you have mastered the rules, you will then know when it is appropriate to break them.

You should always be aware of composition, even when you do small drawings on your sketch pad. Each time you place an object on the page, remember that it is cutting into the negative space. Make sure that the spaces behind the subject are as interesting as the foreground. Integrate the positive and negative spaces until each piece of your drawing contributes to an interesting composition.

6–2

Two legs divide this image roughly into thirds, with objects in the foreground placed on either side. Although the center of the drawing is open space, the composition looks balanced.

Student work: Valerie Hacker (age 16), *In Flight*, 1997. Colored pencil, 18" x 24" (46 x 61 cm).

Sometimes when you are taking pictures of moving objects, you won't have time to compose the picture. In that case, just point and shoot at the moving target. Next, take a photo of the background, composed in the way you would like to draw it, and later combine the two photos to create your composition. Be sure to shoot the background at the same time of day, so you won't have problems with varied lighting.

Six Techniques

One: Use a Blow Up

Make the subject fill the entire page, as in fig.6–1. This technique can produce a dramatic effect by bringing things into focus "up front and personal."

Two: Consider the Concept of Thirds

The most boring place for the subject is the center of the page. It is usually more pleasing to place the focal point in one of the outside thirds. (See fig.6–3.)

Three: Take a Bird's-Eye View

Sometimes it is more interesting to look down at a subject rather than draw it from eye level. This point of view can provide the viewer with a unique perspective that causes them to pause and think about the subject in a new way.

6–3

This student creates an intriguing image by blowing up his subject, placing it off center, and leaving much of it out of the picture frame. Fully half of the image is negative space, which interacts with and draws attention to the curved outline of the subject.

Student work: Nicolas Coldren (age 14), *The Man's New Toy,* 1998. Colored pencil, 12" x 9" (30 x 23 cm).

6–4

This bird's-eye view of a basketball game presents the viewer with a unique and dramatic point of view.

Student work: Christy Dunkle (age 16), *The Meek May Inherit the Earth, but They Won't Get the Ball,* 1991.
Colored pencil, 18" x 24" (46 x 61 cm).

6–5
This artist takes advantage of the distortion that can come from a worm's-eye view. The focal point (the doctor's eye), drawn smaller than the hand and framed by the magnifying glass, appears "pushed back" into the distance.
Student work: Kathryn Vierra, (age 48), *Dr. Death,* 1995.
Colored pencil, 10" x 8" (25 x 20 cm).

Four: Take a Worm's-Eye View

Looking up at a subject can provide a distorted and somewhat provocative point of view. The artist used this perspective to create the drawing in fig.6–5. It can dramatically alter the impact of an artwork.

Five: Use Converging Lines

To lure viewers into the picture and invite them to discover the focal point, converging lines are often used. These directional lines don't have to be linear in nature. They can be composed of an uneven row of bushes or a group of men on a railroad track. (See fig.6–6.)

Six: Push the Subject Back

Compositions with a distant subject can visually draw the viewer in for a closer look. One way to achieve this is to frame the subject in such a way that the viewer is invited to look through a window. (See fig.6–5.) Another way of pushing the subject back is to blur the foreground and add detail to the background. Because a camera with a zoom lens will do this beautifully, photographers often use this principle.

6–6
The converging lines of the railroad tracks lead the viewer to the focal point of the drawing.
Student work: Ken Cook (age 42), *My Only Drawing,* 1993.
Colored pencil, 20" x 16" (51 x 41 cm).

Working Out a Composition

As you arrange your composition, consider doing some thumbnail sketches. This is a great way of thinking with a pencil. Draw a few small boxes in your sketchbook. With a graphite pencil, rough out a variety of layouts inside each box. Use several different techniques of composition, and determine which is the most appealing. Once you settle on a good composition, draw it on a larger sheet of paper. If you are still not satisfied, lay tracing paper over the sketch, and try out possible additions. By moving the tracing paper around, you can consider placing objects in different areas without having to change your sketch.

Students frequently settle for their first or second idea. Force yourself to create a minimum of ten to twenty sketches before you decide on a layout. Barbara Edidin (whose work appears on pages 41, 85 and 110), does her thumbnail sketches with a camera by shooting as many as seventy photos before she is satisfied with her composition. Pushing the brain and forcing it to think may be somewhat challenging, but in the long run your work will turn out better if you do so. Very few people create something brilliant on the first try.

6–7
By allowing his subject to expand beyond the picture frame, this artist creates an image that seems to pop off the page.

Student work: Martin Villalobos, Jr. (age 20), *Road Rage*, 1998. Colored pencil on illustration board, 10" x 14" (25 x 36 cm).

Atmospheric Perspective: Creating Depth

Creating an illusion of depth on a flat surface can be a challenge. Six techniques of atmospheric perspective can help solve this difficulty and infuse drawings with lifelike dimension. You can modify photos or live objects by using these principles. You'll be amazed at how much you can improve on what you see!

The process of altering reality is called artistic license—a license to change, twist, defy, and transform objects until they suit your creative purposes. As with any license, the privilege to use it must be earned. Although some of the best art is created by breaking the rules, you should use and master these techniques first, until you understand them so thoroughly they become second nature to you. Practicing the techniques will help you develop an intuitive sense of when and how to defy convention.

Six Techniques

One: Focused or Fuzzy

Make the objects that are close to you appear sharper and more detailed. Blur the objects that are farther away. This concept is true to the way that the eyes actually work. You can't focus on objects in the distance while concentrating on objects that are close. Spend some time looking through a camera with a zoom lens and observe what happens to the foreground and background as you focus on different objects. (See fig.6–8.)

Two: Larger or Smaller

Objects that are close always appear larger than those in the distance. You can exaggerate the size of the object to make it seem even closer. (See fig.6–9.)

6–8
The artist focuses our attention on the salt shakers in the foreground by rendering every precise detail. The reflections are blurry, causing them to recede.

Deborah Currier, *Salt Shakers,* 1989. Colored pencil, 40" x 28" (102 x 71 cm).

6–9
The largest tree appears to be the closest, while smaller trees appear to be distant. A limited color palette adds interest and contrast to the composition.

Allan Servoss, *Three in the Afternoon,* 1997. Colored pencil and graphite, 12" x 8" (30 x 20 cm).

6–10

To create depth in this drawing, the artist has used more than one of the techniques discussed. Can you identify them?

Bruce S. Garrabrandt, *Why Owls Are Nocturnal,* 1995.
Colored pencil on Bristol vellum, 10" x 15" (25 x 38 cm).

Three: Higher or Lower

Objects that are lower on the page appear to be closer than those that are higher. In fig.6–10, the owls, which appear the farthest away, are drawn at the very top of the page. The coffee pot, which appears to be the closest object, is drawn so low on the page, its bottom is cropped off.

Four: Bright or Dull

As objects recede into the distance, their colors become muted. Bright colors come forward, and dull colors recede. To dull a color and push it back into the dis-

6–11

Warm, bright colors have a tendency to come forward, whereas cool, dark colors recede.

Darryl J. Alello, *Palm Saga,* 1995.
Colored pencil on medium texture paper, 11" x 15" (28 x 38 cm).

6–12

The converging lines of this car, leading to the far right corner of the drawing, give the viewer a sense of both depth and motion.

Student work: Brian Bonner (age 15), *On a Sunday Afternoon,* 1996. Colored pencil, 15" x 20" (38 x 51 cm).

tance, you can simply add some of its complement, as discussed in chapter three. (See fig.6–11.)

Five: Converging Lines

Converging lines, mentioned before, are essentially lines that create perspective and depth in a drawing. Sometimes these lines will be part of an object, such as the sides of a building that diminish in space, or railroad tracks that merge as they move back into the picture. However, converging lines can be composed of objects, such as a row of pumpkins in a field.

Six: Overlapping Objects

Objects that overlap others appear to be closer than those that are being overlapped. In fig.6–13, for instance, the body of the moth in the upper left-hand corner overlaps the monkeys to help distinguish which is closer. The monkey on the left then overlaps the white column and yellow leaf behind it.

6–13
Overlapping objects throughout this work help designate which objects are closer and which are further away.

Karen Warner, *Bon Appetit,* 1998. Colored pencil on Bristol board, 16" x 10" (41 x 25 cm).

BEGINNER EXERCISES

1. Look through magazines to find examples of each of the six techniques of composition and the six techniques of atmospheric perspective. Many drawings may use more than one of these techniques. (See fig.6–14.) Put a sticky note on each page indicating the technique(s) you found. Ask your teacher to check your work and make sure you are identifying the correct techniques.

2. Choose one of your drawings or photo references that has a boring composition. Work out at least ten to twenty thumbnail sketches until you have settled on a better solution. Draw (or redraw) the subject, using the improved composition.

6–14
Many drawings use multiple techniques of perspective to create a sense of depth. In this drawing, the artist used five of the six: **1.** the foreground is detailed and the background is fuzzy; **2.** the girls in the front are larger than those in the back; **3.** the dancers in the front are placed lower on the page; **4.** bright colors dominate the foreground and dull colors, the background; and **5.** the dancers in the foreground overlap the girls who are farther away.

Thomas Thayer, *Kneeling at the Mirror,* 1993. Colored pencil, 26" x 21" (66 x 53 cm).

1. Draw a subject, showing only what you need to know. See how much you can leave out and still communicate the message. It can be intriguing to the viewer if you leave out all but the most necessary information, leaving the rest to the imagination.

6–15

By focusing attention on the red shoes without drawing the person wearing them, the artist invites the viewer to use his or her imagination to complete the picture.

Student work: Elaine Rimmer (age 60), *My New Shoes,* 1995.
Colored pencil, 6" x 11" (15 x 28 cm).

2. Create a composition from a bird's-eye view or from an insect's point of view. Don't forget, objects seem distorted when viewed from above, and to a bug, everything seems huge!

6–16

This unusual bird's-eye view shows the subject actually taking flight. By extending the skateboard and part of its rider beyond the confines of the picture frame, the artist emphasizes the feeling of height and motion.

Student work: Shane Nakamura (age 14), *Snowboarder,* 1997. Colored pencil, 17" x 22" (43 x 56 cm).

1. Draw the same object three times. Use a completely different point of view each time, to create three unique compositions. Also consider modifying the atmospheric perspective to heighten these differences.

2. Complete a drawing that incorporates at least three techniques of composition and three techniques of atmospheric perspective. It is much easier to shoot a good reference that uses these principles than it is to modify the composition later. If you have a camera, go out and shoot some photos from an unusual point of view. If you don't have a camera, here are a few ideas for creating an unusual point of view:

• Set up a still life on the floor or on the top of a cupboard, and draw it.

• Look at the subject through a window, and draw it.

• Peer through a keyhole, and draw what you see.

• Look in a mirror, and draw everything you see, including the mirror frame and whatever is behind it.

• Draw an object as it is reflected on a shiny toaster, a chrome detail on your car, a rearview mirror, a mud puddle, a television or computer screen, or another reflective surface.

6–17
In this imaginative piece, a monster mouth frames a hallway full of converging lines that lead to a blank wall.

Student work: Jesse Boyer (age 14), *Hallway Seen from Mouth*, 1998. Colored pencil, 24" x 18" (61 x 46 cm).

The Creative Process

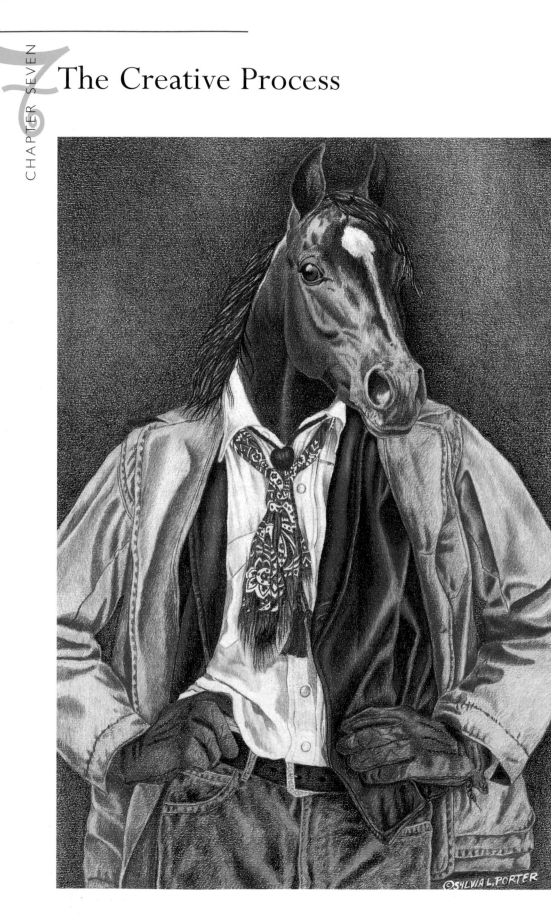

7–1
Surrealist artists are adept at creating a break from reality by using common objects in uncommon situations. A clever title adds to the humor of this piece.

Sylvia L. Porter, *"Calvin Equine"*
Clotheshorse, 1992.
Colored pencil on colored paper, 24" x 18" (61 x 46 cm).

Creativity is an enigma. It is not easy to teach someone how to be creative. In math, a teacher can state that one plus one equals two with the assurance that there is only one solution to that problem. In art, there are millions of correct ways to draw a still life.

Certainly the methods covered in this book do not constitute the only way to develop creative skills. There is no formula for creativity. The beliefs and ideas presented here are based on a classical approach to art—the tradition of building basic skills as a foundation for creative expression.

Most students fall within one of the following three categories. First, there are gifted students who simply need a brief demonstration of materials and techniques. They are born with innate talent, have taken time to develop it, and, after receiving a few instructions, they take the ball and run with it. They are bored by repetitive directions and restrictive guidelines. They absolutely loathe copying and have the skills to express original thought.

Second, there are students who have latent ability but have not had the luxury of pursuing their creative urges. Although they are gifted, they are completely lacking in training so they need to be taught the basics. They absorb these principles quickly, and once they have acquired fundamental skills such as drawing and knowledge of color theory, composition, perspective, and technique, they are off and running.

The remaining students need a lot of guidance. They either have had no background in art or their experience was so frustrating and their work so undeveloped that it never even was displayed on the kitchen refrigerator. They are not sure what kind of paper to use, how hard to press, what it takes to dull a color, and so forth. Although they are intrigued by the creative process, they can't yet tap the imagination. They are not even sure that they can be creative. They need specific directions, a description of the creative process, and an overview of basic rules. This chapter was written mainly for them.

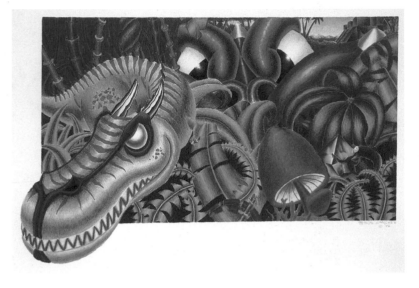

7–2

This student combined references with ideas from imagination, allowing the subject to escape the border to add drama to the piece.

Student work: Jesus Sanchez (age 19), *The Chase*, 1996.
Colored pencil on vellum Bristol board, 8" x 16" (20 x 41 cm).

For the Beginner

Master the Basics

If you don't have basic skills, you will always struggle with creativity. You may have great ideas, but you won't have the ability to pull them off. Acquiring foundational skills is basic to all disciplines. If you wanted to become a writer, you would first take a course that teaches you the fundamentals, such as grammar, punctuation, syntax, and spelling. Once you master the basics, you can become a creative writer. Without these skills, you could not communicate your creative ideas to your reader.

If you have not completed a drawing course, take one. If you can't take a course, buy a book and some videos, and teach yourself how to draw. You will never succeed in any artistic medium until you know how to draw. Begin with black-and-white drawing, and study proportion, line, shading, and texture. Then tackle color theory. If you don't know how to mix color, you will always be frustrated.

If you are just getting started in art, follow the step-by-step demonstrations in each chapter in this book. Whereas intermediate and seasoned artists may not need such detailed instructions, beginners will find these specific guidelines helpful because they break a complex process into easy-to-understand steps.

Don't be discouraged if your initial skills are not very strong. Orville Thompson's first drawing (see fig.7–3) proves that he did not immediately show signs of talent. To build a solid foundation in drawing, he practiced the lessons in a drawing program by the author. (For a listing of Sandra Angelo's books and companion videos, see the Appendix.) In just eight weeks he was creating photographic-quality renderings. Once a person has acquired basic skills, creative work is no problem. (For another examples of later work by Thompson, see fig.7–7 in this chapter and fig.11–13, page 128.)

7–3
Orville's first drawing was pretty weak. Just eight weeks later, after completing a video drawing course, his drawing had dramatically improved.
Student work: Orville Thompson (age 58), *Self-Portrait*, 1989. Colored pencil, 8" x 10" (20 x 25 cm).

Find a Good Teacher

If you are a beginning student, find a teacher who is nurturing and supportive. (If you are a high school student, start by taking the art courses offered at your school.) Once you find an instructor you like, stay with that teacher until you have mastered the basics. Because every art educator teaches differently, a beginner may become very confused by switching from teacher to teacher.

Try a Variety of Styles and Media

Once you have mastered the basics, it's a good idea to try a wide variety of classes in various media with a sampling of instructors. Research the instructor's artistic approach before you sign up for a class. An artist who specializes in realistic renderings will teach that style. You will learn different techniques and approaches from a teacher with an impressionistic bent. Explore everything. As you take workshops and classes, notice

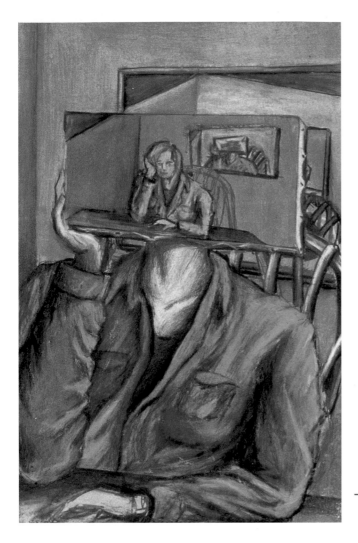

7–4

A supportive high school art teacher can provide strong encouragement and guidance for developing creative ideas and technical skills.

Student work: Ulises Kullick-Escobar (age 15), *Thinking About You,* 1995. Colored pencil, 17" x 14" (43 x 36 cm).

After this stage, you will be ready to create your own collection of technically masterful, compelling visual art.

Emulate the Masters

Throughout history, professionals in every discipline have learned by emulating the masters. Much can be gained by studying an expert's style and imitating what you see.

If you visit the Norton Simon Art Museum in Pasadena, California, you will see a Nicolas Poussin painting in the wing devoted to works by Edgar Degas. You may wonder what a Poussin is doing in that wing.

your personal reaction to the new media and techniques. Some methods will make you purr, and some will set your teeth on edge. But it's valuable to try styles and media that initially don't appeal to you. You will be surprised to see how many techniques can be folded into your own style. You will be influenced by everything you study.

Throughout the intermediate stages of exploration, you will begin to discover your own favorite style, subjects, and media. Pursue them, even if they surprise you, until you are certain that they provide the best avenue for your own unique artistic expression. Then find an accomplished teacher who specializes in your favorite media and style. Study with this person until you have mastered everything he or she has to offer.

SANDRA SAYS

I attended the Rhode Island School of Design, one of the nation's leading art schools. It has a wonderful art collection in its private museum. Teachers there encourage students to study different works, and to mimic the colors, composition, textures, and techniques used by artists who have been singled out as extraordinary leaders.

In my color theory class, my college professor asked us to reproduce a painting by a master in order to understand color mixing. I chose one by Edward Hopper because his work looked easy. I have never worked so hard in my life! This man understood color and light, and to duplicate his work required extensive mixing. Although the process sometimes seemed tedious and exacting, when I was finished, I had a new appreciation of color.

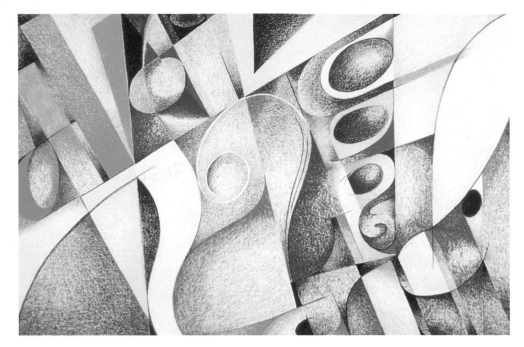

7–5
Although most colored pencil artists tend to work with realistic portrayals of a given subject matter, abstract artists can also use the medium to their advantage.

David Schoch, *All 72!,* 1991.
Colored pencil on 70 lb. drawing paper, 11¼" x 17⅜" (28.5 x 44 cm).

Well, Degas painted it—in order to learn from Poussin. Traditionally, masters have copied other masters to learn about technique, color, style, and more. Although there is nothing creative about replicating a master's work, valuable skills can be gained from it. For a beginner, emulating style often helps provide an insight into the ways of the master. For example, copying fur drawn by a master will help you learn how to draw animals.

Some art teachers frown upon copying the work of other artists and feel that creativity is better developed by drawing from life. Ultimately, there is no right or wrong way to learn to draw. Start by trying whatever method your teacher suggests. Later you can always experiment on your own. Remember, emulation is only a beginning. Once you've learned the basics, it is much more satisfying to move on to personal creative self-expression. There's probably nothing more fulfilling than creating your own original visual statement, something very personal that comes from your soul.

Guidelines for Creating Original Art

Expose Yourself to Creative Art

When you are inspired to create an original piece of art, you often have something you want to communicate visually. Like a writer who does research for a book or a magazine article, you can improve the quality of your drawing by investigating your options and drawing inspiration from the masters who have gone before you.

To begin your research, surf the Net, go to the public or school library, or create a library at home. Look at a collection of books that contain work done by your favorite artists in styles that inspire you. Build a reference library if you can, so that you can peruse your own books when you are trying to be creative. If you can't afford books, consider buying posters, prints, or postcards of your favorite artworks, and hang them in your studio for inspiration.

A wonderful way to view a wide collection of contemporary art is to look at the *Society of Illustrators Annual.* (See Resources in the Appendix.) It offers up the year's most creative visual solutions to a variety of illustrative

problems, many of which you may encounter in your own work. Browsing through the pages of this annual is like wandering through hundreds of galleries in one sitting. Looking at a multitude of styles and compositions may spark ideas that will take you in new directions. Although your own work won't be an exact copy of an illustration that stimulates you, it can plant a seed of creativity and get your artistic juices flowing.

You can usually find copies of these annuals at your local library; if not, ask the librarian to order one. If you can afford them, add a few to your own library. Past issues are often available at a discounted price. Ordering information can be found generally in the back of the annual or at your local bookstore in *Books in Print.*

Stimulate your mind by collecting as many books, art magazines, postcards, posters, and annuals as you can afford. Many bookstores, discount stores, and used bookstores have regular sales on such books, especially annuals that have expired. Over time, you can build up a nice collection. Whenever you need creative inspiration, take your books off the shelf and wander through them, jot down notes, and create sketches.

Practice Creative Synergy

A synergistic effect occurs when creative minds work together to enhance their artistic energy. When two creative people work together, in a sense they produce a third, more inventive mind that is capable of greater accomplishments than two people working separately. Just being in the company of a group of artistic people can be mentally stimulating. Taking classes, looking at other artists' work, and visiting museums, galleries, and art shows can be very energizing.

You can even find good ideas while shopping. Whenever you look at creative work, your mind will be stimulated. Peruse gift shops, card stores, and print galleries. Even flea markets, vegetable stands, holiday parades, beaches, parks, gardens, garage sales, and junk yards can spark creative ideas. Carry a camera everywhere you go. You can never tell where you will spot a good idea for a drawing.

7–6

Because this juried book contains the year's finest solutions to creative illustration problems, the annual is a great source of inspiration and ideas.

Cover drawing by **Bill Nelson,** *Rocking Roy,* 1992.
Colored pencil on charcoal paper, 20" x 15" (50 x 38 cm).

SANDRA SAYS

I was recently developing a series of drawings about relationships. One day while driving fifty-five miles per hour down the freeway, I spotted a motorcycle next to me, carrying a yuppie dad and his toddler, who were both dressed in black leather jackets and spanking new helmets. They were traveling down the highway without a care in the world. My friend grabbed my camera and took the reference for my next drawing. Who would have thought I'd find inspiration on the freeway!

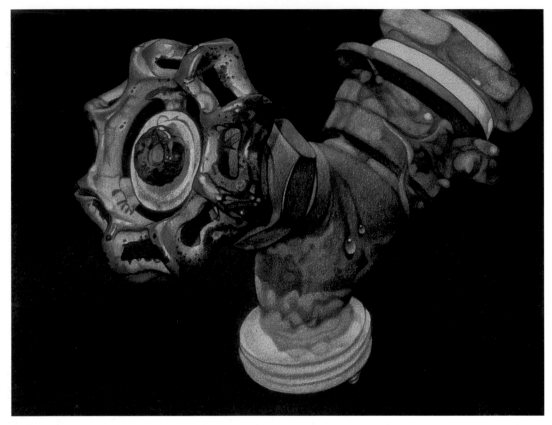

7–7
The creative vision of an artist can transform the most ordinary object into a work of art.

Chris LaMarche, *The Last Drop,* 1997. Colored pencil on 100 lb. Bristol board, 10" x 11" (25 x 28 cm).

SANDRA SAYS

References are essential for most artists. Recently I was demonstrating how to draw an apple. The night before my demo, I spent several hours practicing drawing the apple and used over twenty-three colored pencils to re-create what I saw. I stored the apple in the refrigerator overnight, intending to take it to class for the demonstration. The next day when I reached for it, it had been eaten. I thought, "Oh well, how hard can it be to draw an apple from my head? I just drew one last night." Well, you would be amazed at how weak that demo was compared to the drawing I had left at home. Luckily I was demonstrating to beginners, and they thought my apple looked fine. But when I got home and compared the two drawings, I was astonished to see how much I had forgotten about that apple.

Build a Reference File

Build a photo reference file that contains pictures you have taken, as well as clips from magazines and books that have inspired you. Then, whenever you have time to be creative, you can use your reference files as a source of inspiration instead of spending hours looking for something to draw.

When you use a snapshot as a reference for your drawing, remember that you don't have to be a slave to the photo. You can change the composition, move things around, and correct optical errors captured by the camera. For example, when you use flash photography, a harsh black outline often forms around the subject. This shadow, which was caused by the flash, is not natural. Eliminate it. If you shoot a face in bright sunlight, it may be counterproductive to reproduce the stern shadows that you see in the photo. You may want to soften the dark areas on the face to create a more natural look or even eliminate the shadows altogether. Sometimes you might put these sharp shadows in a drawing if they create interesting patterns. The wonderful thing about being an artist is that you are not bound by what you see. You can choose to use it or alter it, depending on your intentions.

Don't hesitate to use photos, videos, live models, or anything you need to create your own original art. Only about five percent of naturally gifted artists can draw strictly from their imagination. Most of these artists are cartoonists, and even cartoonists and animators use live models and photographs from time to time.

Still, you must always infuse your work with your personal artistic style. Exact copying is simply not creative, and copying from copyrighted photographs is even illegal. Use photo, video, and television references to obtain facts and data, but be original in your interpretation.

7–8
This photograph of the artist's daughter cast very harsh shadows on her face. Photo by Orville Thompson, 1997.

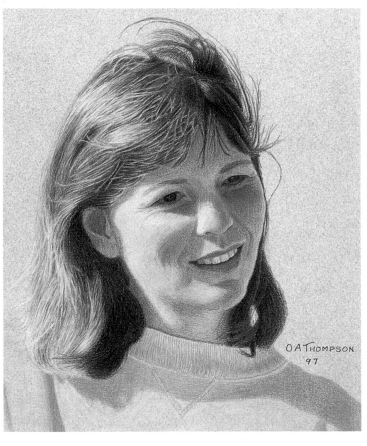

7–9
The artist used the photograph as a reference, but softened the harsh shadows for a more pleasing effect.

Orville Thompson, *Suzanne,* 1997.
Colored pencil, 9" x 12" (23 x 30 cm).

7–10
This was Sandra's original reference photo for *Find an Old Lap, You'll Get a Longer Nap*. Photo by Sandra Angelo, 1995.

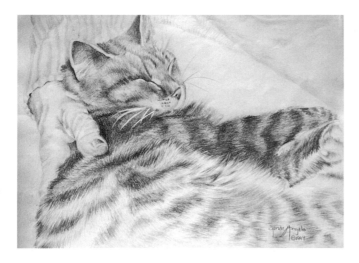

7–11
To begin her drawing, Sandra worked out values and composition with a graphite study. This was later photocopied onto the paper used for her final drawing.

The Creative Process

Many creative inspirations don't arrive as complete ideas. Instead, various stimuli in the environment register in the brain, and over time, they combine to form an inspired idea. To help you understand how a drawing evolves from idea to fruition, let's look at the creative process involved in a recent drawing made by the author. The sequence of events may seem quite simple, yet it represents an evolution of ideas.

The idea began with the author's visit to a cousin's house on Christmas day. She noticed that the family cat, to escape the bedlam created by a hoard of festive children and cousins, slept on the grandmother's lap all afternoon. Sandra shot a photo of this scene and created a graphite drawing.

She later got a call from her agent, telling her of a company that wanted a cat calendar. She decided to use this drawing as the basis for a colored-pencil rendering for the calendar. Visiting retail stores to look at current calendar drawings, Sandra discovered a kiosk in the local department store featuring work by Mary Engelbreit. (See fig.1–12 in chapter one.) "I was fascinated by the way she incorporated borders and words into her drawings. I liked that idea," Sandra comments. "Yet my natural style is soft and delicate, not graphic like hers. I had to think about how to blend this concept with my style. I let the idea simmer in my brain for a while."

The next week Sandra wrote an article about artist Barbara Edidin. (See fig.7–12.) "I fell in love with the fabric and lace that she used in her drawing. I thought, 'This is it! I'll use fabric and lace behind the cat.' But after a trip to the fabric store, I became exhausted at the thought of drawing as much extensive detail as Barbara Edidin does. But I tucked away the idea of using fabric and lace."

Later, at a bed-and-breakfast hotel, in a bedroom with handmade quilts and ruffled pillows, a light went on in Sandra's head. Responding to her passion for quilts, she decided to use quilts and ruffles as a source for the border of her drawing. She took a trip to a bedding shop and studied quilts, hand stitching, Battenburg lace, and quilt patterns.

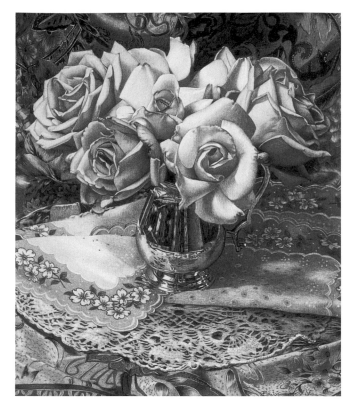

To choose a border for her lettering, she referred to favorite Art Deco and Art Nouveau books, adapting several different borders to create one that was suitable. "Because I'm no good at lettering," Sandra created the caption for her drawing on a computer and ran her drawing paper through a laser printer. She drew the border around the letters with pen and ink. "I colored the quilt, the ruffle, and the cat in a way that expresses tranquility. Whenever I look at that drawing, I remember the wisdom of choosing serenity in the midst of bedlam, and I feel restful." The drawing was a big hit among cat lovers.

7–12
Barbara Edidin's intricate drawings inspired Sandra to use fabric and lace in her work.
Barbara Edidin, *April Fool,* 1995.
Colored pencil, 14" x 12" (36 x 30 cm).

7–13
Quilted items and lace pillows served as a source for Sandra's drawing.

7–14
Although the artist drew inspiration from a number of sources, the completed work is a result of her own unique ideas and preferences.
Sandra Angelo, *Find an Old Lap, You'll Get a Longer Nap,* 1995.
Colored pencil, 8.5" x 11" (22 x 28 cm).

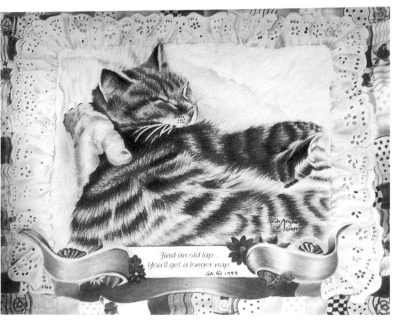

Here are some creative exercises and a solution to each one. If you don't have basic skills yet, you may have great ideas, but find it difficult to draw them. Don't be discouraged! If these are too hard for you, just write down your ideas and come back to these exercises after you've built a solid foundation of basic skills.

1. What would happen if an alligator had satin skin and an evening gown had scales? What if a cat's fur was plaid or a dog looked metallic? Tease your brain with outrageous possibilities and create an object with the wrong texture, such as the furry ice cream cone in fig.7–15.

7–15
The furry ice cream on this cone is a departure from standard reality.

Student work: Joella Reinbold (age 57), *Good Humor*, 1996.
Colored pencil, 11" x 8½" (28 x 22 cm).

J. Iavelli '96

ADAM'S APPLE

2. Fig.7–16 shows a creative response to the word *apple*. Draw your own creative apple, or wacky versions of the following words: bells, dragon, spaceship, shark.

7–16
Using the word "apple" in a play on words, this exchange between Adam and God was inspired by Michelangelo's painting in the Sistine Chapel.

Student work: Julie Iavelli (age 60), *Adam's Apple*, 1996.
Colored pencil, 4" x 6" (10 x 15 cm).

1. How would Vincent van Gogh paint an office full of computers? What would Prince Charles look like to Andy Warhol? How would Salvador Dali paint an NFL game? Study the styles of three master artists whom you admire. Create three different drawings of a very simple object, rendering each in the style of one of these masters.

7–17

The first cow in this series is done in the style of René Magritte. Works by Pablo Picasso inspired the second cow. The third cow was done in the style of Piet Mondrian, using an analogous warm color scheme.

Student work: Tracy Watt (age 31), *Cows,* 1996.
Colored pencil, 4" x 5" (10 x 13 cm).

2. M. C. Escher was a master of the integration of positive and negative space. Many of his drawings feature complex interlocking shapes (called tessellations), in which an object gradually transforms into something else. In *Metamorphosis III,* he took this to an extreme by creating a series of evolving images that spanned twelve feet!

Create a drawing that incorporates interlocking shapes, a transformation of one object into another, or both. Transformations can occur in objects with similar shapes that evolve into a new form, or be based on something more abstract, such as a chain of words or ideas. Work to integrate positive and negative spaces in your design.

7–18

The blue colored ground and white horizontal lines unify this design as the fish undergo transformations in color: from white to red, right to left; and from white to blue, left to right.

Student work: June Chen (age 68), *Transformation,* 1997.
Colored pencil on blue colored paper,
8½" x 11" (22 x 28 cm).

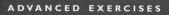

1. Using colored pencils on a 2-ply cotton Bristol board, create a half mask that can be worn on your face. Consider using the mask to divulge a secret side of yourself.

2. Using the work of Matisse for inspiration, create a drawing in which three-dimensional objects are reduced to flat shapes. To do this, focus on the basic outlines and shapes of objects and drop out detailed or realistic val-

ues. Colors within shapes can be limited to variations of one color. In fig.7–20, the artist frames flat, stylized shapes within a semi-realistic border, with leaves and rocks linking both sections of the drawing.

7–19

Student work: Deborah Settergren (age 43), *Carmen,* 1996.
Colored pencil, 9" x 8"
(23 x 20 cm).

7–20
This exquisitely detailed work combines the stylized, flat look of Matisse's work, framed by a more realistic style. Look at the part opener on page 65 for a detail of this artwork.

Dyanne Locati, *Musing Matisse II,* 1995.
Colored pencil, 30" x 22" (76 x 56 cm).

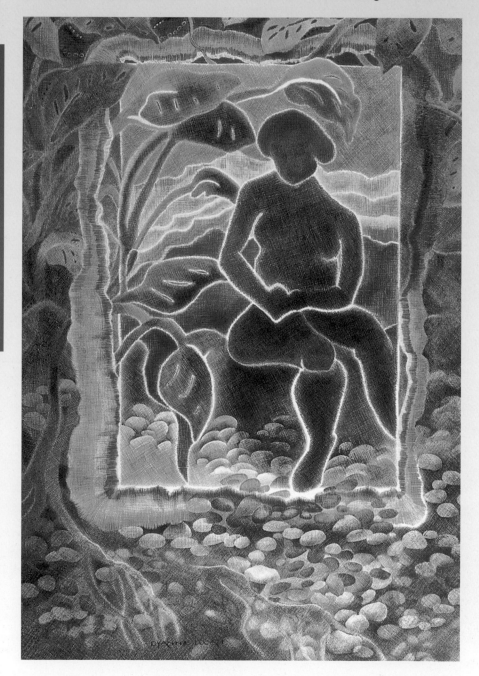

Subject Matter

Drawing Animals

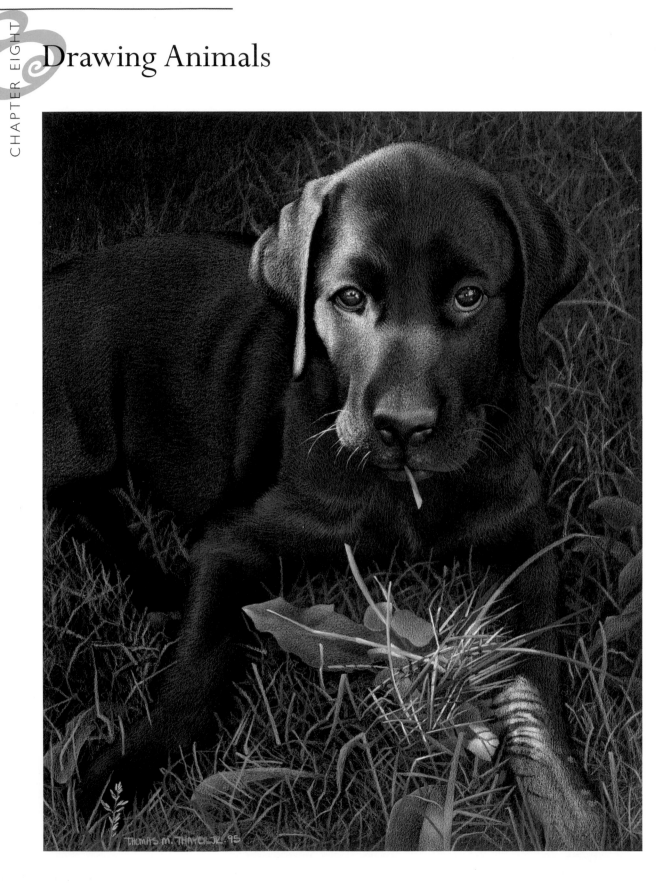

Sagging elephant skin, prickly porcupine quills, fluffy cat fur—how do you achieve such a variety of textures with just a humble pencil? First, you must study the animal, whether by joining an African safari, taking a quick jaunt to the local zoo, or tuning in to a National Geographic or Discovery Channel television special. Try to observe the animal up close, becoming familiar with its particular behaviors. If that's not possible, study photo references in magazines or books at the library, or view animals on videos or TV shows. However you gather your data, some simple rules apply.

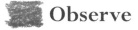 ## Observe

Movements, Behavior, and Anatomy

Notice how animals walk, fly, or run. Do they lumber, prance, or glide? How do they look when they are lounging, active, or frightened? Spend some time watching the animal before you begin to draw.

It is useful to study various postures by making thirty- to sixty-second gesture line drawings from life or even from videos or television. Sketching its movements will enable you to capture the essential character of the animal. For example, an elephant lumbers, a flamingo dances, a monkey scampers. You'll be amazed to see how your work improves once you've studied the animal in motion.

It is also useful to study anatomical renderings of the animal's skeletal structure, to discover where bones and muscles connect. This will help you avoid errors in

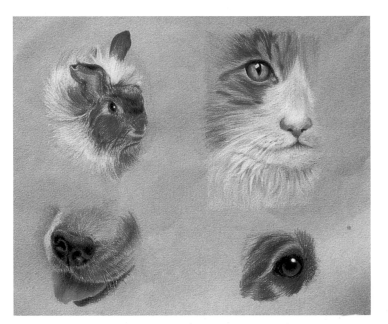

8–1 (Opposite)
The texture in this masterful drawing is so realistic, you can imagine how it would feel to stroke the dog's fur. Artist Thomas Thayer likes to create dramatic effects by using light colors on a dark surface, in this case black paper.

Thomas Thayer, *Grass? What Grass?*, 1995.
Colored pencil, 20" x 16" (51 x 41 cm).

8–2 (Above)
Each species of animal has unique features. Notice that the cat's pupils are almond-shaped instead of round, like the dog's.

Julie Wolfson and **Sandra Angelo,** *Animal Studies.*

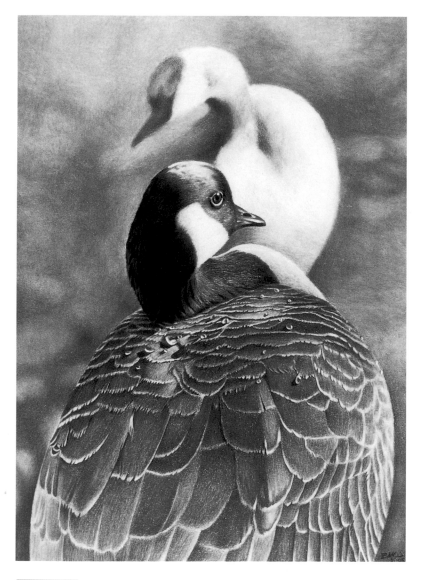

8–3
A blurred second goose in the background provides contrast to the sharply focused detail of the feathers in the foreground.
Bruce Martin Westberg, *The Canadian*, 1995.
Colored pencil on cold press illustration board, 19" x 15" (48 x 38 cm).

drawing its physical characteristics. In a recent class at the San Diego Wild Animal Park, a student was wondering why her elephant drawing looked so odd. Without carefully studying the photo references or the drawings she gathered in class, she had assumed that the animal's leg bent in the middle, just like a human leg. So that's how she drew it. When she later examined an elephant skeleton, she discovered that the leg bends at the ankle and at the shoulder. By correcting this anatomical error, she saved her drawing.

If you are lucky enough to view the animal in its natural habitat, take a camera and shoot close-ups of the animal's eyes, nose, ears, mouth, feet, whiskers, and so on. Use these references to practice drawing these parts. You can also take such pictures at a wild animal park, a farm, or a zoo. Or simply focus on a family or neighborhood pet.

If you live in the country, visit the state fair to take photos of cows, pigs, horses, or chickens. Or drive along country roads, from farm to farm, and shoot photos through the fences. Another possibility is to attend rodeos and dog or cat shows. Take your dog for a walk, and shoot pictures of him playing, swimming, or romping. You can also use postcards and clippings from your reference file as a source of images.

As you practice rendering the eyes, noses, mouths, and ears of various animals, you will notice significant differences. For example, a horse's eye differs from a cat's eye. Cat pupils are almond-shaped instead of round, like those of a horse. Horses and cats do not have white in their eyes, as humans do. When you decide to draw an animal as a performance piece, practice sketching the various parts of that particular animal first, until you can capture the textures correctly. Use a colored paper that matches the skin tones or the fur. This will save you a lot of time.

Habitat

Research the animal's habitat. If possible, study it on location. Look at the vegetation in its natural environment. For a realistic drawing, be careful not to mix animals that would not mingle in nature. Nothing is more glaring than errors of fact in a drawing.

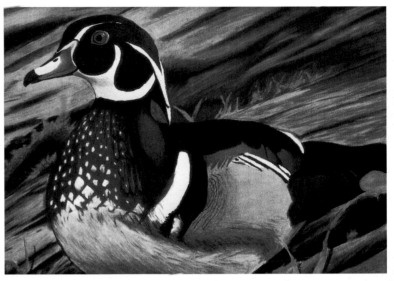

8–5
Although the subject fills most of the space, the background that can be seen is consistent with the natural habitat of the duck. This composition was entered in the Junior Federal Duck Stamp Contest sponsored by the federal Fish and Game Department each year.

Student work: Garrett Van Vleck (age 16), *Wood Duck*, 1997.
Colored pencil, 9" x 12" (23 x 30 cm).

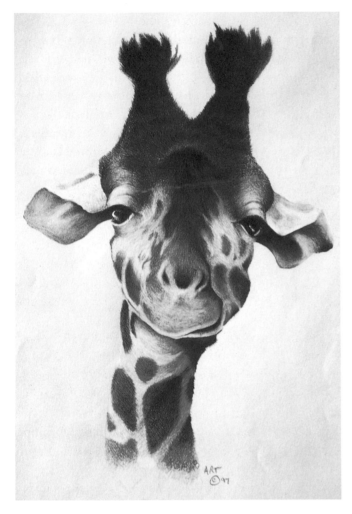

8–4
This intriguing drawing combines what are generally seen to be opposites: humorous caricature and realistic rendering.

Student work: Art Badillo (age 53), *At the ZOOOO*, 1998.
Colored pencil, 13" x 10" (33 x 25 cm).

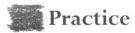 Practice

Creating Textures

One of the wonders of nature is the incredible variety that exists in the animal kingdom. There is a vast difference between the surface texture of a rhino and a koala, an elephant and a cheetah, a fluffy cat and a golden

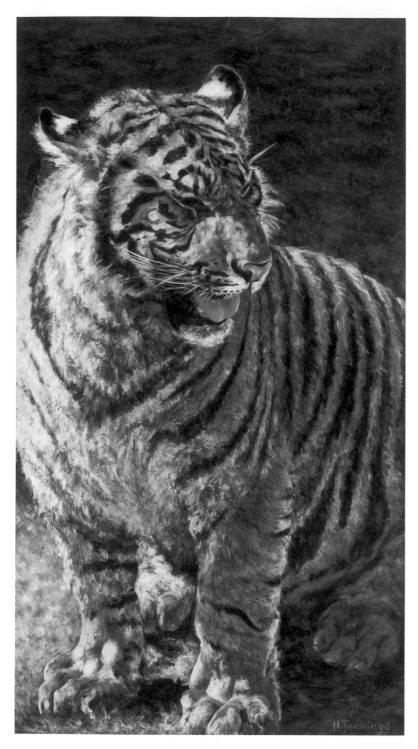

retriever. To learn how to draw animals, practice rendering a variety of textures: sagging and taut skin, feathers, and short, curly, long, patterned, and wiry fur.

To reduce your drawing time and to achieve a wider range of special effects, try combining colored pencil with other media. Sometimes you can capture the textures more efficiently with a mixed-media approach. The clouds in fig.8–7 took about two minutes to draw with an airbrush. Drawing clouds with colored pencils can take hours!

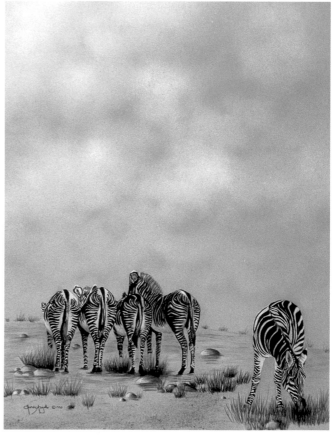

8–7
In this mixed-media drawing completed at the San Diego Wild Animal Park, the author drew the zebras, grass, and rocks with colored pencil, airbrushed the sky, and used watercolor pencils to paint the water and gravel.

Sandra Angelo, *Grazing,* 1990.
Colored pencil, airbrush, watercolor pencils, 30" x 24" (76 x 61 cm).

8–6
Instead of drawing a strictly realistic portrayal of a tiger, this artist uses thick layers of color, loose strokes, and a daring palette to give an impression of foliage and fur. To blur the muted landscape, she smudges it with an eraser.

Helen Jennings, *A Time to Speak,* 1993. Colored pencil, 21½" x 12" (55 x 30 cm).

Working with References

Because most animals move constantly, many artists work from references when they create performance pieces. But even though the photo has captured the lighting and the action, don't be a slave to it. If you want to change the background or remove harsh shadows, go ahead. You can raise or lower a fence or hills in the background. Play around with your composition ahead of time, doing thumbnail sketches to plan your layout. Perhaps you couldn't snap the perfect photo of your subject—animals don't always do what you want them to. If you don't have a completely satisfactory reference, consider combining several. Just be sure that the lighting source is the same in each, to promote color harmony throughout the drawing. (It's best not to try combining sources if you are a beginner.)

Depicting Shadows

Body Shadows
Shadows define the characteristics of an animal's anatomy—the protrusions of bones, muscles, and fat. Shadows tend to be very soft in nature (usually medium to light in value) and are generally graduated from dark in the "valley" to light on the "hill." If you pay close attention to these subtle body shadows, your drawing will depict the animal's form realistically, indicating the structure that lies underneath the surface.

Cast Shadows
Created by strong sunlight, cast shadows are usually darker than body shadows. They show the direction in which the light is cast and even suggest the contour of the animal's body or the surrounding landscape.

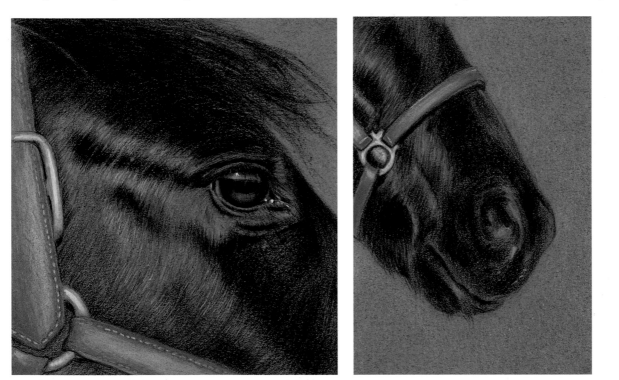

8–8

These detailed studies helped the artist practice rendering the horse's fur, eyes, nose, mouth, and even the leather on its harness.

Student work: Julie Wolfson (age 70), *Horse Study*, 1996.
Colored pencil, 8" x 5" (20 x 13 cm).

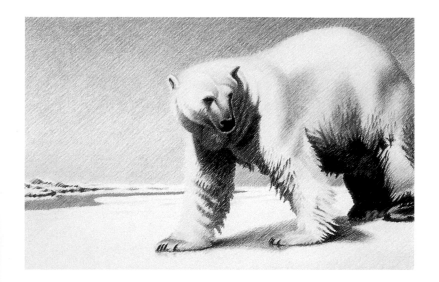

dark shadows. Very often there is a slight "ring of light" between the shadow on your subject and the cast shadow on the ground.

- Use artistic license. Modify a shadow if you need to. Sometimes shadows distort or block detail. Many times, the animal won't move to the full sun, so you are stuck with references taken in the shade. Make it work for you, not against you.

8–9
The cast shadow is stronger where it touches the animal and fades as it moves further away.
Brent Bowen, *Polar Bear on Ice,* 1992.
Colored pencil, 30" x 40" (76 x 102 cm).

Sometimes they enhance a drawing, and sometimes they detract from it. If you've shot a photograph in strong sunlight or with a flash, the shadows might be too harsh. Unless they serve a particular artistic purpose, soften them when you create your drawing.

Helpful Hints

Shadows can be compositional friends. They can help carve up the negative space in the background, creating an interesting interplay of positive and negative shapes. (See fig.8–10.) Here are some hints on drawing them successfully:

- Shadows tend to be darkest where they touch the animal and gradually fade as they move away, unless the sunlight is very strong. Even when it is strong, it's usually best to gradually fade the shadow as it moves away from the animal or other element. Harsh, solid shadows can draw too much attention away from the subject. Also watch for reflected light at the edge of the

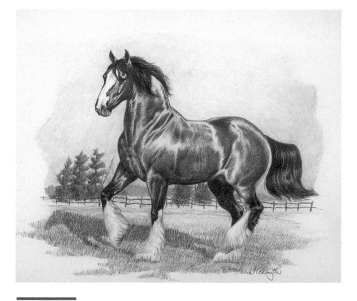

8–10
The horse's shadow helps break up the boring horizontal band of negative space in the grass and gives a diagonal thrust to the composition, which enhances the feeling of movement.
Donna Adamson, *Clyde,* 1990.
Colored pencil, 16" x 20" (41 x 51 cm).

1. Draw the cat in fig.8–11, top.

• One way to develop confidence before making an ink drawing is to do a full-blown rendering of your subject with a graphite pencil for practice before you create the final version. For this exercise, try using lines, rather than shading, to convey your subject in graphite pencil. When you are ready to draw in ink, you can mimic the textures and strokes you created with the graphite pencil.

• After completing the graphite drawing, make a line drawing in non-photo blue pencil. This one needn't be as detailed as the graphite rendering, since it is merely a "skeleton" for the ink drawing. Just draw the basic outlines, and use the graphite drawing for a reference. (Applying ink directly over the slick surface of graphite won't work because the ink won't adhere to it.)

• Cover the blue line drawing with an ink rendering. Use a permanent ink. If you like, you can erase the non-photo blue lines after the ink dries on each completed area.

• Lay a watercolor-pencil wash over the ink rendering, and finish off the details with dry wax-based colored pencils.

2. Draw the bulldog in fig.8–11, bottom.

• When planning the colors to use for an underpainting, it's a good idea to do a value sketch of the subject first in graphite pencil. Draw the bulldog in graphite, using shaded areas, not lines, to form shapes. Analyze the bulldog in terms of its dark, medium, and light tones.

• Refer to this black-and-white study to determine the value of the colors you will use for your watercolor-pencil underpainting. Before you start, test your colors so you can see how they will change when wet.

• Use a wet brush loaded with pigment (from the tip of your watercolor pencil) to lay down colored wash inside each shape. Choose the lightest color for each underpainted area since this underpainting will serve as the highlight. By using a collage of colored grounds, you will have cut your drawing time by fifty percent or more.

• After your colored underpainting is completely dry, use dry wax-based colored pencils to complete the rendering.

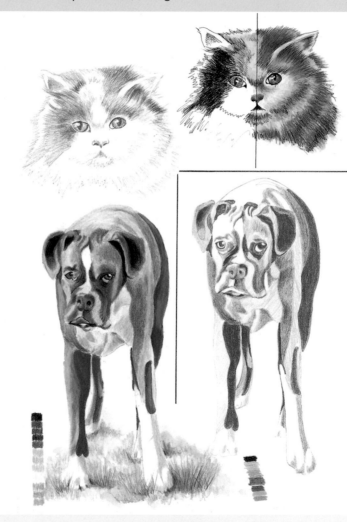

8–11
Illustration by Sandra Angelo

1. Use your own animal references to find examples of various surface textures, and make sketches to explore how to render them realistically. After you've practiced, create an original drawing of one or more animals, using the principles of composition discussed in chapter seven. Before you start the final drawing, experiment with various layouts by making quick thumbnail sketches.

2. Experiment with the impressed line technique for drawing fur.

• Choose a furry animal to draw. Match a colored paper to the highlight color in the animal's fur.

• On this paper, use a graphite pencil to create a contour line drawing of the animal.

• Place a sheet of tracing paper over your paper. Using a dull, pointed object such as a wooden meat skewer, a medium-nib ballpoint pen, or a similar instrument, impress lines in the paper to create the texture of the fur within the lines of the contour drawing. Be sure to make the lines match the fur pattern on the animal.

• Remove the tracing paper, and shade the animal using the sides of colored pencils instead of the points. Select colored pencils that are quite a bit darker than the impressed lines so that the contrasting colors will enhance the fur you created. Be careful not to deposit pigment in the grooves you just created.

• Finish the details on various body parts until the rendering looks complete.

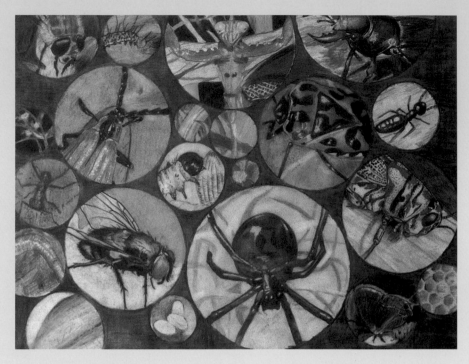

8–12

Bugs are animals, too! In this unique study, a selection of insects are featured in circles of varying sizes, which are then arranged in a balanced, colorful composition.

Student work: Lindsey Bain (age 15), *Bugs,* 1997. Colored pencil, 8" x 10¼" (20 x 26 cm).

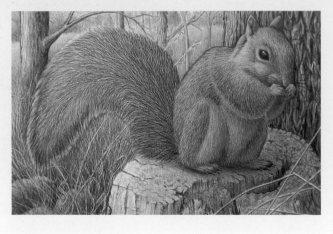

8–13

To create the detailed lines of the squirrel's fur, the artist used the impressed line technique. To obtain close-up photographs of squirrels, she put a bird feeder on the back side of a fence so the squirrels felt safe. Then she just snapped away while they ate.

Ruth McCarty, *Afternoon Break Fox Squirrel,* 1990. Colored pencil, 16" x 20" (41 x 51 cm).

1. Choose an animal that fascinates you, and study it in depth. Find out about its habitat, its personality, its behavior and ways of moving, and more. If you choose your pet or another very familiar creature, your work will probably take on a special quality. Having a close connection with the subject will bring a unique energy to your art.

2. Compose a drawing of an animal, using a realistic approach. Then draw the same animal again, this time employing impressionistic, loose strokes.

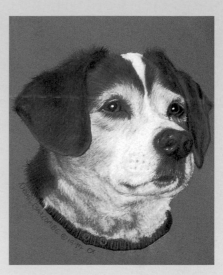

8–14
The medium-tone paper selected for this art-work not only saved a lot of drawing time, but also provided a strong contrast for the lights and darks in the dog's fur and eyes.

Student work: Noah Balcombe (age 16), *Jack,* 1998.
Colored pencil on colored paper, 6" x 5½" (15 x 14 cm).

8–15
Compare this drawing of a dog to the other one on this page. What are the differences in style and technique? Fig.8–14 is more of a formal portrait; this deceptively casual work focuses on the composition as a whole: contrasting shadows, the dog's relaxed posture, and the color and line in his environment.

Doreen Lindstedt, *Old Lab #2,* 1994.
Colored pencil on watercolor paper, 15" x 20" (38 x 51 cm).

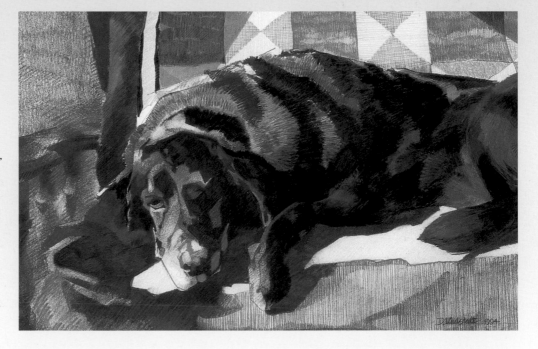

The Great Outdoors

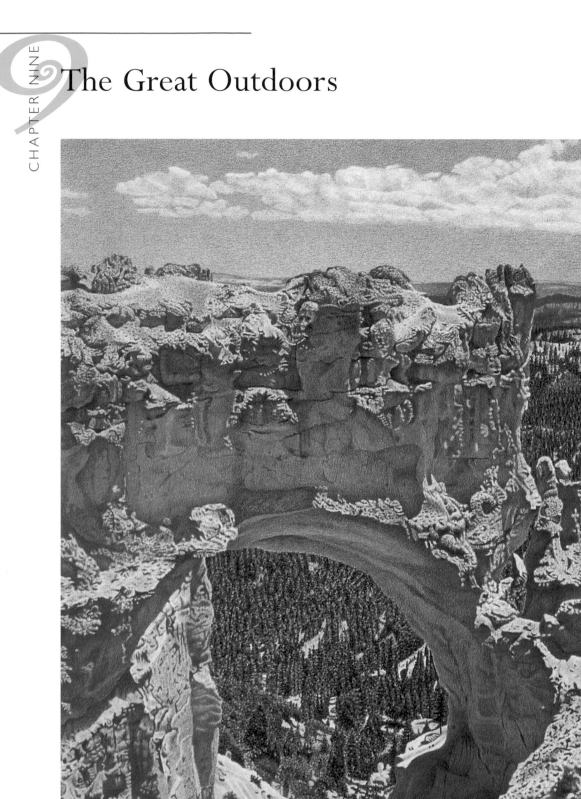

Whether you are drawing the vast expanse of a canyon or intricate botanical studies, there is a spine-tingling thrill in encountering the wonders of nature. An ever-changing diorama of plants, trees, landscapes, clouds, and water provide great inspiration for artists of all ages.

If nature is your passion, seize every opportunity to hike into the wilds to photograph and sketch what you see. Closely study the veins in a leaf, lie in the grass and watch the moving clouds, or sail on a lake at sunset as you take in the shimmering colors splashed across water. Even if you live in a city, you can find bits of nature tucked away in small nooks and crannies amidst the stark human-made landscape. Appreciate and record natural beauty wherever you can find it.

9–1
This massive landscape was drawn with the transparent layering technique. By using each color's complement in the shadows, Nelson intensified the bright, sunburnt color of the rocks.
Bruce Nelson, *Natural Bridge,* 1995.
Colored pencil, 23½" x 20" (60 x 51 cm).

9–2
Fascinated by the minute details found in nature, this naturalist renders traditional botanical drawings with a colored pencil. Using very gentle pressure on a vellum Bristol surface, she allows the soft granulated texture of the paper to show through just enough to create a soft mood, without distracting from the subject.
Andrea Kessler, *Jamaican Bird of Paradise,* 1994.
Colored pencil, 28" x 20" (71 x 51 cm).

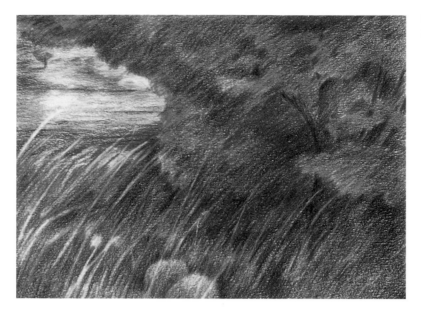

9–3

Not all colored-pencil work is realistic. Loose, fluid lines and rich colors give this landscape an abstract, breezy look.

Mary Ford, *The Grass Is Greener.* Colored pencil on cotton paper, 8½ x 11" (22 x 28 cm).

En Plein Air Sketching

Drawing on location is an artist's first choice. The experience of being submerged in nature contributes intangible authenticity to a work. However, drawing *en plein air* (outdoors) has its limitations. The light source will shift continually, the winds will disturb your paper, and small animals will shift in their poses. Birds can leave droppings on your paper, and the insects may drive you wild. Still, a sense of spontaneity infuses work that is completed on site, and there is no better way to gather data and fully experience nature.

When you work on location, don't try to produce the sort of masterpiece that you can achieve in the quiet, controlled atmosphere of the studio. Instead, experience the moment, drink in the sounds, savor the scents, enjoy the antics of the creatures, gulp in the fresh air, and absorb the essence of the environment. You will carry these experiences and memories back with you to the studio, and they will influence your work. Take copious notes in words, colors, sketches, and photos. Use these later to re-create your experience. If you simply take photos and don't sketch, you will not remember as many details. There's nothing like drawing to increase your powers of observation.

Your sketchbook can become a scrapbook of sorts, which will trigger memories of your experiences. Even in the dead of winter, you can relive a lively summer jaunt by flipping through your sketchpad and reviewing your notes. Make your book as personal as you want. If you are a poet, write verse next to your drawings. If you are a comedian, observe the humor in nature and make funny notes to yourself. Naturalists can add botanical notes. Create a sketchbook that pleases you and reflects your own personality.

Explore Your Style Preferences

Those of you who like to draw in a realistic style will spend hours absorbed in detailed studies, meticulously defining each thorn on a prickly pear cactus or refining reflections in raindrops. If you're an impressionist, the details will bore you. Eschewing sharp pencils and fine pens used by realists, you'll reach for fat colored-pencil crayons or watercolor pencils and big brushes. Instead of spending hours fussing with minutiae, you will work quickly, focused on the total effect and the big picture.

When you are just getting started, pay attention to your personal reactions to various media, subjects, and styles. Try big fat pencils and finely sharpened instru-ments. If you find yourself fussing with sharp, hard pencils to detail the veins in a leaf, chances are you're a realist. If you are bored with detail and like to work quickly with large, broad instruments, you may be an impressionist.

Keep in mind that you will always do a better job when you love the subject. After all, most leisure draw-ing should be for pleasure. If you find yourself anxious to finish, you have probably chosen the wrong subject. If you love what you are doing, you won't even notice the hours flying by—practice will be enjoyable and cathartic.

9–4
Wavy rows of bright yellow dots of color create the impression of wild-flowers blowing in the wind. A back-packer motivated by her love of nature, artist MacLean often draws endangered or forgotten wild, open places as remembered by her mind's eye.

Teresa McNeil MacLean, *Top of the Mesa (Montana de Oro)*, 1996. Colored pencil on Bristol board, 11" x 14" (28 x 36 cm).

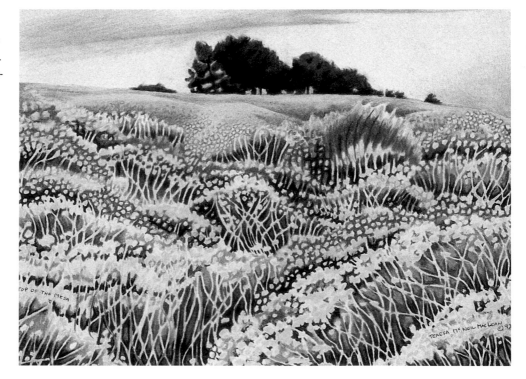

Nature Up Close

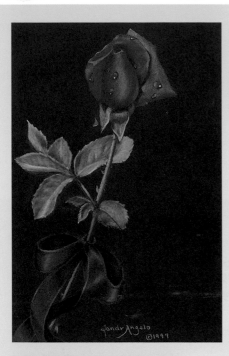

Bright colors really pop out when applied to black, creating a dramatic effect. It's a good idea to get acquainted with using colors on black paper by making color swatches on the back of a paper. Since erasing on a black paper will leave skid marks, it makes sense to practice on a sheet of white paper to work out the contour line drawing. Then a sheet of white transfer paper can be used to place the drawing on the black surface.

Sandra Angelo, *Raindrops on Roses,* 1997. Colored pencil, 10" x 7" (25 x 18 cm).

Step One: First, a contour line drawing is created with a white colored pencil, to use as a map for shading. An underdrawing is created for each object. The lightest values are laid in first: for the ribbon, white; for the leaf, light green; for the rose petal, peachy pink.

Step Two: Next, the dark areas are applied: for the ribbon, a dull, dark red and a bit of dull, dark green; for the leaf, dark green. The medium values of the petal are overlapped with a dark,

deep red. Neighboring colors are overlapped to form a gradual progression from dark to light. Without such overlaps, a rainbow pattern will emerge instead of a smooth transition from one color to another.

Step Three: To draw a dew drop, first determine the light source. Divide the drop into two sections: a light and a dark area. Using the same colors in the flower, place the light values on the side farthest from the light source. The dark values should

be placed on the same side as the light source. After graduating values from light to dark, place a dark crescent-shaped shadow next to the light value and a small white highlight on top of the dark value.

Working with the color sequence used in the layering process, the drawing is burnished until the paper's tooth is completely obliterated. The transition from dark to light tones has to be made very carefully.

Choosing a Nature Sketchbook

If you are doing colored studies of landscapes, use colored paper. Medium-tone grays are a perfect backdrop for most natural subjects. Besides lending unity to your piece, a colored surface will save you a lot of time. For in-depth or detailed studies with colored pencils, use a white, one hundred percent cotton tablet. Natural fiber papers are much better than the paper in standard sketchbooks because cotton papers have a tremendous amount of bite, an absolute necessity for using wax-based colored pencils.

Drawings from nature can range from the minute details on individual leaves and rocks to the breadth of a massive landscape. Although both ends of this spectrum are intriguing, most folks have a propensity for one or the other. If you love detail, the first will fascinate you. If you like dealing with the whole scene, you may prefer the second. Try both approaches, as presented in the demonstrations, to see which suits you better.

9–5
Lush landscapes and a whirlwind of animal activity can provide a steady stream of inspiration. Recording impressions in a sketchbook can allow you to mentally return to a site and relive your experience there. This sketchbook page was completed by the author while teaching at the San Diego Wild Animal Park.

Sandra Angelo, *Sketchbook Page,* 1997.
Colored pencil, 12" x 9" (30 x 23 cm).

When selecting your field materials, considering buying a spiral book with a hard cover. A heavy cover can be folded over to act as a portable drawing board, making it much easier to travel light. Select your paper pad based on the instruments you will use for drawing. If you are going to sketch with watercolor pencils and pens, take a watercolor sketch pad.

9–6
Colors that may have been ordinary in an outdoor setting are dramatically enhanced to a rich luster by the contrasting black background.

Norman Holmberg, *Autumn Berries,* 1995.
Colored pencil on Arches 140 lb. hot press paper, 18¾" x 26⅝" (48 x 68 cm).

The Big Picture

Bruce Nelson uses a methodical drawing method for his detailed landscapes.

Step One: To keep the white paper clean while working on this large landscape, Bruce Nelson began at the top left-hand corner and worked his way down the page. He kept a scrap piece of paper over the unfinished portion in order to protect the surface from smudges.

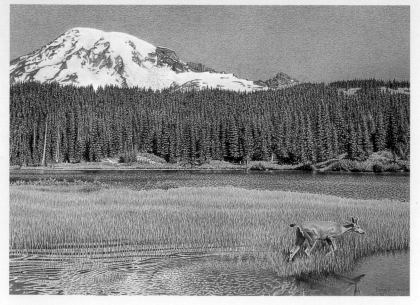

Step Two: Nelson used a light tapping motion to layer pointillistic dots of color on the page. The eye will blend the colors to create the soft look he desired. Using the tip of a very sharp pencil, he layers color after color next to each other until the landscape feels rich and full bodied.

Bruce Nelson, *A Walk in the Water,* 1996. Colored pencil, 19" x 23" (48 x 58 cm).

Practicing small parts of a drawing is much less threatening than testing your skills directly on the performance piece. If you make a mistake on a small vignette, it's no big deal. If you mess up on a performance paper, you may have to discard the whole drawing. Make it a standard practice to keep a scrap piece of your performance paper handy whenever you are performing. Practice the textures on this paper first. Once you have mastered the texture, you can tackle the performance drawing.

Don't expect to master everything at the first sitting. We live in such a fast-paced age that we often expect instant results. All masters who draw well became great through extended practice. Practice makes perfect. If you love the subject, the practice will seem like play and you will enjoy the journey.

1. Practice drawing this hibiscus flower. You don't need to complete the background—just experiment with the effect of blending color on different petals. Before you begin, you may want to review the guidelines for using a colorless blender on page 57 in chapter five.

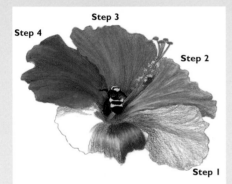

Step 3
Step 4
Step 2
Step 1

Step One: This petal has been shaded with a layer of colored pencil.

Step Two: Next, the underdrawing was blended with a colorless blender.

Step Three: The petal was then covered with a layer of colored pencil, using the local color of the flower.

Step Four: Finally, the drawing was burnished, using the same colors that were applied in the underdrawing.

The stamen was outlined with a fine black pen to give it emphasis.

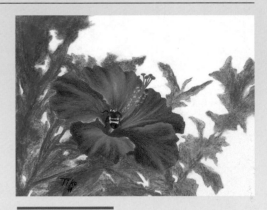

9–7
Once you've practiced drawing the hibiscus, create an environment around it to complete the picture.
Student work: Tiko Youngdale (age 49), *Hibiscus*, 1994.
Colored pencil, 8½" x 11" (22 x 28 cm).

2. Practice drawing water. This will require some alert observation, as we tend to think of water as either colorless or blue like the ocean. In reality, water takes on the hues of surrounding objects reflected on its surface. These reflections are often duller in hue than the object itself and distorted in shape. The easiest way to begin is to render a surface that is calm. Reflections can be drawn with intermittent horizontal strokes. Practice drawing fig. 9–8 for starters, and then finish it off with your own ideas.

9–8
A drawing of water is always more interesting when it includes distinct reflections. This study from San Diego's Balboa Park captures the reflections of waterlilies in full bloom. The warm gray paper helps achieve the strong lights and darks that characterize bright sunlight.

Sandra Angelo, *Balboa Park Waterlilies,* 1995.
Colored pencil, 8½" x 11" (22 x 28 cm).

1. To achieve the variegated hues found in an autumn leaf, consider using the splash technique with water-color pencils.

• First, outline the silhouette of the leaf with a light graphite pencil.

• Mask the background with frisket paper.

• Lay a light yellow wash over the whole leaf.

• While the yellow is still wet, flick a variety of colors into the wash, controlling the light and dark splashes.

• When your paper is completely dry, use a sharp, hard, colored pencil to detail the veins.

9–9
Carolyn Fairl, *Autumn Leaf,* 1996.
Watercolor pencil on hot press watercolor paper, 11" x 8½" (28 x 22 cm).

2. Practice drawing a night sky. Use a white colored pencil on a black paper. Remember, the harder you press, the lighter the value will be. To create dark values, allow the paper to show through.

9–10
This monochromatic cloud study was drawn with white pencil on black paper. Light values are achieved by allowing the paper to show through.

Student work: Rose Marie Barr (age 64), *Night Sky,* 1997.
Colored pencil on black paper, 11" x 8½" (28 x 22 cm).

1. Complete a scene entirely composed of clouds at sunset and the corresponding reflections in the water. The warm hues from the setting sun will bathe the whole sky and the water, providing you with a very rich palette.

• Start by identifying the color range you will be working with. Chances are you will be exploring the color complements blue and orange. Experiment with these colors before you begin.

• Notice where you want to place highlights in the water. Apply masking fluid in horizontal strokes in these areas, and then allow them to dry completely.

• Apply watercolor-pencil washes over the surface of the paper. The masking-fluid resist will keep the water reflections white. To achieve the soft cloud texture, use the wet-on-wet technique: Wet the paper, and apply watercolor-pencil washes to the wet paper.

• After the paint dries, remove the mask with a rubber cement pickup, and add the colors of the reflection in the white spaces.

2. Sit by a lake, stream, or river, and draw the reflections on the water. Complete a drawing that includes a large expanse of water, as fig. 9–12 does.

9–11

The sky is full of brilliant hues at sunset. The artist captured these colors by using the wet-on-wet technique. The shimmer on the water was planned and covered with masking fluid before the main body of water was laid down.

Student work: Julie Wolfson (age 70), *Sunset Cloud Study,* 1996.
Watercolor pencil, 5" x 7½" (13 x 19 cm).

9–12
Using transparent layering, the artist built color with gentle pressure, allowing the color of the paper to be a factor in the final drawing.

Rose Kapka, *Gull Watching with Grampa,* 1996. Colored pencil on colored paper, 10" x 8" (25 x 20 cm).

10 Still Lifes

Before the camera was invented, enabling the artist to capture the image of a moving creature or a particular quality of light, still lifes were a popular subject for artists to paint. Still lifes also offered the convenience of working in a studio. Before tube paints were developed, pigments had to be mixed from scratch, making location sketching very cumbersome. Also, once a still life is arranged, it holds still. Artists still find it an appealing way to create a subject for a drawing.

When arranging still-life composition, you have several options:

- One way to control the lighting, to keep it consistent from day to day, is to compose the still life, photograph it, and work from the reference.
- If you have the luxury of time, you can draw from life. This would require coming back to the objects each day at the same hour, hoping that the weather is consistent so the lighting won't change. In this case, you must also choose inanimate objects that won't wither or spoil.
- You can set up a still life in a dark room and use directed lighting to illuminate the subject.

When setting up a still life, choose objects that appeal to you. If you are a beginner, stay with very simple shapes and colors so that your drawing will be uncomplicated. You don't even need to complete a whole drawing. Simply study various textures by creating vignettes.

10–1 (Opposite)
By choosing a cloth backdrop with the same colors as the bouquet, the artist creates a seamless interplay between foreground and background.
Barbara Edidin, *So Very Merry,* 1994.
Colored pencil on 100% cotton Bristol board, 31" x 21" (85 x 53 cm).

10–2 (Above)
A still-life arrangement needn't be complex. Simple objects, simply placed, can provide a rich study of textures and color harmonies.
Student work: Michael Pacheco (age 17), *Unusual Relationships,* 1997.
Colored pencil, 18" x 24" (46 x 61 cm).

Selecting a Subject

Artists who enjoy still life select their subjects based on types of objects that they find fascinating. Richard Tooley's work shows a penchant for presenting an uncommon view of a common object. In fig.10–3, he captures a tangle of wires—most of us can relate to the task of untangling that awaits some unfortunate person. By contrast, David Dooley is intent on capturing reflections in shiny surfaces. (See chapter 2, fig.2–1.) He is a master of reflections, and nothing escapes his observant eye. In fact, if you linger in his doorway for a minute, your likeness might be reflected on one of his still-life objects and immortalized in one of his drawings!

When constructing your still life, consider everything, even common objects such as your breakfast plate (fig.10–4). Absolutely anything can be interesting if you present the viewer with a unique point of view.

10–3
Even ordinary objects provide a challenging study when seen through an imaginative eye.

Richard Tooley, *Extension,* 1995.
Colored pencil, 15½" x 20½" (39 x 52 cm).

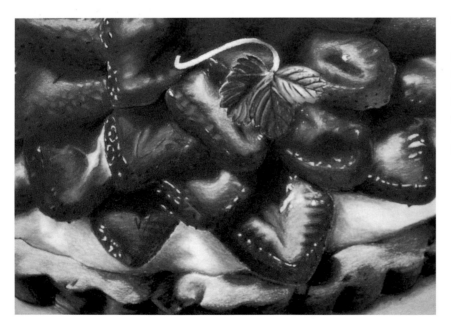

10–4
Using the burnishing technique, Brian captured the glistening reflections on his strawberry tart. The strongest white highlights were achieved by adding an opaque white gouache.

Student work: Brian Ross (age 15), *Strawberry Tart,* 1996.
Colored pencil, 9" x 12" (23 x 30 cm).

Still Life Value Studies

Step One: The artist, Julie Wolfson, arranged a still life with some simple objects she had in her home. First she drew the objects in graphite pencil. A black-and-white value study is very useful in determining the light and dark patterns in the arrangement. Compositions need a wide range of values to suggest depth and dimension. If your subject doesn't have this range, you can exaggerate, modifying lights and darks to obtain good contrasts. Working out your drawing in black and white first allows you to determine these values and to fix compositional problems.

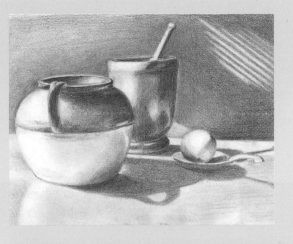

Step Two: After her value study, Julie repeated the drawing, in color this time, on a sheet of gray paper.

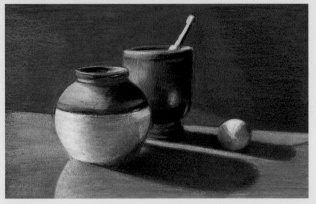

Step Three: Taking her study one step further, she completed the same drawing on white paper. You can see that the color of the paper significantly affected the outcome. The objects look much brighter on white paper, seemingly bathed in natural sunlight. On gray, the lighting seems muted, but richer. Neither is good or bad, right or wrong; it's a matter of preference. Experiment until you find what suits you.

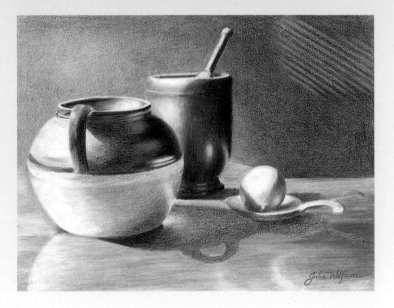

Student work: Julie Wolfson (age 70), *Still-Life Studies*, 1996. Colored pencil, 8½" x 11" (22 x 28 cm).

10–5

When selecting objects for your still life, look for a variety of shapes, sizes, and colors. In this work, the organic shapes of the vegetables and cloth contrast with the straight diagonal boards of the bench. The three-dimensional quality is enhanced by a bird's-eye view and the use of strong shadows.

Joanne Smith, *Backyard Labors,* 1993.
Colored pencil, 19" x 15" (48 x 38 cm).

Setting Up a Still Life

If still life excites you, learn from professionals who specialize in it. Barbara Edidin, a passionate still-life artist, keeps a closet full of objects and fabrics that fascinate her. (See fig.10–1.) When she is ready to start a drawing, she carefully arranges a still life next to the window where the sun can bathe the objects with light. Because she prefers the bird's-eye view, she often stands on a stool while she's shooting photographs of the subject. To get a photo that pleases her, she sometimes takes as many as seventy shots from various angles.

Once she has a satisfactory photo, Edidin transfers the image to paper. Beginning in the top left-hand corner, she slowly works her way down the page until each section is complete. A professional artist, she works from 8:00 a.m. to 5:00 p.m., five days per week, and generally finishes one drawing per month. Her intricate drawings take from 120 to 160 hours to complete, yet for her these long hours are filled with relaxation and contentment. She enjoys the journey.

Common Errors

When you set up your still life, remember that composition is critical. The most common mistake beginners make is setting up a horizontal line of objects similar in height and proportion. This creates a fat clump of objects in the middle and ignores the space around the still life. Consider using objects that have differing proportions and textures as well as varying heights. Plan how each positive shape will intersect with the negative space, to integrate the two. Choose how you will treat the background from the very start, rather than trying to figure out what to do with the void once you've finished.

You can improve your composition dramatically by reviewing the design techniques discussed in chapter six. Notice that each still life in this chapter has used one or more of these techniques. For example, in fig.10–4 the subject fills the whole page, and the concept of thirds is evident in fig.10–2. What other techniques can you identify? If you have trouble with composition, consider completing some loose thumbnail sketches or even a quick photo shoot to see which arrangements look best.

10–6

Even a simple object like a fishhook can become the subject of a fascinating composition. Notice how the diagonal arrangement carves into the negative space, forming interesting background shapes. The shadows also work to strengthen the composition.

Deborah Currier, *Catch of the Day* (detail), 1995.
Colored pencil, 26" x 38" (66 x 97 cm).

1. Practice the various textures in the vignettes in fig.10–7, on a paper of similar color.

• Begin with an underdrawing of all the light, medium, and dark value. (Study the strips of colors for each object, arranged from light to dark.)

• In some drawings, such as the bear, use gentle strokes and stop after the transparent layer. These light strokes allow the paper to be a factor in the drawing.

• With shiny objects such as the buttons, finish by burnishing with the same color sequence you used in your underdrawing. Go back over the drawing several times until you blend each neighboring color, creating a smooth transition from dark to light.

• The one shiny object that is not burnished is the marble. Use a gentle stroke and allow the paper to show through slightly to create the feeling of transparency.

2. Once you have practiced a range of textures and techniques, arrange a complete composition using some of your favorite objects. Choose a theme for your drawing such as the topic chosen by a student for fig.10–8.

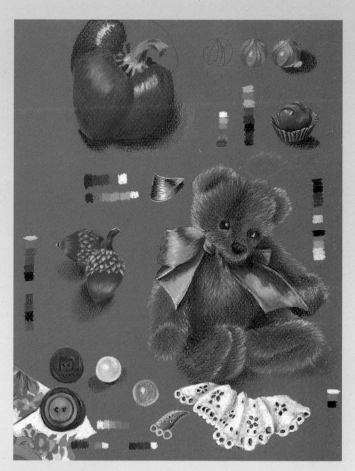

10–7
Illustration by Sandra Angelo.

10–8
The introduction of red flowers enhances the focal point of this drawing and gives it some pizzazz. The red reflections in the trumpet add a nice touch as well.

Student work: Tricia Robison (age 15)
The Trumpet Player, 1997.
Colored pencil, 11" x 17" (28 x 43 cm).

1. Practice the steps shown in fig.10–7 for drawing a marble. Concentrate on creating a surface that appears reflective. Experiment with different pencil colors on varying paper colors. When you're ready, arrange a composition using only marbles. For an extra challenge, arrange them on a reflective surface.

10–9

The marbles and their reflections fill the page, making good use of negative space. The shapes of the mirrored marbles deviate from the perfectly round spheres they reflect.

Deborah Currier, *Landscape in Glass,* 1989. Colored pencil, 26" x 38" (66 x 97 cm).

2. Arrange a composition of shiny objects on your desk or other smooth surface. Draw the objects and their reflections. Study your still life carefully before you begin, noticing any distortions that occur in the mirror images. Colors and shapes in the reflections may differ dramatically from those of the objects themselves.

10–10

Reflected objects in these surfaces are muted and distorted.

Student work: Deborah Settergren (age 44), *Lustre Reflections,* 1997. Colored pencil, 6½" x 5" (17 x 13 cm).

1. Choose a collection of still-life objects, and draw them in an abstract form. If you're having trouble abstracting your shapes, take a picture of your still life. Have it blown up to 8" x 10" on a black and white copier. The lack of detail in the copy will help you abstract the shapes. Consider cutting the shapes out and rearranging them in different ways, like a set of jigsaw puzzles. Make photocopies of these "puzzles" and practice various color combinations.

10–11
Bruce Nelson, a fastidious realist, decided to challenge himself by doing a more abstract drawing.

Bruce Nelson, *Still Life with Flowers,* 1988. Colored pencil, 14" x 20" (36 x 51 cm).

2. If you feel daring, set up a still life with a complex background such as the one in fig.10–12. If you have trouble composing your still life, look at examples done by the masters. Review composition techniques in chapter six. You can experiment by drawing objects on tracing paper and moving them around your paper until you arrive at a composition that is dynamic. Stagger the heights of your objects to avoid horizontal banding. Construct the basic framework for the composition, and fill in the details slowly. Take your time.

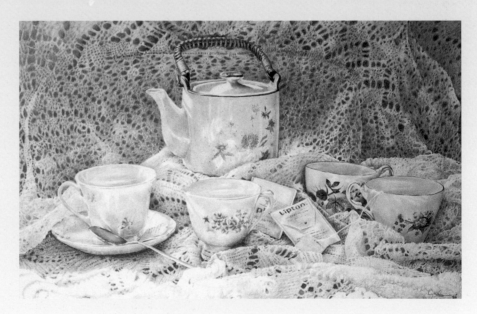

10–12
A high school teacher with a passion for detail created this monochromatic still life with varying textures. Notice how just the slight hint of color enhances the focal point.

Lynn A. Byrem, *Suzanne's Treasures,* 1996. Colored pencil, 11" x 16¾" (28 x 43 cm).

11 The Human Face

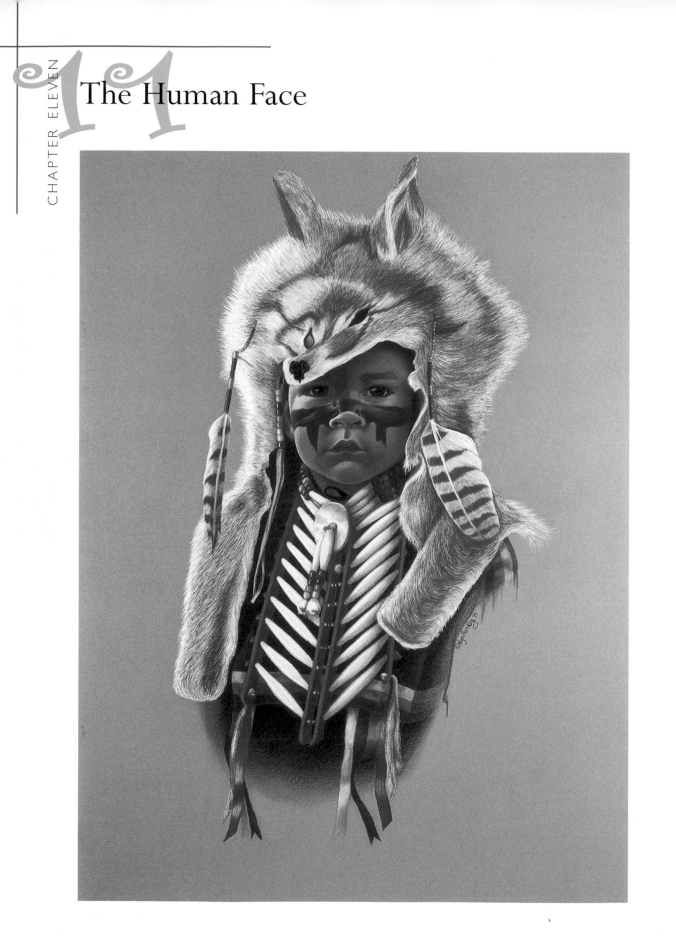

"Yes, that looks like a baby, but not like my Susie." This common complaint baffles people who are learning to draw portraits. What makes the face seem so difficult? It's just a collection of lines, shapes, values, textures, and colors, like any other subject. If you drew a tree and it didn't look exactly like the tree you copied, you would feel okay. But when you are drawing a face, you're never satisfied unless the result looks just like the person it represents.

Why Are Faces So Difficult to Draw?

Sensitive renderings in art rely on an ability to intuitively study each subject—to grope through the maze of values, textures, lines, shapes, and colors and record exactly what you see. During this process, artists typically lose track of the world around them and really focus on drawing. However, when drawing a face, it is difficult to enter this state of concentration. A nagging desire to see if a likeness has been achieved can disturb the natural process of drawing, which involves discovering and recording the facts without imposing preconceived ideas on the subject.

When drawing faces, you might find yourself pulling information from your memory about what this person looks like, rather than copying what you see. You might want to doctor the picture. For example, you may have a tendency to make both nostrils equal in size because your mind tells you, "Nostrils are always the same size."

11–1 (Opposite)
Sharp focus and fine detail make this a striking portrait. When drawing faces, you'll notice that the bridge of the nose has not developed yet in small children. The greatest range of value in this child's nose occurs around the lip and the nostrils.
Lyn Aus Roy, *Little Bear,* 1991.
Colored pencil on colored paper, 24" x 18" (61 x 46 cm).

11–2 (Above)
Drawings of the human face need not be one-hundred percent realistic to be effective. This stylized portrait makes striking use of bold line and color.
Student work: Jennifer Cole (age 18), *Me and Hiroshi,* 1998.
Scratchboard and colored pencil, 8½" x 11" (22 x 28 cm).

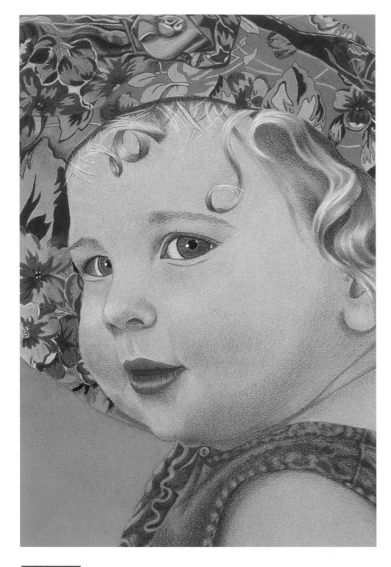

11–3

The proportions of facial features change when the head turns. Instead of being equal in size, the eye and the nostril closest to the viewer appear larger than those farther away.

Student work: Susan Hurst (age 65), *The Blue Hat,* 1997.
Colored pencil, 14" x 11" (36 x 28 cm).

Actually, faces rarely display absolute symmetry. Also keep in mind that when the head moves from side to side, or up and down, the proportions change. In a three-quarter view, one nostril appears to be larger than the other. The same applies to the eyes and mouth.

Helpful Techniques

The following hints provide ways to take a fresh look at a face as you draw it, so you can analyze its parts and achieve a realistic likeness.

Using a Grid

The best way to keep facial proportions accurate is to view facial features as shapes. To this end, the grid is a valuable tool. Used historically by masters of art, the grid is a set of horizontal and vertical lines that are superimposed on the drawing surface to aid in grasping proportion. The lines break the subject into smaller shapes, revealing the way they fit together. By placing a set of horizontal and vertical grid lines over the face, you can study facial features as a collection of shapes. Render the drawing only one square at a time so you can focus on shapes and values in each portion of the face, instead of looking for an overall likeness.

Vary the size and number of grid squares used for any given drawing based on the amount of detail in the drawing. A grid with fewer, large squares would be appropriate for a drawing with simple shapes. An intricate, detailed drawing might require a tighter grid with more smaller squares.

One way to use a grid is to draw the lines on your paper and erase them as you fill in each square. Another method is to use paper you can see through, and attach a sheet of grid squares under your paper. The grid can be removed when you are finished.

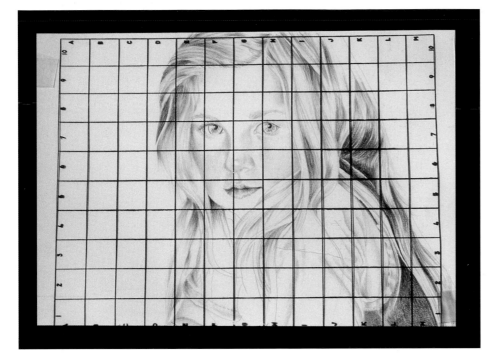

11–4
Placing a grid on top of your drawing and your photo reference can help to break the face into a collection of interlocking pieces.

Sandra Angelo, *Leslie,* 1900.
Graphite, 8½" x 11" (22 x 28 cm).

To enlarge a picture, place small grid squares on the photo reference and use larger grid squares on your drawing paper. For example, if you use ¼-inch squares on your reference and you want your drawing to be four times as big, use one-inch squares on your drawing.

Using a Window

Another way to break an image into manageable parts is to use a window the same size as one of your grid squares. To do this, cut a one-inch-square opening in an opaque paper, and place it over your reference photo. As you view parts of the face through the window, you won't be able to tell whether you are looking at a nose, a mouth, or an eyebrow. If you accurately draw the shapes one square at a time, by the time you are finished you will have a very accurate drawing. If you cut the window slightly bigger than your grid square, you will be able to link together shapes seen through the window.

11–5
By blocking out the rest of the drawing, the use of a window allows you to focus on the shapes and values in only one square at a time. The use of a window can dramatically improve your accuracy.

11–6
Drawing faces in black and white can strengthen your skill in rendering value and detail before you tackle the more challenging step of working with color. For this artist, black-and-white renderings are an artform unto itself.

Ann Massey, *Rueben McDaniel,* 1990.
Black colored pencil, 12" x 9" (30 x 23 cm).

Starting with a Black-and-White Drawing

When Michelangelo painted the Sistine Chapel, he began this immense project by doing black-and-white studies of individual elements—the arm, the hand, the thumb, and other body parts—before he tackled a whole figure. In the same way, you can benefit from practicing individual features with graphite pencils first. This will build proficiency before you take on the more complicated task of rendering faces with colored pencils.

Drawing Parts of the Face

The step-by-step drawings in this chapter show a natural sequence for drawing various parts of the face. If you are a beginner, you may want to practice the steps as shown in the drawings. Intermediate students may prefer to practice these same features with the help of a friend who's willing to model or by observing themselves in front of a mirror.

Drawing the Eyes

To practice drawing eyes, start with a contour line drawing made with a graphite pencil. Form the iris by marking its outermost edge with a dark line. Place a strong, dark value in the pupil, leaving one spot free for future placement of the highlight (which will be added later with opaque white). Extend the highlight slightly into the iris. Be sure to place the highlight on the same side in both eyes, or the subject will look cross-eyed. Even though eyes may have more than one highlight, plan for just one. This will make the subject look more focused and less dazed.

Look closely at the mottled colors in the eye that you are drawing. Most eyes have a minimum of six to eight colors in them. Shade the iris by putting color exactly where you see it in your reference or in the mirror.

Look in the mirror at the whites in your eye. They are never entirely white. Make an underdrawing of the white of the eye, using a shadow color such as a dull light blue. Use graduated tones for the underdrawing: Build a darker value at the edge of the eye, then shift to a lighter value in the middle and to the faintest of all where the white of the eye touches the iris. Cover this underdrawing with white. The graduated tones will create an illusion of roundness.

Likewise, create a gradual change in value at both edges of the eyelid so that it looks rounded and has volume. Repeat this process with the eye socket until you have built up the values surrounding the eye. Now you are ready to add detail.

Eyelashes must be added very carefully. If you look in the mirror, you will notice a space along your bottom lid between the eyeball and the start of your eyelashes. Allow for this space and place the eyelashes exactly as you see them. Eyelashes tend to grow in clumps of three or four. Treat each section individually, using short, crisp, slightly curled strokes. The top eyelashes often do not show at all. If you can't see them, leave them out.

To achieve a precise likeness, place the eyebrows one hair at a time. Look for the pattern of hair growth. A child's eyebrows are often so light that you can hardly see them. Change the direction of your strokes when the hair growth changes. Use short, crisp strokes like the ones you used for the eyelashes. It is the subtle differences that make each person unique. If you pay very close attention to the details like eyebrows, you are more likely to succeed in the elusive goal of capturing a convincing likeness.

Usually a light source above the eye casts a small shadow beneath the upper eyelid. Place this shadow over both the iris and the white of the eye. Lastly, to add a translucent, reflective quality, create a kidney-shaped pool of color in the bottom section of the iris in a more intense shade of the eye color. For instance, use yellow ochre for a brown eye, light turquoise for a blue eye, and a light lime green for a green eye.

Drawing the Nose

Vary the values you use when drawing the nose. Part of the nostril is very dark, but the darkness fades as it moves away from the cavity. The ball of the nose has a medium value; the end of the nose and the bridge are very light. By using a wide range of values, you will get a nose that looks three-dimensional. Notice that most babies don't have a bridge on the nose. The bridge becomes more pronounced as a child grows older.

Pay close attention to the shadows next to the nostrils. They can help make the nose stand out. Notice the small ditch or groove that lies between the nose and the lips. This area requires curved lines. Leave light values on either side of it to create a highlight that will give this area dimension.

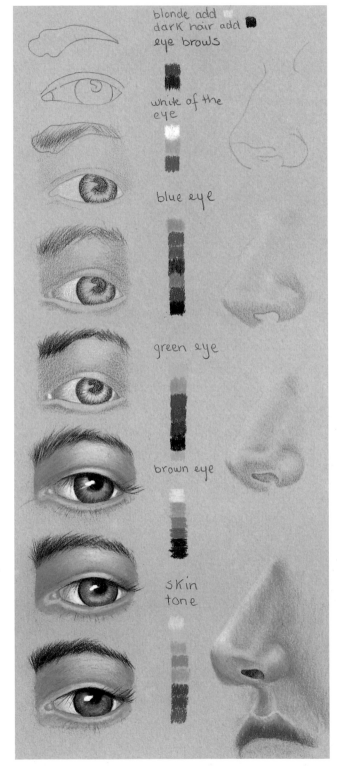

11–7a

Illustration by Sandra Angelo.

Drawing the Mouth

At first, practice drawing mouths with lips that are closed. Drawing teeth is a more difficult exercise, so save that for later. The center horizontal line is the most critical part of the mouth—everyone has a unique one. Some are straight and crisp, some are wavy, some droop at the ends, and some turn up. Always start by placing the center line first.

Now look at the top lip. Some people don't have one, whereas others have a very full one. Some top lips extend the full length of the center line, but others stop short. Notice too that many folks have a very light value right above the top lip. This light line can be indicated by shading the skin around it.

The bottom lip can vary as much as the top. Most people have a bottom lip that is fuller than the top lip, but some folks don't have one at all. Study your subject closely. Place a deep, dark value next to the center line so that the lip shadow will give the illusion of depth. Use short, curved lines on the bottom lip, placing dark values at both edges and a highlight in the middle of the bottom lip. Almost every bottom lip has a highlight in the middle and a cast shadow under the lip.

Drawing Skin

Beginners sometimes ask questions like, "What color do I use to mix flesh tones?" The answer is, "It depends."

- In the first place, whose flesh are we talking about? Skin colors vary significantly, even within a given race. If you are in a classroom, place your arm next to someone else's arm. Try this with several people. Chances are you will find a lot of variations in color, both subtle and obvious.
- Second, we would have to ask, "What is the light source?" Light will change flesh tones significantly.
- Third, we'd need to know what colors surround the subject. Colors reflect the hues around them.

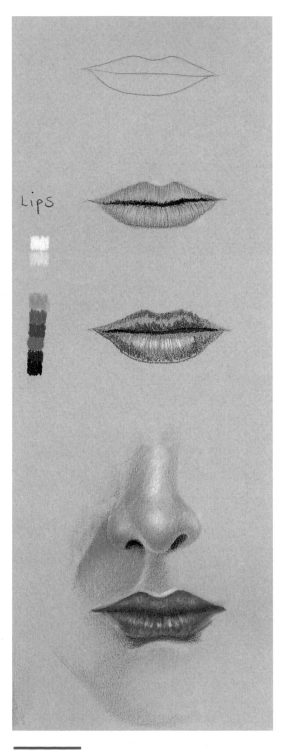

11–7b

Illustration by Sandra Angelo.

The best solution for learning how to mix flesh tones is to learn how to mix color. Then, whenever you need to depict flesh of whatever color, you will know how to replicate its hues

For practice in rendering skin tones, divide the face into flat planes. The direction of the lines you draw will sculpt the shape of the face. Use soft, graduated strokes to complete a dark value study under the medium and dark skin tones. Good results can be obtained by using the complement of the subject's particular skin tone for the underdrawing. After you have completed this underdrawing, layer on the skin tones, graduating the

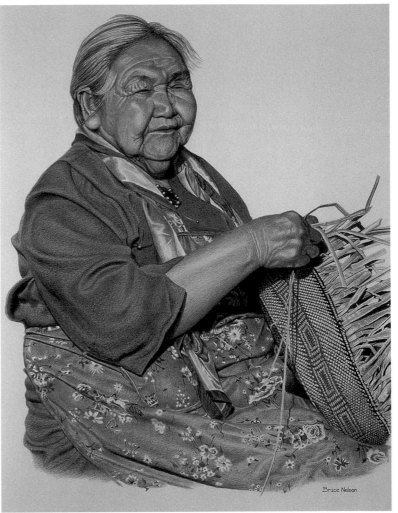

11–9
Wrinkles are very similar to folds in the fabric. Both have dark values in the shadows that gradually change in value as they taper toward the highlights.
Bruce Nelson, *Basket Maker—Skokomish,* 1987.
Colored pencil, 20" x 16" (51 x 41 cm).

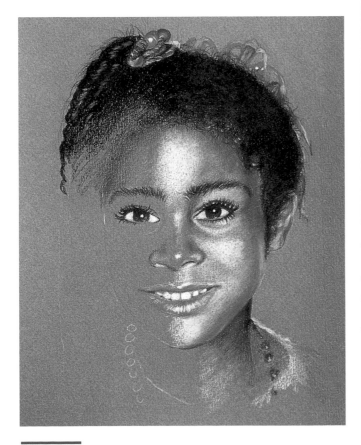

11–8
For the left side of the forehead, the value underdrawing was completed with an indigo blue colored pencil. The artist used this color because it is the complement of the orange glow in the skin tone.
David Dooley, *Nicole,* 1996.
Colored pencil on colored paper, 11" x 8½" (28 x 22 cm).

colors smoothly from dark to light. Overlap each neighboring color to produce a very gradual change from light to dark.

Wrinkles should be treated as if they were folds of fabric. Think of a wrinkled face as a gentle, rolling landscape with gradual changes in value. If you use distinct lines for wrinkles, they will look artificial. Your lines must change in value very gradually, with pockets of dark in the "valleys" gradually lightening to highlights on the "hills."

Drawing Hair

Drawing hair can be a relaxing and therapeutic exercise, but many people are intimidated by this feature. It is common for beginners to scribble circles to indicate a girl's hair and to use straight lines for a boy's. Yet a person's hair is as individual as his or her facial features. If you treat your model's hair like a generic head of hair, the likeness will be lost. It is worth taking time to capture the unique character of the hair.

When you analyze hair closely, you'll see that it tends to fall in clumps. If you draw each cluster individually, before long the whole head of hair will come together nicely. If the hair is curly, place dark tones at both edges of each clump and a highlight in the middle. Place dark tones at the roots, to anchor the hair to the head. Even if the hair lacks obvious highlights or roots, still place them. It will enhance the three-dimensional quality of your work.

Babies generally have short or fuzzy hair. If a baby (or an older man) is almost bald, draw the skin tones first before drawing strands of hair on top of the skin.

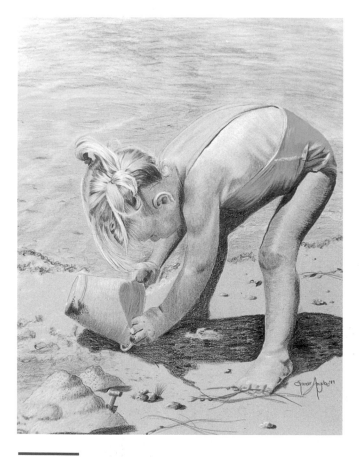

11–10
Hair tends to fall in clumps. If you draw each clump individually, with attention to the directional lines of the hair and its posture, the portrait's likeness to its subject will be enhanced.

Sandra Angelo, *Beach Fun*, 1990.
Colored pencil, 20" x 16" (51 x 41 cm).

Drawing the Ears

Although many people are intimidated by the ear, it can easily be viewed as a set of lines, shapes, and values, just like other features of the face. Break it down visually into pieces, and observe how each section interlocks with the next. Remember that value changes on the ear are very gradual except in the inner ear, where there is a darker shadow.

Drawing the Teeth

The secret to drawing teeth is to remember that less is more. Lightly pencil in the teeth, and when you shade them, dull them ever so slightly. If you make the teeth pure white, they will protrude. On the other hand, dark lines between the teeth can make them look rotten. Use very soft lines to define individual teeth. A very young baby won't have teeth, so if the mouth is open, just draw the dark and light shadows as you see them.

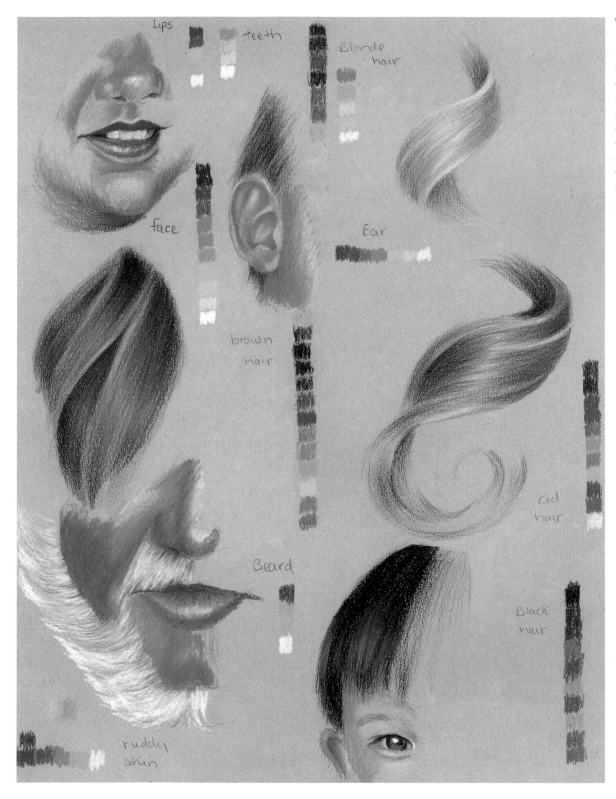

Lips

teeth

Blonde hair

face

Ear

brown hair

red hair

Beard

Black hair

ruddy skin

11–11
Beginners may find it useful to practice drawing these vignettes. Focusing on individual parts of the face helps to develop an understanding of the components of each feature. More advanced students may practice drawing parts of the face while looking in the mirror.

Illustration by Sandra Angelo.

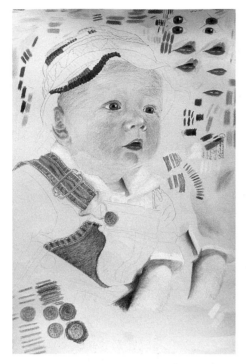

11–12
A work can be greatly improved by a willingness to practice before starting the final drawing. This artist selected a tan paper for his work and then used a practice sheet to explore color solutions and to experiment with textures.

11–13
Tan was the ideal color for the skin tones in this baby. (Refer back to Thompson's first drawings in chapter seven, fig.7–3. Completed seven years later, this drawing makes evident what is possible with practice.)
Orville Thompson,
Andrew, 1996.
Colored pencil, 14" x 10"
(36 x 25 cm).

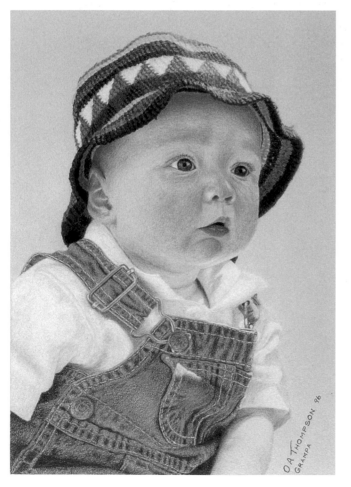

Colored-Pencil Portraits

The easiest way to draw people is to select a colored paper that reflects the subject's dominant skin tones. The tinted ground will save time and bring a sense of harmony to the piece. Because colored pencils are transparent, their hues will be altered by the color of the paper. Test your colors to determine the correct pencils for skin tones, hair color, and so forth. Practice on a sheet of the same colored paper that you will use in your performance piece. Once you've resolved the color combinations, you can begin the portrait.

Tips for Success

Practice is the key to learning how to draw a face. If you are a beginner, you will have much more success if you follow this sequence in your learning process:

- Copy the masters' drawings or vignettes in this book to learn how to shade various features.
- Begin with black-and-white studies of individual features, and then complete a whole face with graphite.
- Practice rendering the parts of the face in colored pencil. If you need to see a demonstration of this technique, watch the video on drawing faces listed on page 140 of the Appendix. The advantage of using a video is the option to rewind and watch it repeatedly until you fully understand the techniques it presents.
- Once you've practiced enough to feel confident, draw an entire face in color. Begin by drawing people whom you don't know, so you won't be distracted by the familiarity of known faces and the desire to please friends by achieving a likeness. Once you become comfortable with technique, you can begin to draw people you know.

Once you are ready to draw someone familiar, here are a few points to keep in mind:

- If you are using a photograph, work from a reference in which the face itself is a minimum of 5" x 7". If your snapshot is too small, take it to a copy shop that makes color photocopies, and ask them for an enlargement of the face that measures a minimum of 5" x 7". You simply can't get a likeness when you can't see the individual features clearly.
- Practice drawing the separate parts of the face in color, including facial features, hair, and clothing texture and details.
- When you are ready to draw the whole face, plan for its size to be a minimum of 8" x 10", so you will have plenty of room for shading subtle features.

Correcting Your Work

Sometimes after you've finished a drawing, you'll want to make changes. While you are absorbed in drawing a piece, you tend to lose objectivity. You need the distance of at least an hour—or better yet, a full day—to accurately analyze the errors you might have made. Also, drawings generally don't look correct until they are completely finished. If you check for errors too early, you may be changing things that were right in the first place. If you find you are struggling with your drawing, stop. Leave it alone for a day or two, and go back when you feel refreshed. If you start obsessing about your mistakes, you can easily destroy the drawing.

Because portraits are a bit more complicated than the average drawing, you may have to redo the same drawing more than once before you get a good likeness. Instead of correcting the same drawing over and over again, just start a new one. With a battery-powered eraser, you can effectively lift mistakes two or three times, but if you erase repeatedly, you will destroy the bite of the paper. If a drawing needs extensive corrections, it generally means you haven't practiced enough and would do better to start over. Also, you can avoid mistakes by resolving color solutions and texture problems on a separate sheet of paper.

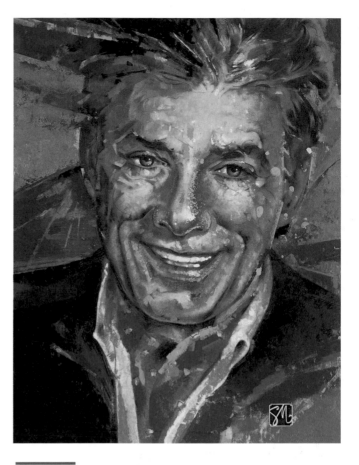

11–14

This artist has an uncanny ability to incorporate a loosely-flowing, multi-media style while still portraying his subject's face with accuracy. This portrait of musician Louie Bellson was a commission for the *Playboy Jazz Festival* program.

Steve Miller, *Louie, Louie,* 1998. Colored pencil, oil pastel, and graphite, 14" x 12" (36 x 30 cm).

Adding Faces to Your Photo File

Keep your camera with you at all times. You never can tell when someone you love will do something endearing. Nothing captures a personality better than a candid shot. Since people, especially children, move constantly, count on going through quite a few rolls of film before you get a good reference. The guidelines on the next page will help you improve your ability to photograph people.

11–15
This photograph provided a reference for fig.11–16.

11–16
Using artistic license and a strong vision of the mood she wanted to create, the author made several key changes while remaining true to the essence of her reference image.

Sandra Angelo, *Mother and Child,* 1994. Colored pencil, 14" x 11" (36 x 28 cm).

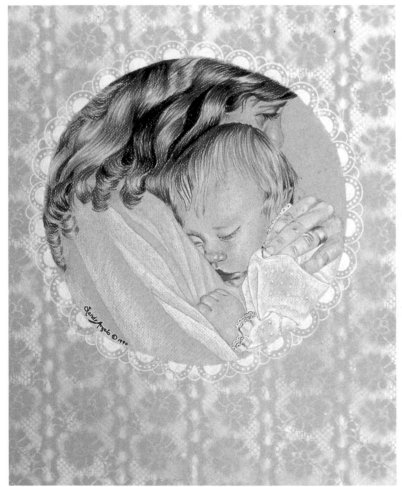

Eliminate Harsh Shadows

In photographs taken with a flash or in direct sunlight, harsh black shadows may appear around facial features. Photographs taken in the shade on a bright day or near a window in a sunny room usually offer the best lighting for people subjects. Observe how the light falls across the face of your subject, and reposition him or her as needed before taking the photograph. If that's not possible, no problem! As the artist, you can ignore overly strong shadows. Soften shadows, and make them lighter than they appear in your reference. Doing so usually results in a more harmonious, realistic drawing. (For an example, see figs.7–8 and 7–9 on page 83.)

Correct Photo Flaws

Sometimes it's a good idea to work out the composition for a colored-pencil drawing in black and white first. Graphite is easy to erase and correct, allowing you to resolve visual problems before beginning the color rendering. You may wish to smooth rumpled clothing or exclude an element in the photograph. If you have more than one photograph of the same subject, practice combining features from several views. Such modifications are common because photo references are almost never perfect.

SANDRA SAYS

One of my students once discovered that Van Cliburn, the world-famous pianist, would be occupying the cottage next to hers on Martha's Vineyard for the summer. She anticipated lying in her hammock and listening to private piano concerts wafting through the air. Much to her surprise, the only thing Van Cliburn played the entire summer was scales and arpeggios. We can gain understanding from such masters. Learning to achieve a likeness does not happen overnight. It comes from hard work, dedication, practice, and attention to detail. Keep practicing, and one day you'll agree that drawing faces is the most fun you can have with a pencil.

Modify Colors

Sometimes you may want to modify items in a photograph to make the drawing more interesting, to alter the mood, or to remove distractions. The sentiment in fig.11–15 was charming, but the patterned dress drew too much attention. The author softened it and changed the mother's hair color, using a monochromatic pastel palette that was more in keeping with the mood.

Remember to enjoy the process, and don't expect miracles. Congratulate yourself if part of the face looks good. Next time you draw it, you will improve the likeness. Remember that even accomplished artists fill sketchbook after sketchbook with practice drawings.

1. Practice drawing facial features—eyes, nose, mouth, and ears—as described in this chapter. Refer especially to figs.11–7a, 11–7b, and 11–11 for guidance. Lay out the colors you wish to use by value, to give you a reference for color selection.

2. Devote several pages in a sketchbook to practicing only drawings of hair. First, copy the examples in fig.11–11, and then look around you for inspiration. The variety in color, texture, and form is astonishing, especially when you include facial hair and eyebrows.

11–17

Illustration by Sandra Angelo.

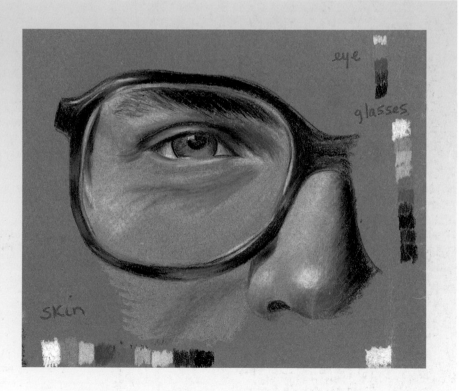

1. Practice drawing a whole face with a limited color palette. Draw someone you don't know, or do a study of one of the faces in this chapter. Pay attention to details that give individuality and personality to your subject. You don't have to know the person to notice unique characteristics of their appearance.

11–18
Using subtle colors for this portrait, the artist conveys a strong mood by the placement, posture, and details of her subject.

Linda Greene, *Deep Thought,* 1996.
Colored pencil on mat board, 8" x 12" (20 x 30 cm).

2. Draw the parts of the face of someone you know. Then put the whole drawing together, creating a full-color portrait. Review the principles of composition in chapter seven. Rather than draw your subject dead center and face forward, like a mug shot, position the face in an interesting manner to make good use of negative space.

11–19
Enlarging the subject to fill the entire picture plane, the artist skillfully layered soft, delicate colors to capture a tender moment.

Pamela Whyman, *Michelle,* 1994.
Colored pencil, 10" x 14½" (25 x 37 cm).

1. Create a personality portrait of someone you know. To capture the person's essence, costume the sitter in a favorite outfit, use props or catch the person in his or her favorite activity. Candid photographs sometimes best capture a person's true spirit. Since photos aren't often perfectly staged, composition may have to be modified. Consider doing a black-and-white rendering first, to work out compositional problems.

11–20
After hours of interviews with a wide variety of Appalachian natives, this artist produced a series of personality portraits that convey their everyday life.
Monta Black Philpot, *Pete Lewey,* 1986. Colored pencil, 31½" x 26" (80 x 66 cm).

2. Draw a creative self-portrait, using colored pencils. Feel free to use a mixed-media approach if it enhances your creativity. When considering creative options, say to yourself, "She didn't say we couldn't . . ." The term creative self-portrait can mean a lot of things. For example, when the author was given this assignment one summer, her solution was to draw her feet holding a cola bottle, in a hammock. The teacher didn't say she had to draw her face!

11–21
This creative self-portrait was done with a combination of media. The background was washed with watercolor, the face was lightly drawn with pastels, and a multitude of details were added with colored pencils.

Student work: Isidro Macedo, Jr. (age 18), *Self-Portrait,* 1998. Mixed media, 14" x 11" (36 x 28 cm).

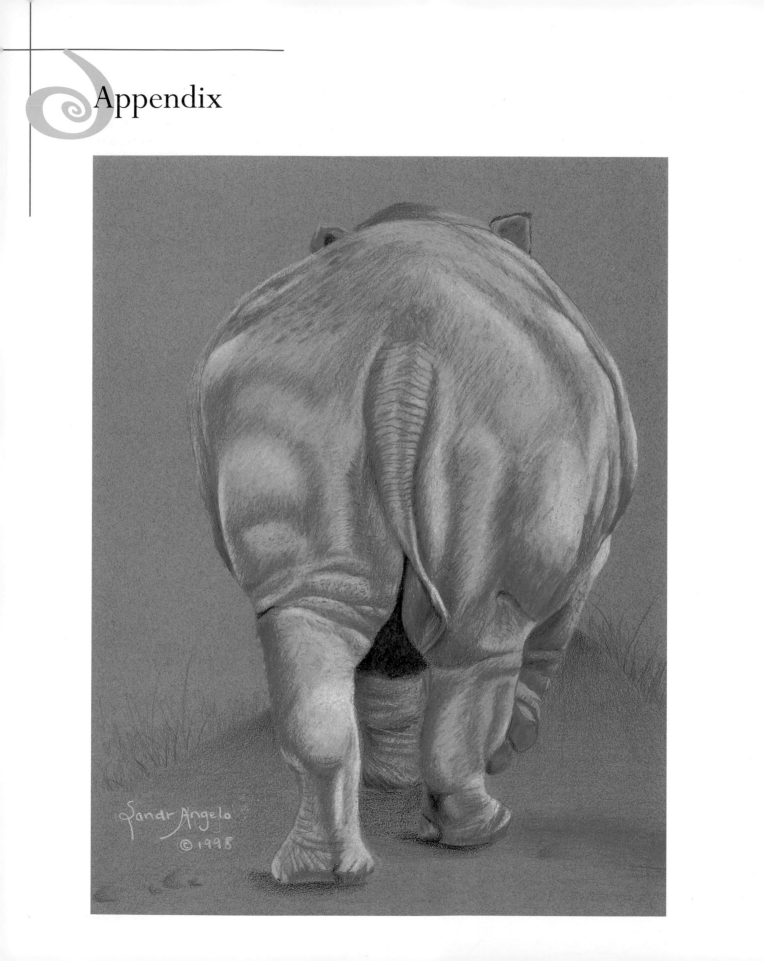

Sandr Angelo
© 1998

Portfolios

Recording and Promoting Your Work

Any artist, whether professional or amateur, will benefit from maintaining a portfolio to show the range of work they have created. If you plan to promote your art, apply for art school, or work as an illustrator or professional artist, you will need to have slides of your work, preferably with duplicates of each. Publishers of magazines, newspapers, and books always have tight deadlines. When they decide to publish your work, they will expect you to deliver slides of your artwork immediately. If you have everything organized in three-ring binders, you can simply go to the shelf, put together a slide sheet, and send a cover letter along with your work. (Always store your slides in archival-quality plastic sleeves.)

Most publishers and galleries work from slides. If you want to include tear sheets from published work or high-quality laser prints, that's okay too, as long as the work is also submitted in slide format. Newspapers sometimes use 5" x 7" black-and-white photos of the artist or action shots, so keep those on hand too.

Unless you are a fabulous photographer, always have your slides produced professionally. As an author of books and articles, I can't tell you how many times I've wanted to use work that had to be thrown out simply because the slides were awful. Never photograph your work with your fingers showing, on your car bumper, or on the grass in your backyard. If you do take your own slides, mount your work on a black, white, gray, or neutral background, and shoot outdoors in the shade on a sunny day (to get accurate color). Don't shoot in direct sunlight because the colors may become overexposed or harsh shadows may show on your work. Never photograph framed work that is under glass, as it is nearly impossible to avoid glare.

Even though I used to teach photography, I send my work to a lab that charges ten dollars for the first slide and eighty cents for each duplicate. In the long run, it would cost me about the same if I bought the film and had it developed. If you create large works, be sure to ask the lab about size limitations. Some shops can't photograph large work. If you need to locate a professional lab, call a local advertising agency and speak to the art director there. Art directors tend to be finicky about quality and will likely know who does good work.

As a standard practice, when I finish a piece of art, I immediately send it in to the lab where I have twenty to thirty slides made. I ask for slides with white frames on both sides and request that my name, address, and phone number be printed on the back of the slide, in case someone who sees it wants to contact me.

Make a habit of putting your name, address, and phone number on every single thing you send out. Numerous times when I have wanted to call an artist, I haven't been able to find the address or phone number. If there is room on the slide, ask the lab to print the title, dimensions, and copyright date on the front. If they don't, use a black Identipen (which writes on any surface, including plastic) to write all the information yourself. Be sure to write legibly. When sending slides to prospective users, always include a typed slide sheet that lists the same information, for cross-reference. Number each slide to match the caption on the slide page, and put your address and phone number on this sheet.

Conservation

The Five Enemies of Paper and Pencils

Works on paper generally sell at a lower price than works on canvas because of their lack of durability. It's not uncommon to see a work on paper priced at fifty percent less than a comparable work on canvas. To avoid this problem, consider working on Windberg Masonite Panels, which are lightly coated with marble dust. This ground can hold its own when compared to an oil painting surface. After all, many oils are painted on Masonite. Most brands of pencils provide a chart listing the archival colors. When you use an archival ground and lasting colors, your work's longevity will compare favorably with that of oils and acrylics.

Alternatively, many of the problems associated with paper conservation can be prevented by avoiding the "enemies" that tend to destroy paper:

Sandra Angelo, *The End,* 1998.
Colored pencil on colored paper, 11" x 8½" (28 x 22 cm).

Enemy Number One:
Poor Quality Paper and Other Grounds

Select papers or surfaces of archival quality. Paper is discussed at length in chapter two, but suffice it to say, poor-quality papers with acid composition will fade and take your art along with it.

Enemy Number Two:
Ultraviolet Light

Sunlight, which is full of harmful ultraviolet (UV) rays, can destroy your art. Most paper will yellow and gradually disintegrate when exposed to sunlight, even when it is reflected from a distant source such as a skylight. For best protection from these damaging rays, frame your work using the UV filter glass sold in finer frame shops. It will cost you roughly twice as much as standard glass. You might regret not shelling out the money if you encounter damage down the road.

I was recently shocked to discover that my family photo gallery in the hallway had quietly faded away. All the photos were displayed on an interior wall, not exposed to the sun at all. However, at the top of the stairs, adjacent to my picture gallery, there is a skylight. This small amount of reflected sunlight faded my photos mercilessly. Priceless family memories are now a shadow of their former glory. I wish I had known about UV filter glass when I framed them.

When you complete your art, before you frame it, store it in a metal file cabinet with wide, shallow drawers. Make sure the drawing lies flat, and keep the cabinets away from heat, to prevent wax bloom. Frame one piece at a time to spread the cost out over time. If you need several pieces mounted, you can wait for sales at the local frame shop.

Enemy Number Three:
Bugs

Silverfish and moths have a voracious appetite for paper. To prevent them from making a meal of your art, consider lining your storage drawers with cedar or placing several cedar pieces in each drawer. You can purchase cedar chips, blocks, or balls at a bedding and bath shop.

Enemy Number Four:
Humidity

To make paper, manufacturers combine various fibers with water. This liquid mixture is then laid out, mechanically or by hand, to dry. When the water evaporates, the mixture becomes paper. As you can imagine, the reintroduction of water convinces paper that it should again become a liquid mixture, so it begins to warp. Paper can absorb moisture from the air in bathrooms, kitchens, a pool house, or any humid climate. To protect your art, display it in the driest rooms in your house. If you live in a moist climate, consider using a dehumidifier.

Enemy Number Five:
Heat

As you well know, paper is flammable. Common sense tells us to avoid placing art next to a heater or an air vent. Paper that is covered with colored pencil has an additional problem. Colored pencil is made from wax, and when it is exposed to heat, the wax tends to separate from the pigment, causing a layer of white film to form over the drawing. To prevent this wax bloom, you can spray your drawing with fixative (see chapter two) or move it away from the heat source.

Fugitive Colors

Colored pencils are made of a combination of clay, wax, and pigment. Although many art pigments consist of archival-quality materials, some colors can be derived only from pigments that are fugitive. In the past, because colored pencils were not considered a serious art medium, most pencil manufacturers did not publish a list of the archival properties of various colors. Now most do. You can write to the manufacturer to inquire about the permanence of colors—the address is generally listed on the container sold with the pencils. Write to the product manager in the marketing department. Most companies will gladly send you a brochure detailing the lightfastness ratings for each color. One brand even lists this information on each pencil. If you plan to create a drawing that will last, make sure you choose colors that won't fade.

Matting and Framing

When you frame your work, you are in effect creating a protective sandwich around it. On the front side, use a glass that screens out UV rays. Next to that, place an archival-quality rag mat to keep the glass separated from your drawing. If you place glass directly on your art, the wax will transfer to the glass, and your drawing will slowly disintegrate.

The next ingredient is a hinge of archival tape. This one-to three-inch piece of tape should be attached to the top of the artwork on the right and left sides. This simple hinge lets the paper hang free, allowing it to adapt to changes in humidity and temperature. On the back of the mat, place archival-quality foam core, which is available in various widths and should be cut to fit the frame. The assembled sandwich is now ready to be placed in the frame and sealed with a piece of brown archival-quality framing paper on the back. Attach wire to the back, and your art is ready to be hung.

When you are selecting a frame or mat, take your artwork with you. Pull out several sheets of mat board to see which color matches best. Sometimes you'll be quite surprised to find yourself choosing a color that you wouldn't have predicted as the most suitable. When framing fine art for an exhibit, the protocol is to use white or off-white mats and very simple frames. Galleries would have a terrible time hanging a show of artworks presented in a variety of colored mats.

When you are framing art for decorative purposes at home, you can add a second or third color as a border inside the first mat. Sometimes you may even select a colored mat and pull it off. Keep this rule in mind: The art is the star. You never want someone to look at your work and say, "My, what a nice frame!" The mat and frame should simply support the art, not detract from it. Keep in mind that simple and neutral is always safe.

Finally, remember that art is created for enjoyment. Indulge yourself, and display your work in your own home and in the homes of your family and friends. Art, after all, captures a bit of your soul and offers the viewer a personal glimpse into your world. Living your daily life surrounded by work that was generated from your heart is relaxing and comforting, and will return you to the joy you had while creating it. Art can soothe the soul.

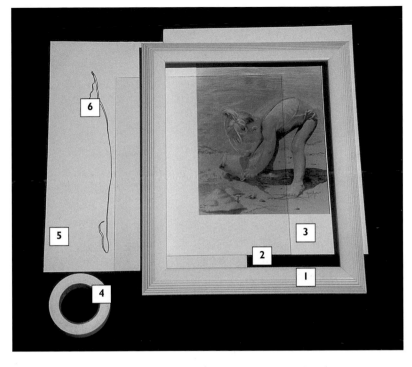

Matting and framing your work is critical to its preservation. You must in essence create a sandwich of archival-quality materials to protect your art. These should include, from front to back,

1. a frame
2. UV filter glass
3. archival-quality rag mat
4. archival-quality tape hinges on the back of the art, top left and right
5. foam core
6. optional: wire (can be attached directly to the frame for hanging)
7. archival-quality brown sealer paper on the back (not shown)

This drawing has been framed to match the decor of the home in which it is displayed. This approach towards matting and framing is considered decorative.

Sandra Angelo, *Dreams,* 1993.
Colored pencil on colored paper, 11" x 14" (28 x 36 cm).

Glossary

archival-quality materials Products that will last over time.

atmospheric perspective Creating the illusion of distance on a two-dimensional surface.

burnishing A process of creating saturated color that is unique to work in colored pencil. Begin with a transparent layer of multiple hues, using very gentle pressure. Follow with the exact same sequence of color, but this time, gradually increase the pressure until the wax pencil melds together and completely obliterates the drawing surface.

colored ground Colored paper or other drawing surface; or an underpainting made with watercolor, watercolor pencils, a blender, or an airbrush.

colorless blender A felt-tip marker that has no color or pigment; used for making underpaintings in colored-pencil drawings.

complementary colors Colors that are directly opposite each other on the color wheel.

composition The arrangement of shapes or objects on a page.

contour line drawing A preliminary line drawing that serves as a map for the future placement of shapes, shadows, and colors.

cover letter Whenever you send out your work for publication, you should submit a letter explaining what you are sending and why. Always be sure to put your name, address, and phone number on the letter and on everything you submit.

dusting Lightly covering a drawing area to "glaze" or tint the underdrawing. (A synonym for the term glazing as it is used when painting with watercolors or oils.)

fugitive Pigments that will fade when exposed to light, such as the dyes used in markers.

gesture drawing Very quick linear sketches which are completed in thirty to sixty seconds, capturing only the action, not the detail.

gouache An opaque, water-soluble paint. Colored-pencil artists use white gouache to create highlights after colored-pencil work is complete.

gradation, gradated Any gradual change in hue or value.

grisaille A technique in which a black-and-white underdrawing or underpainting is followed by a glaze of color.

hue Color.

impressed line Marks produced by using pressures. A slightly blunt instrument is pressed into the paper to reveal the color of the paper and provide details, such as the veins of a leaf or lace patterns.

local color The natural color of an object.

monochromatic Of one color.

pointillism A style of nineteenth-century French painting in which colors are systematically applied to canvas in small dots, producing a vibrant surface.

primary color Pure pigments that cannot be mixed from any other color: yellow, red, and blue. All art pigments are made by combining these three hues in various proportions.

pure hue A color that has none of its complement in it.

pure value A pure color, mixed with white.

reflected color The color that is created by mixing the local color with an adjacent color that is reflecting into the object.

secondary color A color obtained by mixing equal amounts of two primary colors.

tear sheet A type of work sample. When your work is published in magazines, you can remove that page and send it as a sample of your work.

tone Modifying a color by adding neutrals to it. Also, the relative lightness or darkness in a work of art.

transparent layering Applying layers of colored pencil gently, one on top of another, with an extremely sharp pencil until a rich, variegated tone is achieved.

tertiary color A color obtained by mixing equal amounts of a primary color and its adjacent secondary color.

value An element of design that relates to the lightness or darkness of a color.

Resources

Books

Adams, Norman. *Drawing Animals.* New York: Watson-Guptill Publications, 1989. A good collection of animal drawings in graphite pencil as well as numerous skeletons of a wide variety of animals. An excellent reference.

Borgeson, Bet. *Colored Pencil Fast Techniques.* New York: Watson-Guptill Publications, 1988. Methods and strategies for gaining speed and improving colored pencil drawings, 140 pp.

Borgeson, Bet. *Colored Pencil for the Serious Beginner.* New York: Watson-Guptill Publications, 1998. The author shows how to create form, volume, and space and avoid overworking a picture. She also shares special techniques for both popular and nontraditional subjects and discusses how to become a professional artist. 200 color illlus., 144 pp.

Borgeson, Bet. *The Colored Pencil, Key Concepts for Handling the Medium.* New York: Watson-Guptill Publications, 1983. Provides the reader with an introduction to the colored-pencil medium and step-by-step demonstrations of a variety of colored-pencil techniques, all in the author's graphic style, 140 pp.

Borgeson, Bet. *Colored Pencil Techniques.* Cincinnati: North Light, 1997.

Colored Pencil Society of America, *The Best of Colored Pencil.* Rockport, MA: Rockport Publishers, 1993.

Colored Pencil Society of America, *The Best of Colored Pencil 2.* Rockport, MA: Rockport Publishers, 1994.

Colored Pencil Society of America, *The Best of Colored Pencil 3.* Rockport, MA: Rockport Publishers, 1996.

Curnow, Vera, *The Best of Colored Pencil 4.* Rockport, MA: Rockport Publishers, 1997.

Curnow, Vera. *Creative Colored Pencil.* Rockport, MA: Rockport Publishers, 1995.

Curnow, Vera. *Creative Colored Pencil Landscapes.* Cincinnati: North Light, 1996.

Curnow, Vera. *Creative Colored Pencil Portraits.* Cincinnati: North Light, 1996. In the first section of this book, six artists create a portrait of the same model, working from identical reference photographs, for stunning variations. The second section of the book shows ten artists' self-portraits. It includes expert advice on every aspect of painting portraits, from working with a photo to developing a composition to mixing skin tones, 84 pp.

Doyle, Michael E. *Color Drawing: A Marker/Colored Pencil Approach for Architects, Landscape Architects, Interior and Graphic Designers, and Artists.* New York: John Wiley & Sons, 1997.

Greene, Gary. *Creating Textures in Colored Pencil.* Cincinnati: North Light, 1996.

Greene, Gary. *Creating Radiant Flowers in Colored Pencil.* Cincinnati: North Light, 1997.

Kullberg, Ann. *Colored Pencil Portraits Step by Step.* Cincinnati: North Light, 1998.

Martin, Judy. *The Encyclopedia of Colored Pencil Techniques.* Philadelphia: Running Press, 1997. A step-by-step directory of key techniques, plus a gallery showing how artist use them, 192 pp.

Poulin, Bernard. *The Complete Colored Pencil Book.* Cincinnati: North Light, 1992. Through advice on the versatile medium of colored pencils, from the basics to advanced techniques. Discussion includes: materials and work space, the preliminary sketch, color and its impact, creating textured surfaces, portraits and figures, and landscapes. Abundantly illustrated with work by the author and others, 136 pp.

Rodwell, Jenny. *Colored Pencil Drawing.* London: Studio Vista, 1995. A variety of subject matter demonstrated step-by-step in large follow-along format. Demonstrations are in both watercolor and dry wax-based colored pencils, 95 pp.

Strother, Jane. *The Colored Pencil Artist's Pocket Palette.* Cincinnati: North Light, 1994.

Warr, Michael. *Coloured Pencils for All, A Comprehensive Guide to Drawing in Colour.* UK: David and Charles, 1996.

Wise, Morrell. *Colored Pencils (Artist's Library Series).* Walter Foster Pub., 1990.

Sandra Angelo Books and Videos

Series: Colored Pencil and Mixed Media

Angelo, Sandra. *Colored Pencil Drawing.* Laguna Hills, California: Walter Foster, 1994. Step-by-step lessons that guide you through seven basic colored-pencil drawing techniques. 32 page book.

Getting Started with Colored Pencils, 1994. Videotape: 46 min. Step-by-step demonstrations of four basic colored-pencil techniques as well as a discussion of various brands of pencils, papers, and accessories.

Special Effects with Colored Pencils, 1994. Videotape: 55 min. David Dooley demonstrates how to draw metal and glass; Sandra Angelo shows six watercolor-pencil techniques as well as time-saving techniques for drawing on colored paper.

Realistic Colored Pencil Textures, 1996. Videotape: 70 min. David Dooley and Sandra Angelo demonstrate special effects for combining colored pencils with various media to create textures including satin, glass, foliage, rocks, grass, skin tones, and more.

Time-Saving Colored Pencil Techniques, 1996. Videotape: 75 min. David Dooley and Sandra Angelo demonstrate special effects for cutting your drawing time in half while dramatically improving results.

Building A Nature Sketchbook, 1997. Videotape: 75 min. Whether you are in a backyard, a park, or a jungle, you can use colored pencils, watercolor pencils, and pens to create a very personalized sketchbook.

Watercolor Pencils, The Portable Medium, 1999. Videotape: 50 min. Six techniques for working with fast, easy, portable, water-soluble colored pencils. Demonstrations include combining watercolor pencils with watercolor and ink.

Creating Dynamic Drawings: What Do I Do with the Background?, 1999. Videotape: 65 min. Sandra Angelo walks you through basic principles of composition as well as the thought process and research that goes into producing creative drawings. Steve Miller, an award-winning portrait artist with a celebrity client list, demonstrates his secrets for creating dynamic drawings.

Color Theory Made Really Easy, 1997. Videotape: 55 min. Learn simple color-mixing theories and exercises that will make your drawings come alive. Demonstrated in acrylics but theory applies to all media including colored pencil.

Paint Like Monet in a Day™, 1997. Videotape: 52 min. Demonstrations with oil pastels, a fast, inexpensive, non-toxic medium that combines very well with colored pencils.

Angelo, Sandra. *Create with Colored Pencils on Wood.* Dodgeville, WI: Walnut Hollow, 1997. Step-by-step methods for using colored pencils on a wood surface. Includes preparing wood, transferring designs, tips for drawing on wood, and patterns for all the lessons. 32-page companion book to the following video.

Create with Colored Pencils on Wood, 1997. Videotape: 58 min. Step-by-step demonstrations showing methods for using colored pencils on a wood surface.

Series: So You Thought You Couldn't Draw™

Angelo, Sandra. *So You Thought You Couldn't Draw™.* San Diego: Discover Art, 1989. This 150-page workbook transforms novices into artists with a fast, easy four-step method. The following companion videos demonstrate the drawings in this book.

Drawing Basics, 1994. Videotape: 47 min. This video guides you through the first half of the book, *So You Thought You Couldn't Draw™,* and provides foundational step-by-step lessons for shading, getting accurate proportions, creating textures, and more.

The Easy Way to Draw Landscapes, Flowers, and Water, 1994. Videotape: 45 min. Step-by-step demonstrations and fast methods for working with water-soluble graphite.

7 Common Drawing Mistakes and How to Correct Them, 1995. Videotape: 62 min. Simple solutions to the most common drawing problems including: proportion, perspective, creating depth, and more.

Series: People and Pets

Angelo, Sandra. *Turn Treasured Family Photos into Art, The Easy Way.* San Diego: Discover Art, 1999. Step-by-step lessons designed for beginners who can't even draw a straight line. This book is a companion for the following two videos.

The Easy Way to Draw Faces, 1994. Videotape: 45 min. Step-by-step demonstrations that show how to draw eyes, noses, mouths, hair, and wrinkles using graphite pencil.

Drawing Your Loved Ones: People, 1997. Videotape: 86 min. Step-by-step colored-pencil demonstrations that show how to draw eyes, noses, mouths, hair, and skin tones.

Techniques for capturing a likeness, correcting bad references, and putting personality into portraits.

Angelo, Sandra. *Capturing the Spirit of Your Pet.* San Diego: Discover Art, 1999. Step-by-step lessons designed for beginner, 150 pp. This book is a companion for the following two videos.

The Easy Way to Draw Cats, Dogs, and Wild Animals, 1994. Videotape: 59 min. Nominated for an Emmy, this step-by-step video, filmed at the San Diego Wild Animal Park, walks the beginner through graphite lessons for drawing domestic and wild animals.

Drawing Your Loved Ones: Pets, 1997. Videotape: 84 min. Step-by-step colored-pencil demonstrations show how to draw animal eyes, noses, and mouths as well as long, short, and fluffy fur. Techniques for shooting and organizing references and correcting bad photos as well as capturing the spirit of your pet.

Organizations and Workshops

Bet Borgeson Workshops
c/o Watson Guptill
1515 Broadway
New York, NY 10036

Colored Pencil Society of America
Cindy Hopkins
244 Orchard
Weerton, WV 26162

David Dooley Colored Pencil Workshops
RR #3, Box 384
Lawrenceville, Illinois 62439
618-943-3680

Discover Art with Sandra Angelo, Inc.
Colored Pencil and Drawing Workshops
PO Box 262424
San Diego, CA 92196
Toll-free 1-888-327-9278

Society of Illustrators
128 East 63rd Street
New York, NY 10021

 # Index

Adamson, Donna, 96
Alello, Darryl J., 72
Allen, Julie Marguerite, 58
Angelo, Sandra, x, 20, 30, 38, 40, 43, 48, 51, 56, 84, 85, 91, 94, 97, 104, 105, 107, 115, 121, 123, 124, 126, 127, 130, 131, 135, 138
animals, drawing, 91–96
 creating textures, 93–96
 habitats and, 93
 movements, behavior, anatomy and, 91–92
 observation and, 91–93
 practicing, 93–96
 references and, 95
 shadow depictions and, 95–96
archival-quality materials, 15–16, 136–138
 paper, 21
See also conservation

Badillo, Art, 93
Bain, Lindsey, 98
Balcombe, Noah, 99
Barber, Emma, vii
Barr, Rose Marie, vi, 108
Bartlett, Jennifer, 6
Benotti, Elizabeth, 9
Berol, 4, 8
Berolzheim, Daniel, 4
Bonner, Brian, 72
Bowen, Brent, 96
Boyer, Jesse, 75
brushes, 17
Bruynzeel, 8
Bull, Joe, 46
burnishing, 36–38
 demonstration, 37
 tips, 36
Byrem, Lynn A., 117

Caran d'Ache, 4
Caskey, Bethany, 31
Castillo, Mario, 7
Chen, June, 87
Cho, Jang, 64
Choulden, Nicolas, 68
Cole, Jennifer, 119
collage, colored ground, 56–59
colored ground, 51–60
 collage, 56–59
 colorless blender, underpainting and, 56–58

demonstration, colorless blender and, 57
monochromatic drawings on colored papers and, 60
mood and, 53
reasons for, 51
selecting, 54–55
testing colors and, 53
watercolor, underpainting and, 59
colored masking fluid, 25
colored papers, 20
colorless blender, 16
 demonstration, 57
 underpainting with, 56–58
color mixing, 33
color wheel, 34
composition, 67–70
 bird's-eye view, 68
 blow up, 68
 concept of thirds, 68
 converging lines, 69
 pushing subject back, 69
 still life, 111
 thumbnail sketches, 70
 worm's-eye view, 69
conservation, 136–138
 archival quality materials and, 136
 bugs and, 136
 framing and, 137–138
 fugitive colors and, 137
 heat and, 136
 humidity and, 136
 matting and, 137–138
 ultraviolet light and, 136
Cook, Ken, 69
creative process, 77–85
 for beginners, 78–80
 defined, 77
 emulating masters and, 79–80
 guidelines for creating original work and, 80–81
 inspirations for, 84–85
 mastering basics and, 78
 reference file building and, 83
 styles, media and, 78–79
 teachers and, 78
creative synergy, 81
Currier, Deborah, 71, 114, 116

Davis, Stuart, 4
Degas, Edgar, 79
density, pencil, 14

Denton, Patry, 44
depth
 bright, dull, 72
 converging lines and, 73
 creating, 71–73
 focused, fuzzy, 71
 higher, lower, 72
 larger, smaller, 71
 overlapping shapes, 73
Derwent, 8
design techniques, 67–73
 composition, 67–70
 depth perspective, 71–73
 thumbnail sketches, 70
Dooley, David, 12, 42, 49, 112, 125
Dorst, Mary Crowe, 64
drawing surfaces, 19–22
 multi-media panels, 22
 Windberg panels, 22
Duchamp, Marcel, 4
Dunkle, Christy, 68
dust brushes, 25

ears, drawing, 126
Eberhard Faber, 4
Edidin, Barbara, 41, 84, 85, 111, 114
Engelbreit, Mary, 10, 84
en plein air sketching, 102
erasers, 23
 battery-operated, 23
 plug-in, 23
eyes, drawing, 122–123

Faber, 8
Fairl, Carolyn, 17, 108
fixative, 26
flick paint, 25
Ford, Mary, 102
Fournier, Evelyn, 54
framing, 137–138
frisket paper, 25–26
fugitive colors, 137

Garrabrandt, Bruce S., 72
Gianera, Jan, 19
Golden, Judith, 6
graphite, 4
 water-soluble, 46
graphite density chart, 14
Greene, Linda, 132
grids, 120

grisaille, 29–32
 demonstration of, 31
 technique, 30–32
Guthrie, Robert, 22

Hacker, Valerie, 67
hair, drawing, 126
Halborn, Matt, 41
Hernandez, Nora, 7
history
 of colored pencils, 3
 of use, 4–6
Hockney, David, 6
Hockstadt, Mark, ix
Holmberg, Norman, 105
Huang, Sharon, 39
human face, drawing the, 119–130
 black, white drawings and, 122
 colored-pencil portraits and, 128–130
 correcting photo flaws and, 130
 correcting work and, 129
 difficulty of, 119–120
 ears and, 126
 eyes and, 122–123
 grids, use of and, 120
 hair and, 126
 harsh shadow elimination and, 130
 modifying colors and, 130
 mouths and, 124
 noses and, 123
 photo files and, 129–130
 skin and, 124–125
 techniques for, 120–121
 teeth and, 126
 tips for, 128–129
 windows, use of, 121
Hurst, Susan, 120

Iavelli, Julie, 86

Jennings, Helen, 94

Kapka, Rose, 109
Kessler, Andrea, 101
Klimt, Gustav, 4
Kullick-Escobar, Ulises, 79

LaMarche, Chris, 82
Lanyon, Ellen, 5
layering techniques, 29–38
 building color, 33–34
 burnishing (opaque layering), 36–38
 demonstration, color opposites for
 shading, 35

grisaille technique, 29–32
 monochromatic, 32–33
 transparent, 34–35
Leach, Mada, 4
Lerback, Jens, 5
Lichtenstein, Roy, 6
lightfastness guides, 15
Lindstedt, Doreen, 99
Locati, Dyanne, 88
Lott, Starlynn, 34

McCarty, Ruth, 98
Macedo, Jr., Isidro, 133
MacLean, Teresa McNeil, 103
manufacturing, 8
Marcum, Beverly, xiv
Martin, Doris, 16, 59
masking products, 25–26
 colored masking fluid, 25
 flick paint, 25
 frisket paper, 25–26
Massey, Ann James, 35, 36, 122
Mater, Gene, 11
materials, 13–16
 archival properties of, 15–16
 archival-quality paper, 21
 brushes, 17
 caring for pencils and, 14–15
 colored papers, 20
 colorless blenders, 16
 drawing surfaces, 19–22
 dust brushes, 25
 erasers, 23
 fixatives, 26
 masking products, 25–26
 multi-media panels, 22
 opaque white, 26
 pencil density and, 14
 professional-grade pencils, 13
 sharpeners, 23
 storage, 15
 tape, 25
 technical ink pens, 18
 textured papers, 20
 transfer paper, 26
 watercolor pencils, 16
 Windberg panels, 22
matting, 137–138
Miller, Steve, 3, 129
mixed-media, 44–46
monochromatic drawings, colored ground
 and, 60
monochromatic layering, 32–33

mouths, drawing, 124
multi-media panels, 22
Myers, Robert, xv

Nakamura, Shane, 74
nature sketchbooks, 105
Nelson, Bill, 9, 35, 36, 81
Nelson, Bruce, 25, 101, 106, 117, 125
Newton, Barbara, xii, 29, 33
noses, drawing, 123

Oldenburg, Claes, 6
opaque layering, 36–38
 demonstration, 37
 tips, 36
opaque white, 26
outdoors, drawing the, 101–105
 demonstration, big picture, 106
 demonstration, nature up close, 104
 en plein air sketching, 102
 exploring preferences and, 103
 nature sketchbooks and, 105

Pacheco, Michael, 111
papers, 19–21
 archival-quality, 21
 colored, 20
 colored ground and, 54–55
 surface of, 19
 textured, 20
Parker, Kathi Geoffrin, 39
Penrod, Mike, 27
Philpot, Monta Black, 133
photo files, 129–130
Porter, Sylvia L., 76
portfolios, 135
portraits, 128–130
 adding faces to photo file and, 129–130
 correcting photo flaws and, 130
 correcting work and, 129
 harsh shadow elimination and, 130
 modifying colors and, 130
 tips for, 128–129
Poussin, Nicolas, 79
promoting work, 135

Raney, Ken, 63
recording work, 135
Reed, Carolyn, 29
Reinbold, Joella, 86
Renick, Patricia, A., 6
Rimmer, Elaine, 74
Robison, Tricia, 115

Ross, Brian, 112
Roy, Lyn Aus, 119

Samaras, Lucas, 6
Sanchez, Jesus, 77
Schoch, David, 80
Scudiere, Rebecca, 24
Servoss, Allan, 32, 71
Settergren, Deborah, 3, 19, 64, 88, 116
shadows, 95–96
 body, 95
 cast, 95
 hints for, 96
sharpeners, 23
skin, drawing, 124–125
Smith, Joanne, 114
Smith, Michael, 55
Staedtler, 8
Stewart, Shelley M., 66
still lifes, 111–114
 common errors, 114
 composition options, 111
 demonstration, value studies, 113
 setting up, 114
 subject selection, 112
storage, 15
Stromsdorder, Deborah, viii

subject matter
 animals, 91–96
 the great outdoors, 101–105
 the human face, 119–130
 still lifes, 111–114
Sutton, Scott, 18

tape, 25
technical ink pens, 18
techniques. See design techniques; layering
 techniques; watercolor-pencil techniques
teeth, drawing, 126
textured papers, 20
Thayer, Thomas, 21, 51, 60, 73, 91
Thiebaud, Wayne, 6
Thompson, Orville, 78, 83, 128
Thompson, Richard, 57
thumbnail sketches, 70
Tooley, Richard, vii, 112
transfer paper, 26
transparent layering, 34–35
Twombly, Cy, 6

underpainting
 colorless blender, 56–58
 watercolor, 59

Vaclavik, Susan, v

value, 33
Vierra, Kathryn, 63, 69
Villalobos, Jr., Martin, 70
Vleck, Garrett Van, 93

Warner, Karen, 73
watercolor, underpainting, 59
watercolor pencils, 16
 advantages of, 43–44
 pen, ink and, 44–46
watercolor-pencil techniques, 43–46
 demonstration of six types of, 45
 mixed-media approach to, 44–46
 water-soluble graphite, 46
Watt, Tracy, 87
Westberg, Bruce Martin, 92
Whyman, Pamela, 132
Windberg, Dalhart, 22
Windberg panels, 22
windows, drawing faces and use of, 121
Wolfson, Julie, 14, 44, 47, 52, 53, 91, 95,
 109, 113
Wood, Grant, 4
Wright, Frank Lloyd, 4

Youngdale, Tiko, 30, 46, 107

Zeller, Deborah, 38

6/02 21 4/02
 7/04 (31) .5/04
 4/06 37 12/05
 3/10 (44) 2/10
 8/12 (48) 3/12